THE CARTOONIST'S BIG BOOK OF DRAWING ANIMALS

CHRISTOPHER HART

Watson-Guptill Publications
New York

First published in 2008 by Watson-Guptill Publications,
an imprint of the Crown Publishing Group,
a division of Random House Inc.,
New York
www.crownpublishing.com
www.watsonguptill.com

Library of Congress Cataloging-in-Publication Data

Hart, Christopher.
 The cartoonist's big book of drawing animals / Christopher Hart.
 p. cm.
 Includes index.
 ISBN-13: 978-0-8230-1421-7 (alk. paper)
 ISBN-10: 0-8230-1421-5 (alk. paper)
 1. Animals in art. 2. Cartooning—Technique. 3. Drawing—Technique.
I. Title.
 NC1764.8.A54H378 2008
 741.5'362—dc22
 2007029102

Printed in China

6 7 8 9 / 16 15 14

Executive Editor: Candace Raney
Senior Development Editor: Michelle Bredeson
Designer: Jay Anning/Thumb Print
Production Manager: Salvatore Destro

This book is dedicated to my Welsh Springer Spaniel, Rusty, who is so clever that he races out the door each morning and retrieves the paper. Unfortunately, he tears it to bits before bringing it back into the house!

CONTENTS

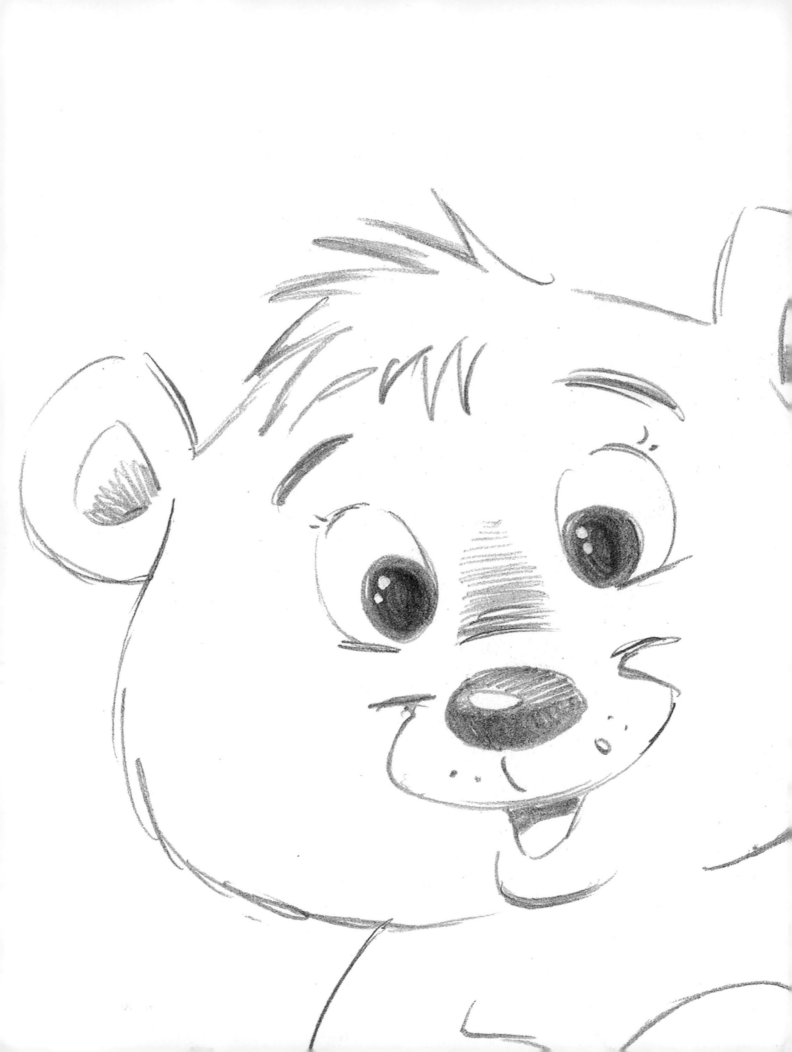

INTRODUCTION

The Cartoonist's Big Book of Drawing Animals is simply the most complete guide to drawing cartoon animals that has ever been available. It is the follow-up to my best-selling book *How to Draw Cartoon Animals* and features even more cute and wacky animals, plus some edgier styles, including retro characters. There are bigger sections devoted to each of the most popular cartoon animals, such as bears, penguins, dogs, horses, cats, elephants, lions, tigers, and more. It also explores individual species. For example, in addition to the classic cartoon bear, you'll learn to draw grizzlies, brown bears, black bears, pandas, and polar bears. You'll also be introduced to the different breeds of cartoon dogs and cats and their corresponding personalities. And there's an entire chapter devoted to humorous "sidekick" animals, including cows, turtles, hippos, kangaroos, and more.

The Cartoonist's Big Book of Drawing Animals covers all aspects of cartoon animal expressions, poses, and actions. It shows you how to turn any animal into a classic cartoon "type," such as the loveable buddy, schemer, bully, or evil genius. Yes, they're all here—the kinds of wildly successful characters that star in computer-animated movies and create today's box office sensations.

I break the drawings down into lots of steps and include tons of "side hints" to illuminate the step-by-step drawings and make them that much easier to master. And the steps are gradual, so that every artist of any level can do it.

Cartoon animals are a ***must-know*** for anyone who's ever wanted to draw cartoons, and this book contains everything you need to know to draw them successfully. Whether you're a novice or a seasoned pro, if you like to draw cartoons, you'll find something of value in this book.

BEARS: 800 POUNDS OF PERSONALITY

They're some of the all-time favorite characters of the cartoon world: loveable, cuddly—but sometimes grouchy—bears. They're funny as adults and irresistibly cute as cubs. I'm starting off the book with bears because they're some of the most popular cartoon critters around and because they're round, which makes them easy to draw. They're also loaded with personality. And that's what I want you to go for in your drawings.

BASIC BEAR

The cartoon bear should look like he's never pushed a dessert tray away from the table in his life. Everything he's ever eaten has gone straight to his hips and stayed there! All cartoon bears are drawn to appear bottom-heavy, which is a funny look. The head should be small in comparison to the body.

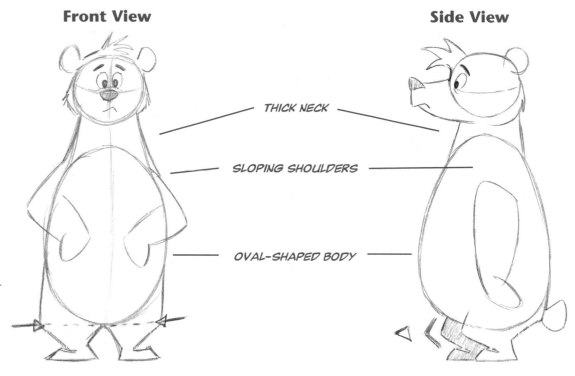

Front View

Side View

THICK NECK

SLOPING SHOULDERS

OVAL-SHAPED BODY

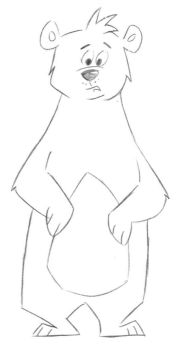

*The knees bend **outward** in the front view. Sketch a light, horizontal line across both knees to make sure that they are at the same level.*

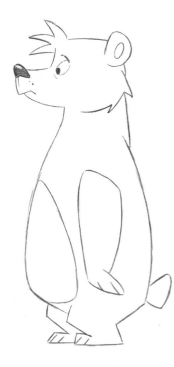

*The knees bend **forward** in the side view.*

ON ALL FOURS

To draw a bear in this position, you can make the bottom half one big circle. The chest is small, but the rump is big and round. There should be very little room between the tummy and the ground; that's because the legs are so comically short.

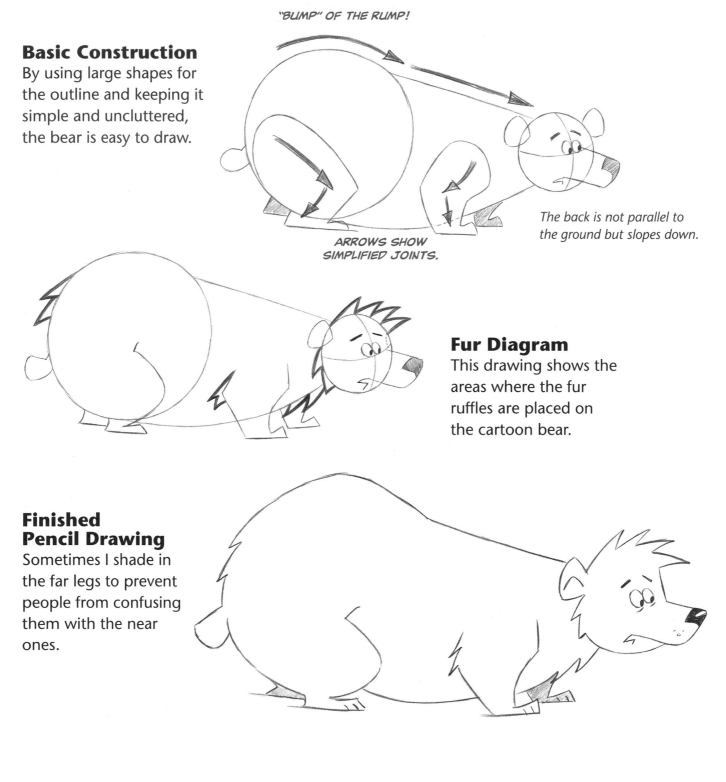

"BUMP" OF THE RUMP!

Basic Construction
By using large shapes for the outline and keeping it simple and uncluttered, the bear is easy to draw.

ARROWS SHOW SIMPLIFIED JOINTS.

The back is not parallel to the ground but slopes down.

Fur Diagram
This drawing shows the areas where the fur ruffles are placed on the cartoon bear.

Finished Pencil Drawing
Sometimes I shade in the far legs to prevent people from confusing them with the near ones.

A WORD ABOUT STYLE:
STRAIGHT LINES & CURVED LINES

You can make a cartoon character look more stylish if you counterpose straight lines with curved lines. This much I know. Why it's true, I have no idea. But they don't pay me to figure out the underlying causes of weighty issues like this, only to show you the techniques! And this one works quite nicely, so let's give it a try. Notice how the curved back of the bear is juxtaposed against the straighter line of the front (stomach). The effect is to give this bear a slicker, flatter, and more stylish feeling, as opposed to making him look like a giant cuddle-toy.

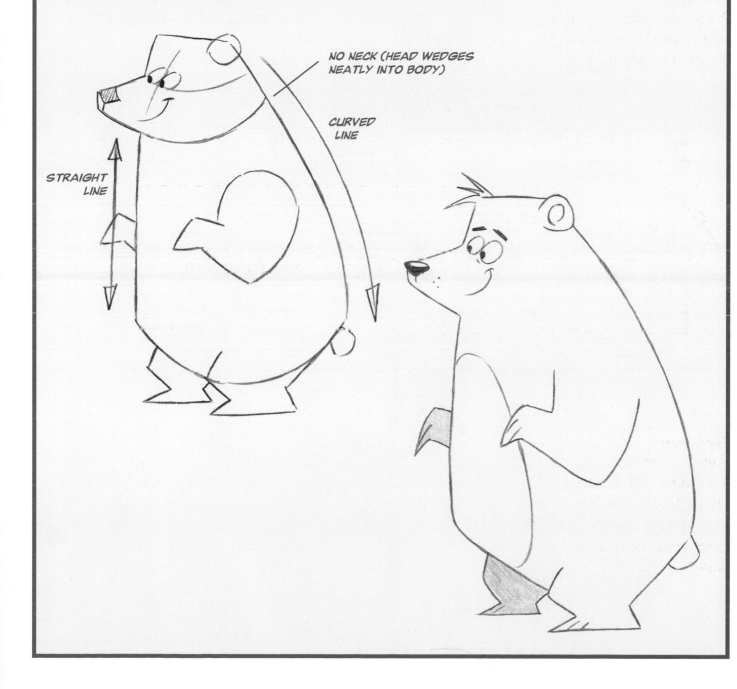

NO NECK (HEAD WEDGES NEATLY INTO BODY)

CURVED LINE

STRAIGHT LINE

BASIC BEAR HEAD

Most people don't realize that bears have pointy snouts. It's just that they have so much fur and fat padding around their faces that we tend to think of their heads as round.

Don't make the snout too short in the side view. In the front view, you have to tilt the head down slightly, to show the length of the snout, or it will appear to flatten out too much, because of perspective.

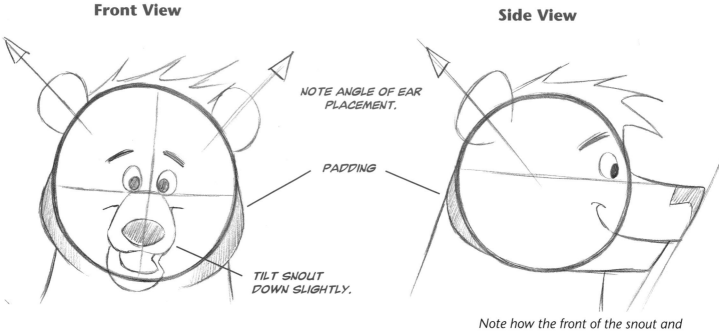

Front View

Side View

NOTE ANGLE OF EAR PLACEMENT.

PADDING

TILT SNOUT DOWN SLIGHTLY.

Note how the front of the snout and the mouth end in a diagonal; they're not flat. (This is true with dogs, too.)

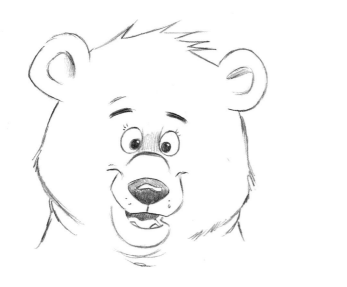

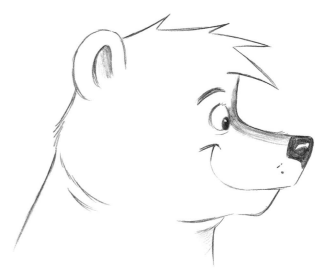

THE BEAR'S SNOUT

Because the bear's snout is long, you don't want it to appear to flatten out when he looks at you in a front view. So we're going to use a couple of subtle techniques to compensate. First, we'll tilt the head down slightly, as we did on the last page. But another technique we'll now incorporate is to **widen** the snout as it travels toward us (note the arrows). And always be sure to show the bridge of the nose. It helps to shade it a little to make it distinct from the other parts of the face.

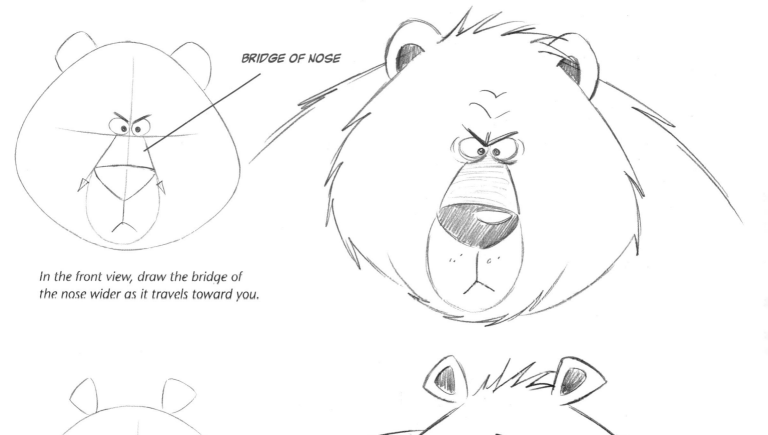

BRIDGE OF NOSE

In the front view, draw the bridge of the nose wider as it travels toward you.

The open-mouth smile looks best with a cupped chin.

PLACEMENT OF THE NOSE ON THE SNOUT

The nose needs to appear to be locked in place for the character design to look solid. It's easy to do, if you know one simple rule: You need to visualize the nose as a triangle. But what we're concerned with here is the bottom tip of the triangle.

Okay, skipping ahead slightly (we'll get back to the nose in a minute), let's now go to the bear's upper lip. It's what we call a "split lip." It indents in the middle. Now, back to the nose again. The bottom of the triangle-shaped nose should *always fall exactly at the indented spot in the upper lip.*

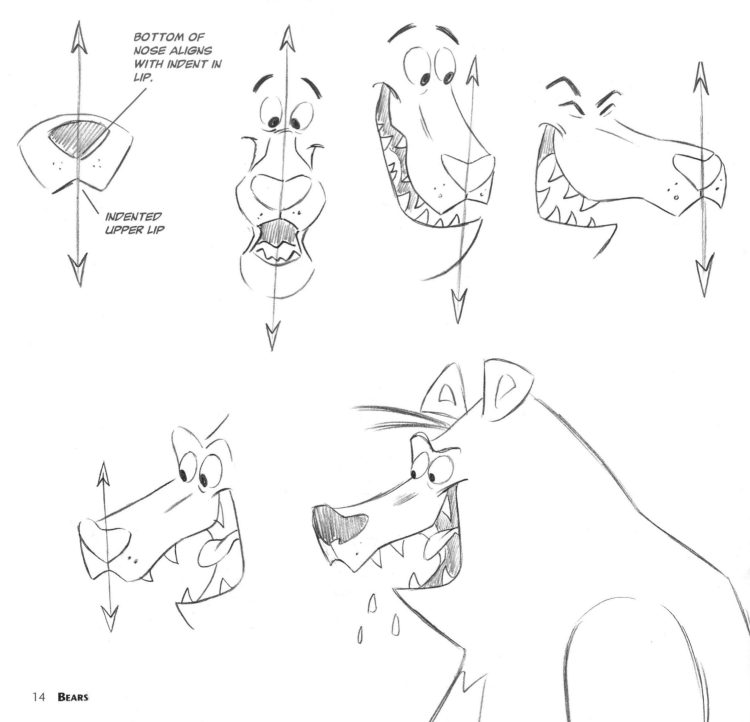

BOTTOM OF NOSE ALIGNS WITH INDENT IN LIP.

INDENTED UPPER LIP

THE BEAR'S MOUTH

Cartoon bears have elastic mouths. They not only move up and down, but they tug *sideways* as well. Use the lips, tongue, teeth, and even the uvula (that little pendulum-like thing that dangles inside the roof of the mouth) to create a variety of fun expressions.

Smug

Ever So Sophisticated

Disappointed . . . Again!

Brace Yourself!

Goofy

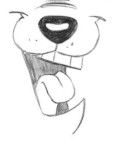

Overconfident

Get Out of My Face!

Worried

EYE EXPRESSIONS

No one ever said cartoon eyes have to be subtle! Don't let the mouth do all the work in creating expressions. The eyes bring the high voltage. Usually, they work together as a unit, frowning or widening (in surprise) in tandem. But there are just as many expressions in which each eye moves individually, with one stretching while the other crushes down, creating some really silly looks.

Keep this in mind as well: Eyes are not only pushed down from above by the eyebrows; sometimes, they're pushed up from below, by the lower eyelids.

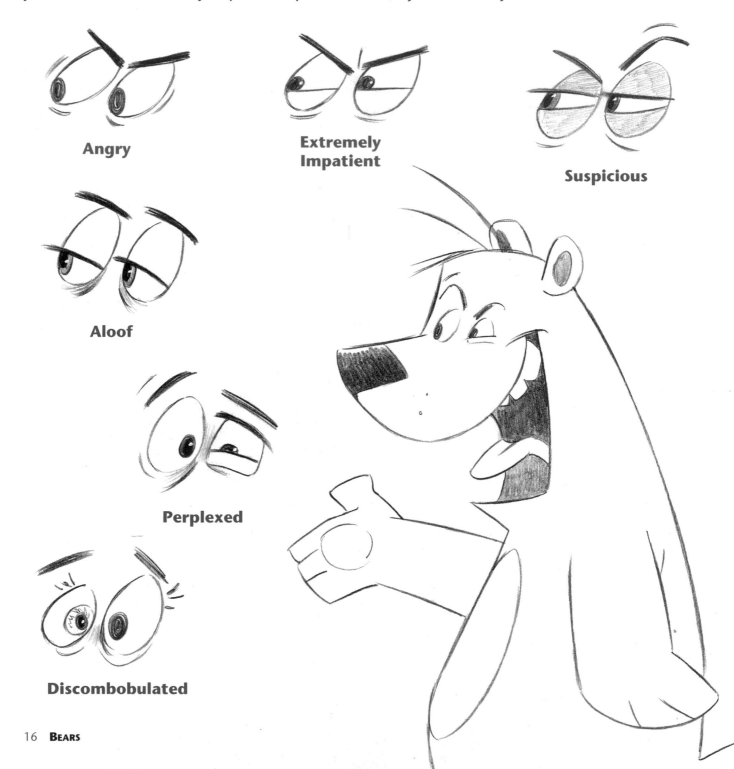

Angry

Extremely Impatient

Suspicious

Aloof

Perplexed

Discombobulated

BEAR HAND AND FOOT GESTURES

When bear hands aren't making gestures that involve individual fingers, their hands automatically return to a mitten-like shape, with all of the fingers fused together. Similarly, the toes do not work independently but act as a single group that makes up the front "paw."

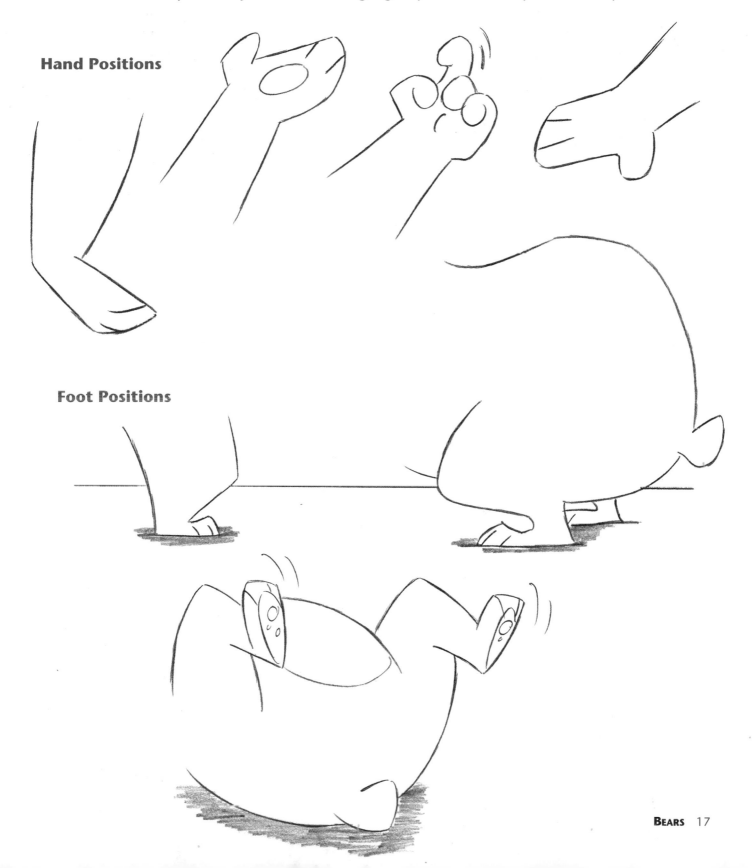

Hand Positions

Foot Positions

CLASSIC BEAR CUB (THE TEDDY BEAR)

Now we're going to see exactly what it takes to turn a young bear into a real cutie. It doesn't happen by accident. What's the secret? Most people would guess "Big eyes!" But this charming bear cub's eyes aren't any bigger than most, so that can't be it. No, the answer lies in the *shape of the head itself.* And you'll find that once you learn this, you can use this same head shape on many different types of animals to get the same cute look.

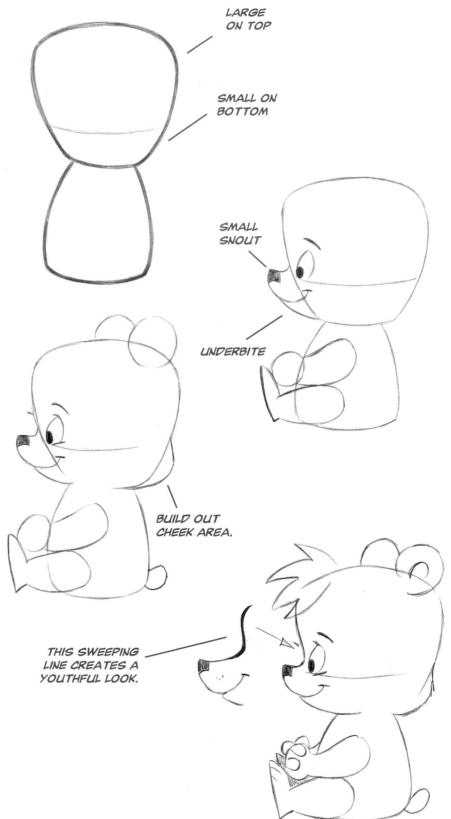

LARGE ON TOP

SMALL ON BOTTOM

SMALL SNOUT

UNDERBITE

BUILD OUT CHEEK AREA.

THIS SWEEPING LINE CREATES A YOUTHFUL LOOK.

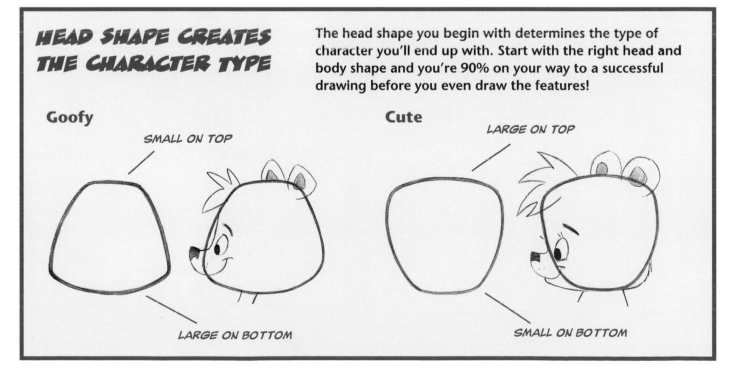

HEAD SHAPE CREATES THE CHARACTER TYPE

The head shape you begin with determines the type of character you'll end up with. Start with the right head and body shape and you're 90% on your way to a successful drawing before you even draw the features!

Goofy

SMALL ON TOP

LARGE ON BOTTOM

Cute

LARGE ON TOP

SMALL ON BOTTOM

RETRO-STYLE BEAR

Notice all the straight lines? He's flat-looking and not nearly as round as the classic cartoon bears. That, combined with a really thick outline, creates a cool "retro" look. But not all of the lines are super thick. It's *very important* that the lines that appear inside of the outline, such as the line of the tummy and the line of the muzzle, remain thin. If every line were thick, the bear would look clunky, not retro.

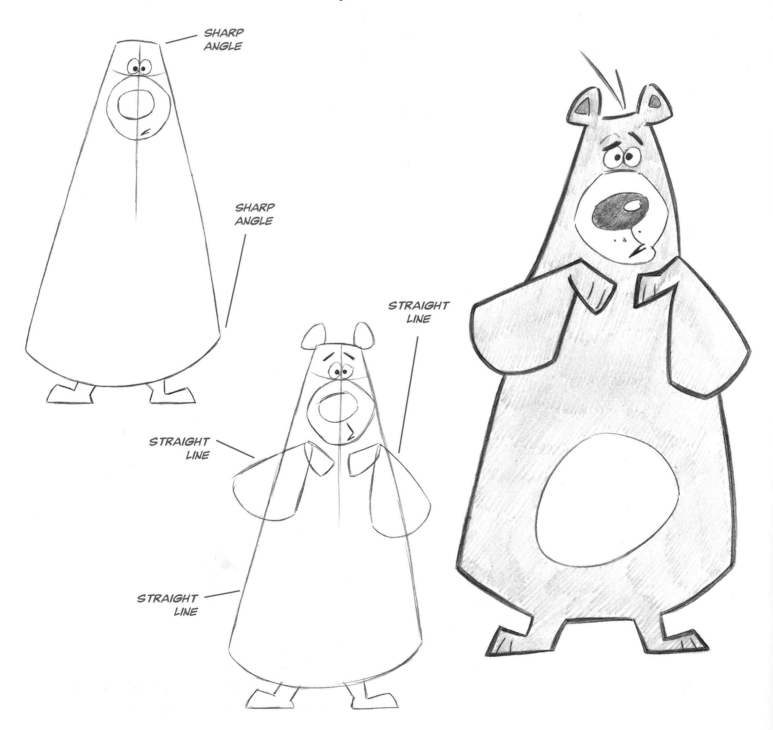

RETRO BEAR VS. "CARTOONY" BEAR

We mentioned styles in the previous page. But how can you tell just what difference a particular style will add to a cartoon? The only way is to draw it two ways and compare. With this kid bear, I've drawn him in the flat retro style and then again in the round, classic cartoon style. Both are popular. Both are correct. Which do you prefer?

Because young bears are famous for their roundness, I prefer to go with the cartoony style for this particular character. I think it suits him better. But it's your choice.

Basic Construction
You can use the same underlying structure for both styles.

Retro-Style Bear
For this style, use straighter lines and harder angles. Draw thick lines for the outlines and thin lines inside of the figure. Keep the lines smooth. Use few, if any, ruffles for the fur.

Classic Cartoon-Style Bear
Draw this style with a regular pencil line throughout. Avoid hard angles and straight lines and show more ruffles of fur.

GRUMPY BEAR

Grumpy bears are powerful characters in cartoon-land. The more powerful a character is, the higher the shoulders should be drawn. In this case, the shoulders are drawn **above** the neck, because he's a really big guy! One swat from his paw would send an SUV tumbling backward. But lest we make him too scary, take a look at those teensy legs. Yep, he's still built for comedy! (Plus, his eyes are round, whereas truly villainous characters are drawn with narrow eyes.)

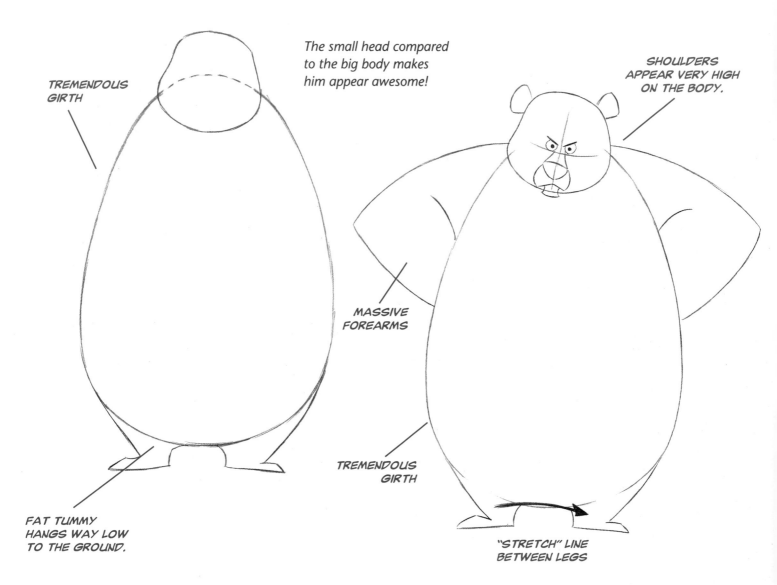

TREMENDOUS GIRTH

The small head compared to the big body makes him appear awesome!

SHOULDERS APPEAR VERY HIGH ON THE BODY.

MASSIVE FOREARMS

TREMENDOUS GIRTH

FAT TUMMY HANGS WAY LOW TO THE GROUND.

"STRETCH" LINE BETWEEN LEGS

Now, that body is way too big an area to go unmarked. It would look empty. You never want to leave this much space blank. It ends up ruining the illusion of the cartoon, reminding the reader that he or she is looking at lines on a blank piece of paper. So let's do something to it. We'll give him a belly marking. There! Now he's got real presence.

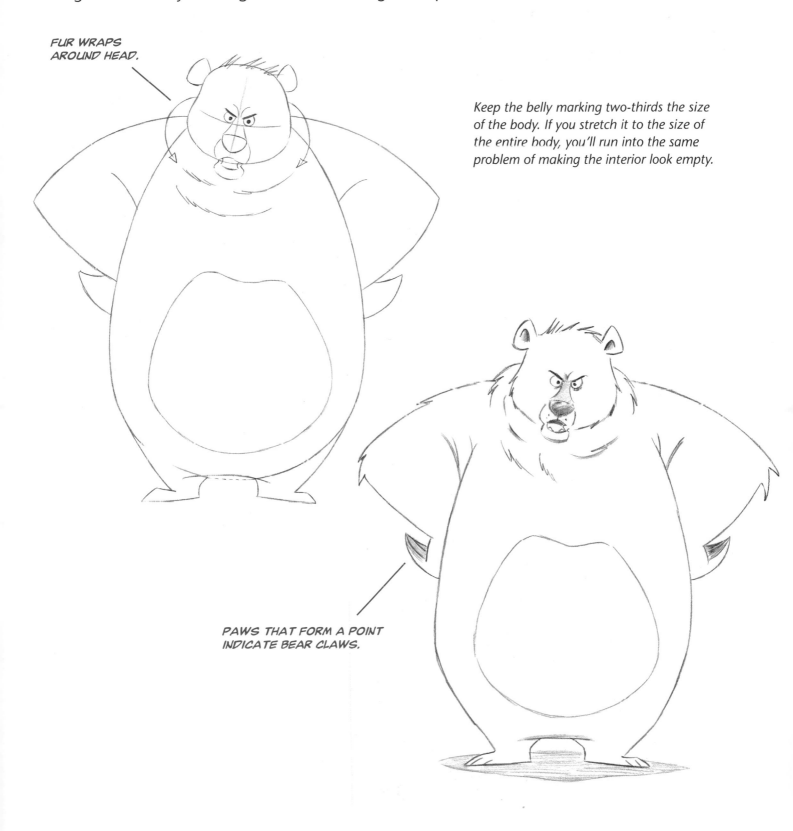

FUR WRAPS AROUND HEAD.

Keep the belly marking two-thirds the size of the body. If you stretch it to the size of the entire body, you'll run into the same problem of making the interior look empty.

PAWS THAT FORM A POINT INDICATE BEAR CLAWS.

BEAR-LY CONTROLLING HIS TEMPER

All the bear tummies we've drawn so far have been protruding out. This one goes in, not because this character is built so differently, but because of his *body action.* He's bending forward, trying to balance himself. Also note that all that weight resting on his back leg causes his right knee to bend outward, instead of straight ahead.

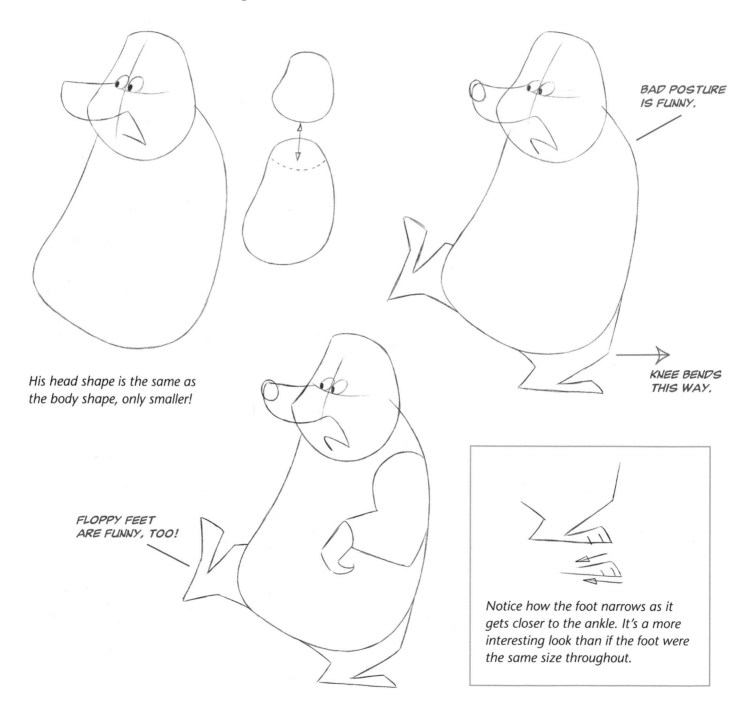

His head shape is the same as the body shape, only smaller!

BAD POSTURE IS FUNNY.

KNEE BENDS THIS WAY.

FLOPPY FEET ARE FUNNY, TOO!

Notice how the foot narrows as it gets closer to the ankle. It's a more interesting look than if the foot were the same size throughout.

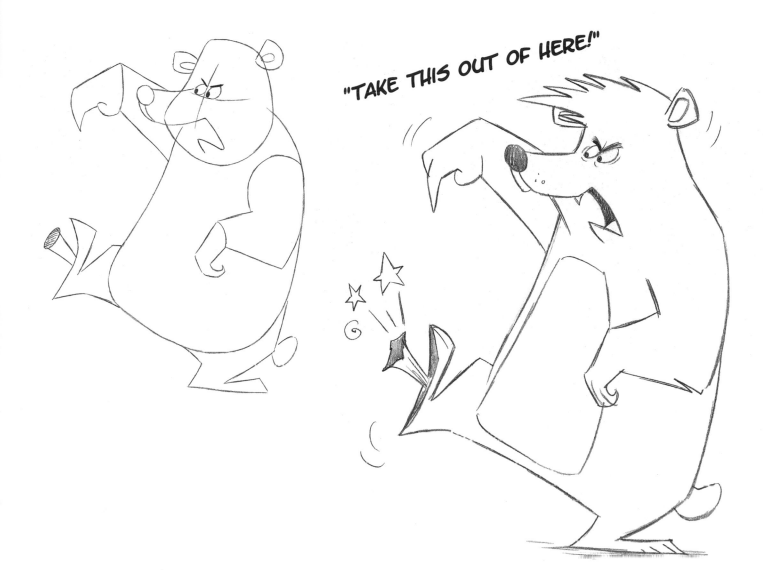

"TAKE THIS OUT OF HERE!"

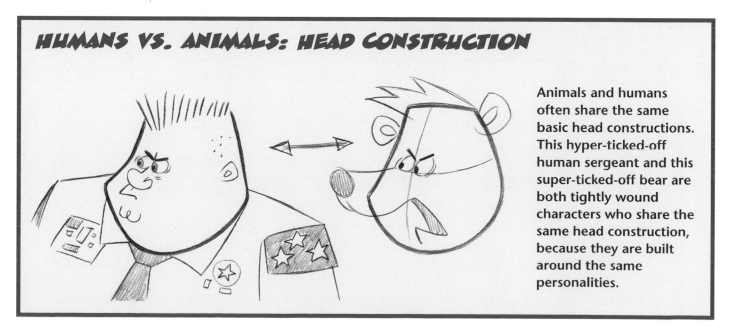

HUMANS VS. ANIMALS: HEAD CONSTRUCTION

Animals and humans often share the same basic head constructions. This hyper-ticked-off human sergeant and this super-ticked-off bear are both tightly wound characters who share the same head construction, because they are built around the same personalities.

BEDTIME BEAR

Bears are so appealing that they are often substituted for children in cartoon roles. When you have an ultra-simplified costume such as these pajamas, you can allow it to serve as the outline of the body. Therefore, you don't need to sketch the bear's body first, underneath the costume, because it won't relate to the final drawing. However, if you were to design a looser, softer-looking costume, sketching the body first would definitely be a good idea.

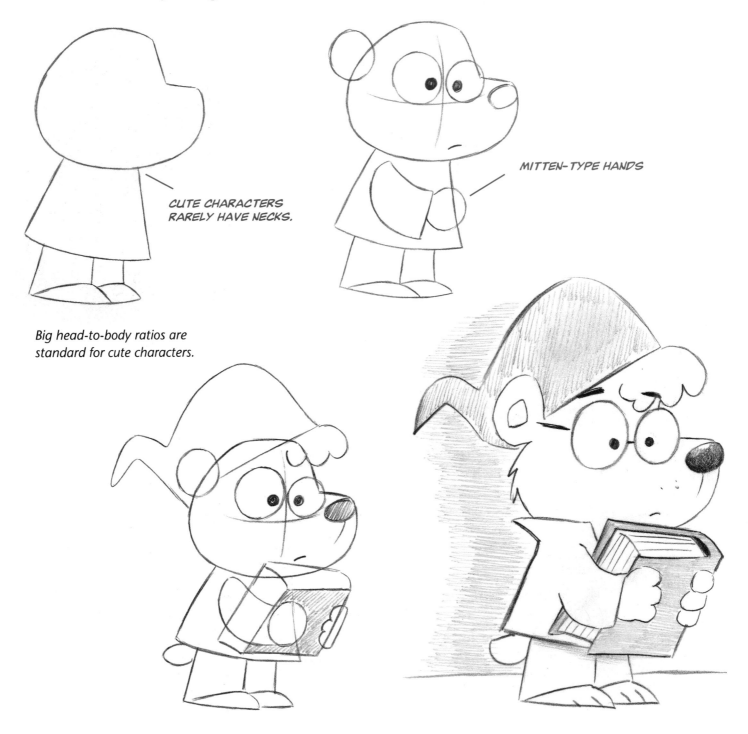

CUTE CHARACTERS RARELY HAVE NECKS.

MITTEN-TYPE HANDS

Big head-to-body ratios are standard for cute characters.

HYPER-CUTE BEAR

Way, way, over-the-top cute characters are very popular in the latest style of cartooning. They're *funny*-cute. The hallmarks are giant, vulnerable eyes (with humongous pupils) combined with a kid-in-an-amusement-park smile. Make this guy chubby and chunky, with "pinchable" cheeks.

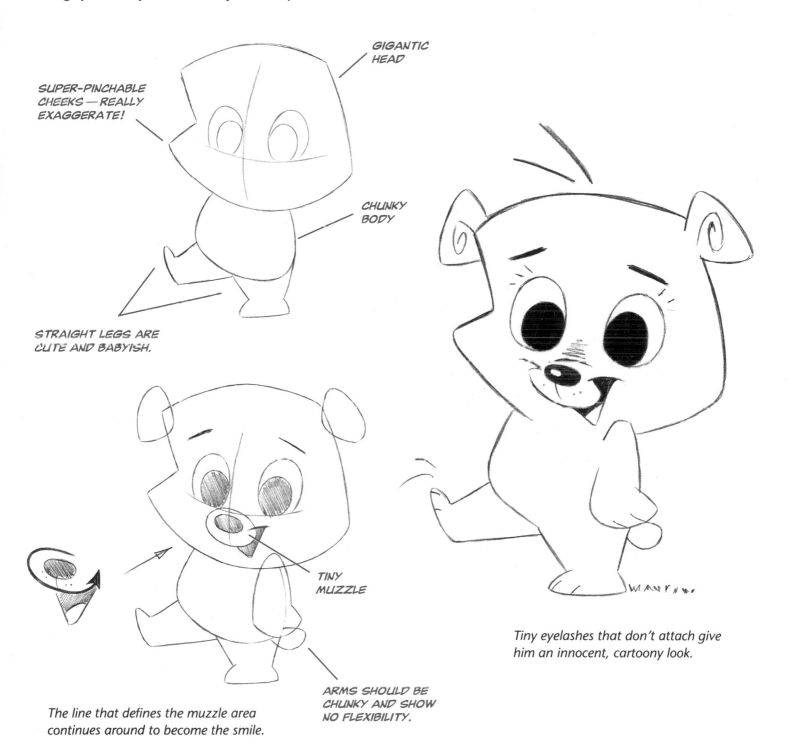

GIGANTIC HEAD

SUPER-PINCHABLE CHEEKS — REALLY EXAGGERATE!

CHUNKY BODY

STRAIGHT LEGS ARE CUTE AND BABYISH.

TINY MUZZLE

The line that defines the muzzle area continues around to become the smile.

ARMS SHOULD BE CHUNKY AND SHOW NO FLEXIBILITY.

Tiny eyelashes that don't attach give him an innocent, cartoony look.

EVIL-GENIUS BEAR

Ah, yes. Wouldn't you know it? Look hard enough and you'll find an insane Einstein in every cartoon animal species, especially if they stand upright, like humans—for extra sure if one of them wears a lab coat! Evil geniuses are almost always skinny, and they are never muscular. They are short and couldn't catch a football if their lives depended on it. Evil geniuses often invent robotic helpers to do their bidding. After all, it's hard to take over the world all by yourself.

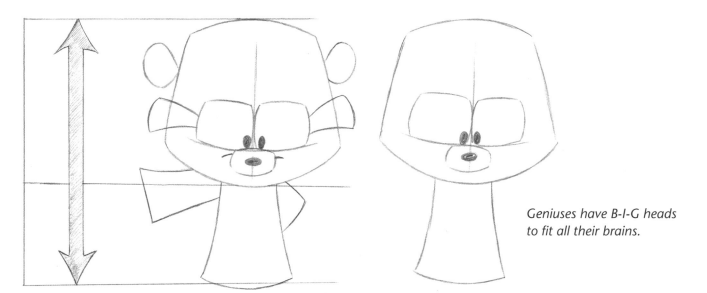

Geniuses have B-I-G heads to fit all their brains.

GENIUS-TYPE EYEWEAR

Evil geniuses usually wear oversized glasses. Never contact lenses. And even still, they have bad eyesight. This is a hard-and-fast rule in cartoon land. It works, and it's funny. If it ain't broke, don't fix it. Here are a few styles of glasses popular with evil geniuses.

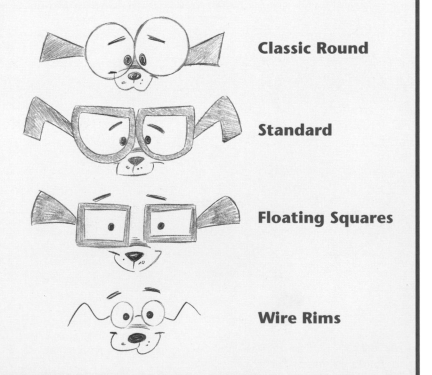

Classic Round

Standard

Floating Squares

Wire Rims

THE DIFFERENCES BETWEEN THE BEAR SPECIES

We've been drawing various bears, but what type, exactly, have we been drawing? Actually, we've been drawing mostly brown bears, which are the bears most commonly drawn by cartoonists. They're the standard bear: very versatile, with many cartoony traits that make them good subjects to draw. But there are other bear species that also make great characters. Let's take a look at all of them.

Brown Bear

The brown bear is the "all-purpose" bear of the cartoon world. He's usually a little lazy, friendly, and an underachiever who always just manages to get by. He's got a belly that's big but always hungry. Here he is, hibernating well past the time to get going (note the spring flowers).

LINE OF THIGH

COMPRESSION FOLD

EXTEND NOSE.

CLOSED EYES ALWAYS CURVE UP.

SNOUT CURVES UP SLIGHTLY.

The Grizzly

The grizzly is the granddaddy of "awesome." It's the bear to draw if you want to show an intimidating character standing upright on two legs. It's huge! But the main thing that distinguishes the grizzly from all others is this (and commit this one to memory): *The grizzly has a square head!* No other bear's head is shaped like the grizzly's. It's super wide. And to make it look even wider, bunch all of the features—the eyes, nose, and mouth—together in the center of the face.

The grizzly bear is actually a subspecies of the brown bear (that's a fancy way of saying they're closely related).

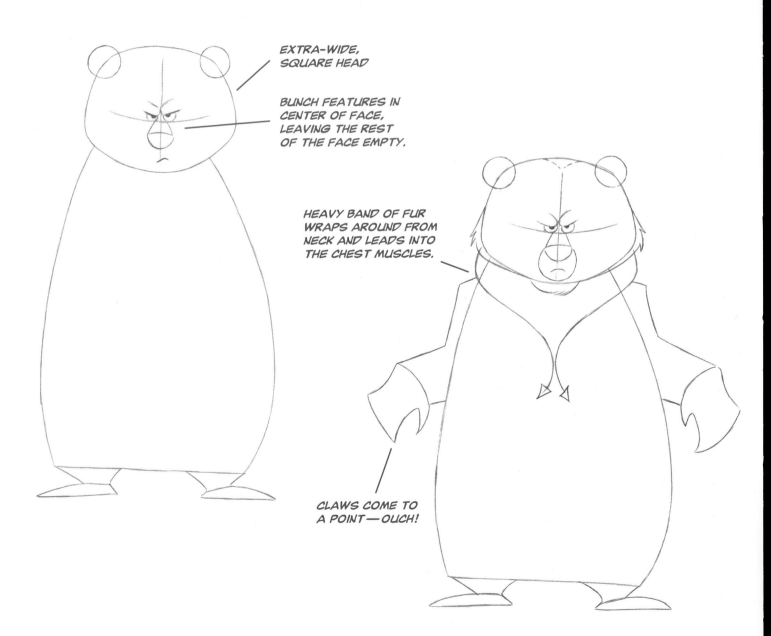

EXTRA-WIDE, SQUARE HEAD

BUNCH FEATURES IN CENTER OF FACE, LEAVING THE REST OF THE FACE EMPTY.

HEAVY BAND OF FUR WRAPS AROUND FROM NECK AND LEADS INTO THE CHEST MUSCLES.

CLAWS COME TO A POINT—OUCH!

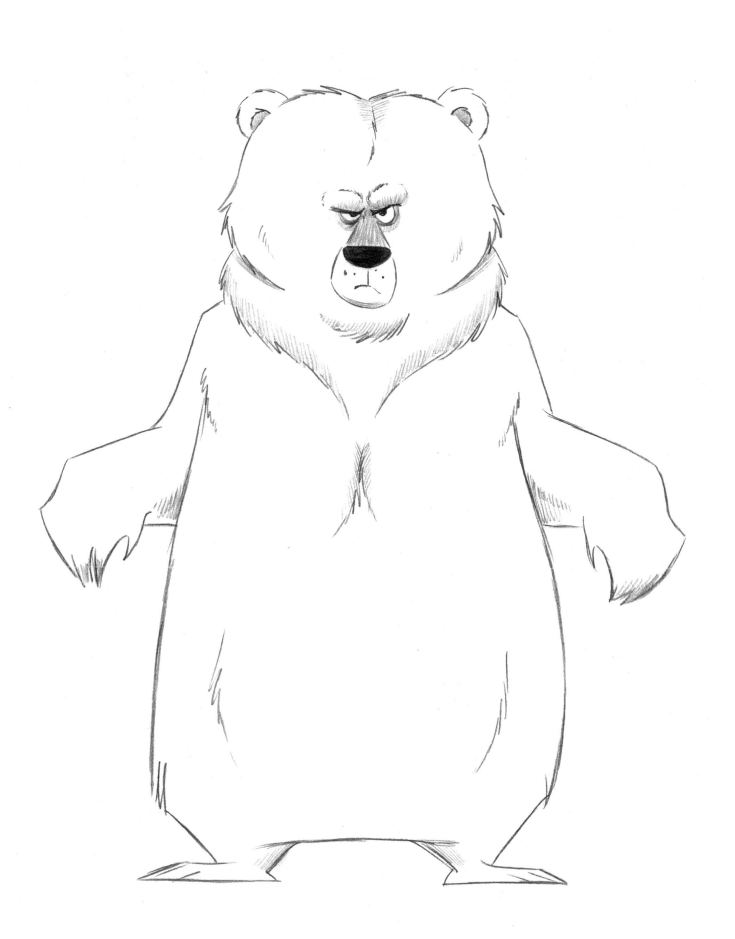

Polar Bear

The polar bear has the distinction of having the longest neck of any bear in the animal kingdom. It also has a unique head shape: Its snout goes way back to its ears without the typical "bump" that other bears have at the forehead. Don't give the polar bear a lot of ruffles of fur inside the outline of the body—keep it clean. This gives the bear the appearance of being white.

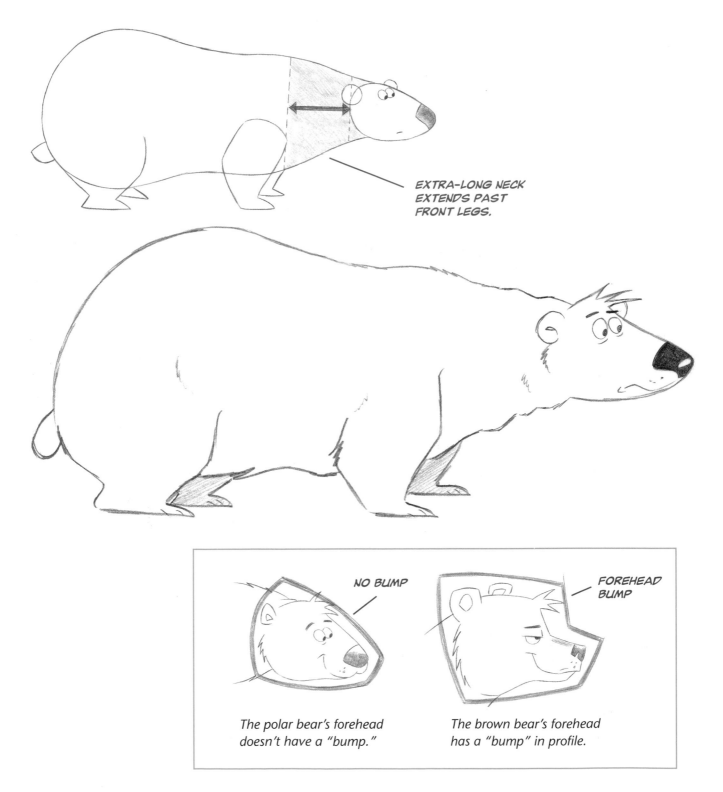

EXTRA-LONG NECK EXTENDS PAST FRONT LEGS.

NO BUMP

FOREHEAD BUMP

The polar bear's forehead doesn't have a "bump."

The brown bear's forehead has a "bump" in profile.

Black Bear

The black bear is the smallest of the bears in North America and has a round, almost circular body. He's just a little guy. I like to draw one when I want a bear who seems a bit overwhelmed. In real life, the black bear's back is highly arched, and it's a trait that works well in cartoons. Although the black bear, in reality, has a rather pointy face, that would detract from its appeal. So I've shortened it and rounded it off.

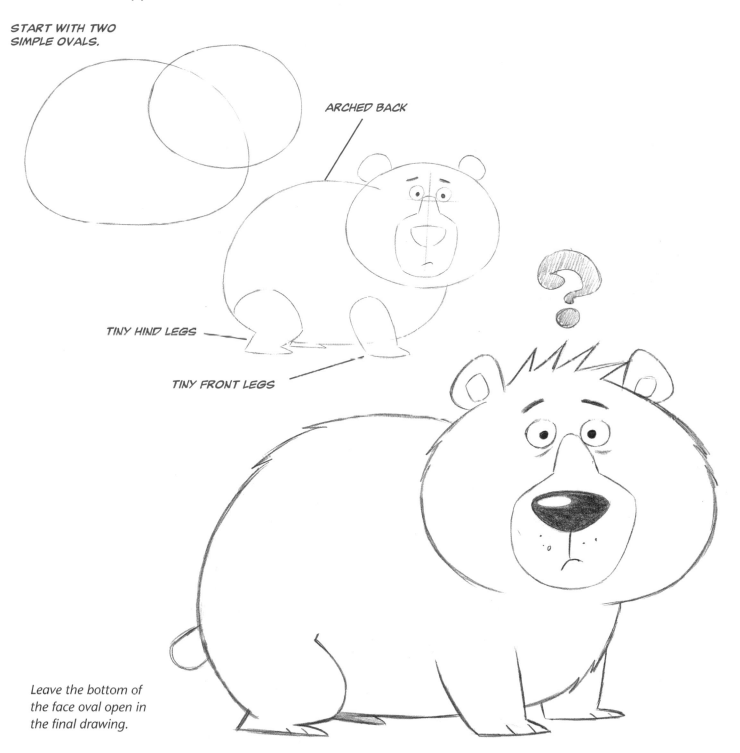

START WITH TWO SIMPLE OVALS.

ARCHED BACK

TINY HIND LEGS

TINY FRONT LEGS

Leave the bottom of the face oval open in the final drawing.

Pipsqueak Panda

Even cuter than the teddy bear (in my humble opinion) is the panda. The panda has great natural markings. But it's the thick, short arms and legs that give it its extreme cuteness. Notice how the hands and feet don't taper. And unlike the other bears, the panda's ears are oversized. But most important, the proportions are different: The head is *huge* compared to the overall length of the body.

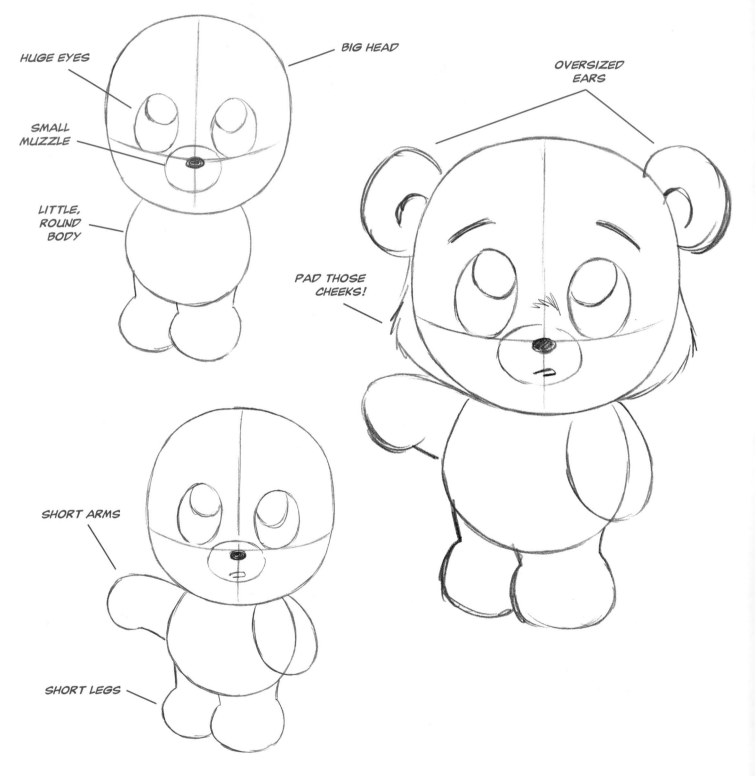

HUGE EYES

BIG HEAD

OVERSIZED EARS

SMALL MUZZLE

LITTLE, ROUND BODY

PAD THOSE CHEEKS!

SHORT ARMS

SHORT LEGS

Note the alternating black and white markings, which are the hallmark of the panda bear.

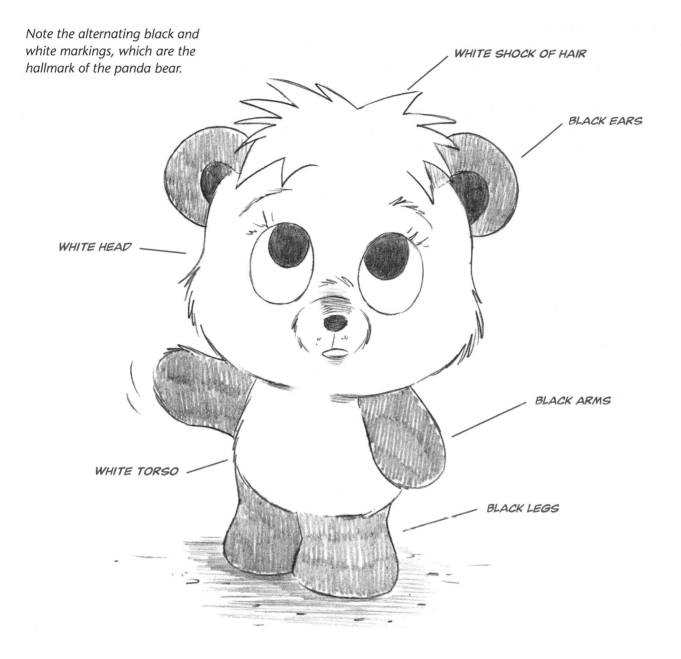

WHITE SHOCK OF HAIR

BLACK EARS

WHITE HEAD

BLACK ARMS

WHITE TORSO

BLACK LEGS

ALTERNATIVE CUTE PANDA HANDS

When drawing cartoons, there are always ways to vary traits of your characters to make them more distinctive. The rounded paws in the final panda drawing are cute, but they're just one option. Here are a few more:

Blunt End **Mitten Hand** **Stubby Fingers**

DOGS: THE CARTOONIST'S BEST FRIENDS

These guys have been the subjects of some of the most popular movies, comic strips, and animated TV shows and films of all time. The cartoon dog is unique in that it is drawn in more shapes, sizes, and breeds than any other animal in the world. There are hounds, beagles, toy dogs, shaggy dogs, and strays. They run the gamut from the stocky bulldog to the teeny Chihuahua, and everything in between. So let's start drawing some of these popular breeds and, along the way, learn the techniques for drawing canines in general, so that you can invent your own original doggy characters.

DOGGY BASICS: CUTE DOGS & PUPS

Let's start off with pups. They have small, round snouts, which make them look charming (and easier to draw than adult dogs). The head shapes may vary some, but they all widen at the cheeks. The body is flexible and shows a slight bend in the back and a protruding tummy, as if the pup just had a nice dinner!

Yes, I know that real puppies have big paws, but in cartoons, cute, young dogs look better with tiny paws. I don't know why that's so, but it is. I'll keep searching for the answer, but meanwhile, you keep drawing!

Cute characters usually have no necks. But if the head is a cute shape and the body is, too, then you can sometimes get away with it!

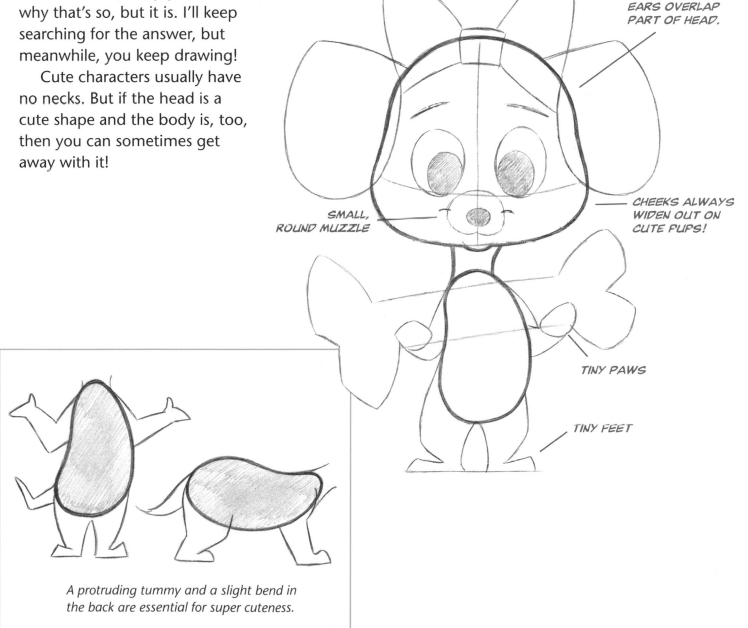

FLOPPED-OVER EARS OVERLAP PART OF HEAD.

SMALL, ROUND MUZZLE

CHEEKS ALWAYS WIDEN OUT ON CUTE PUPS!

TINY PAWS

TINY FEET

A protruding tummy and a slight bend in the back are essential for super cuteness.

One thing is universal: No matter what animal you draw, whether it's a mammal, a bird, or a reptile, the younger and cuter you want it to be, the larger its head should be in relation to its body. See this dog? Its head is the same size as its entire body! You probably didn't realize that until I pointed it out. That's because the proportions work so well that it just seems natural. However, were you to give these same proportions to, say, a villain, it would instantly look wrong.

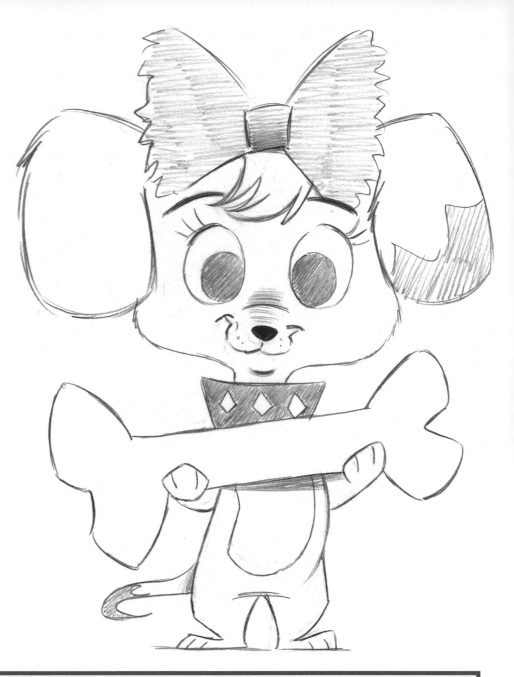

Note the tuft of hair flopping down over the forehead. It's a nice touch. Always sweep it to one side or it will look fussy.

DRAWING A CUTE MOUTH

There are two ways to draw the mouth on a cute pup. The first is simple and effective. However, the second is a bit more modern, and I generally prefer it. Give both a try.

Draw simple curves from the nose to the cheeks.

*Draw simple curves from the nose to the cheeks, but then shoot the smile outward at a sharp angle, into the cheeks. It makes the smile more **extreme**. It also defines the muzzle a bit more.*

DRAWING "PUPPY EYES"

When you want to give your dog "puppy eyes," that quality that melts a person's heart, you must always enlarge the pupils by drawing them big inside of the eye, crowding out the whites.

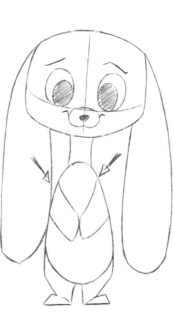

1	
2	
3	◀
4	

The nose and mouth of young characters are typically placed low on the head. If you divide the head into four equal sections, these features would fall in the bottom section.

ALIGN THE KNEES TO KEEP THEM AT THE SAME LEVEL.

CUTE CHARACTERS ALWAYS HAVE SLIGHT SHOULDERS.

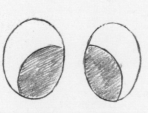

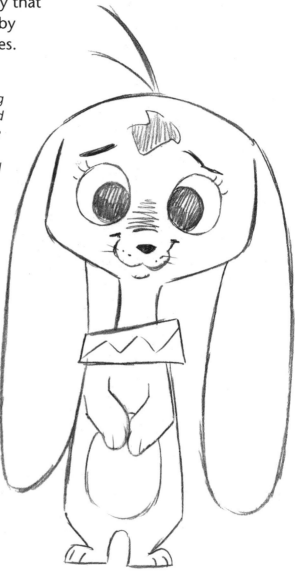

A PUPIL PRIMER

Whether you're drawing large pupils or small, it's essential that you draw them as complete circles within the eyes. Some beginning artists draw the pupils cut off by the outline of the eye. This little habit can ruin the expressive quality of the eyes!

Pupils cut off by outline of eyes.

Pupils are self-contained.

Always draw the pupil as a circle within the eye.

SIT UP, POO-POO! BEG!

I love drawing pups with mindless enthusiasm on their faces. This type of insane eagerness gives me the giggles. Want to know how to get this look in your characters? First, everything about the character needs to be cute, but then tweaked just a touch, to be a little bit twisted. It's sort of like a puppy from another planet. And here are the additional touches that, when combined, give it that over-the-top look.

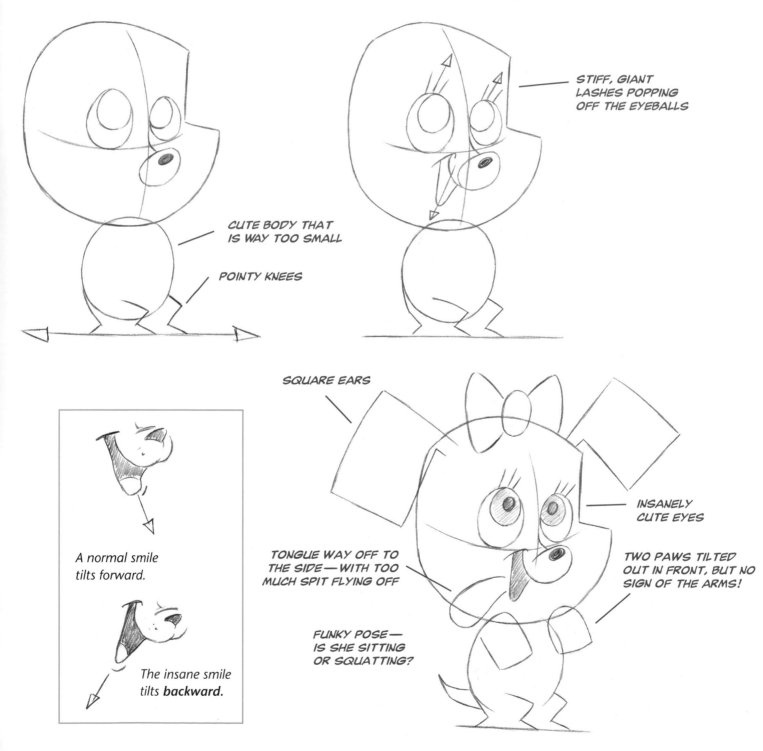

STIFF, GIANT LASHES POPPING OFF THE EYEBALLS

CUTE BODY THAT IS WAY TOO SMALL

POINTY KNEES

A normal smile tilts forward.

*The insane smile tilts **backward**.*

SQUARE EARS

INSANELY CUTE EYES

TONGUE WAY OFF TO THE SIDE—WITH TOO MUCH SPIT FLYING OFF

TWO PAWS TILTED OUT IN FRONT, BUT NO SIGN OF THE ARMS!

FUNKY POSE— IS SHE SITTING OR SQUATTING?

Normally, the rear foot is drawn on a higher plane than the front foot, because of perspective. But because this pup is drawn in a heavy, retro style, we've placed both feet on the exact same line (which, in reality, would be like drawing him balancing on a tightrope—it wouldn't happen). But it looks funny here, and it helps give the character that flat, retro style.

THE CLASSIC "PLAY WITH ME" POSE

Two tiny arms moving about frantically say, "Give me attention!" Add to that a slight backward tilt of the head, and you've got an irresistible pupster. I like to give girl dogs ribbons or flowers in their hair, but keep them cartoony, too. Note the cartoon treatment of the ears: I've left the "squiggle" loops in on purpose.

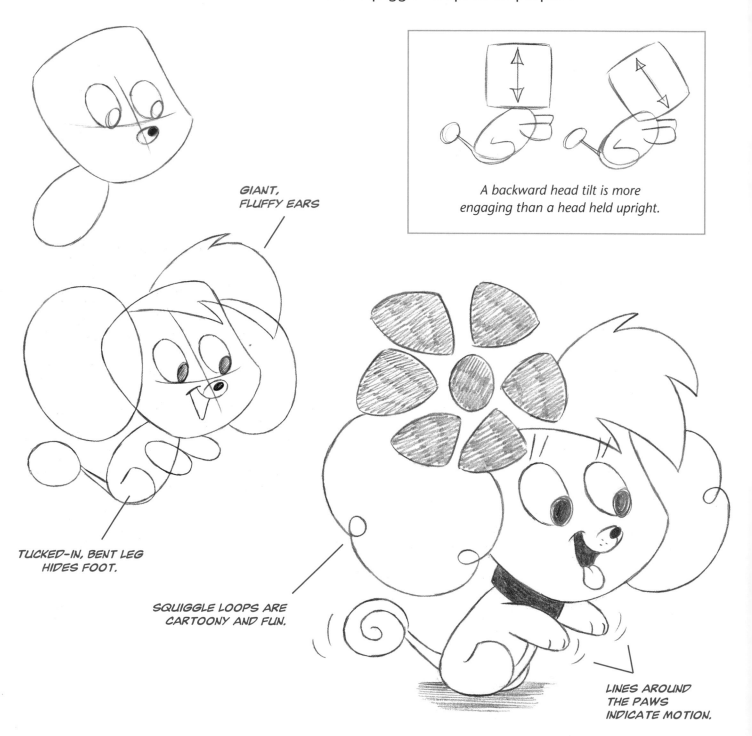

A backward head tilt is more engaging than a head held upright.

GIANT, FLUFFY EARS

TUCKED-IN, BENT LEG HIDES FOOT.

SQUIGGLE LOOPS ARE CARTOONY AND FUN.

LINES AROUND THE PAWS INDICATE MOTION.

PROFILE "CHEATS"

In a strict profile, or side view, you would see only one eye of the dog. But we can make the profile funnier if we place both eyes on the same side of the head, without turning it into a 3/4 view. This is called a "cheat" by animators, and it's an effective device.

The profile is easy to draw, but there are some pitfalls to watch out for. The biggest one is that it can make your character look stiff. So this page has a few hints to help you avoid that, plus a few more pointers for drawing dogs at this popular angle.

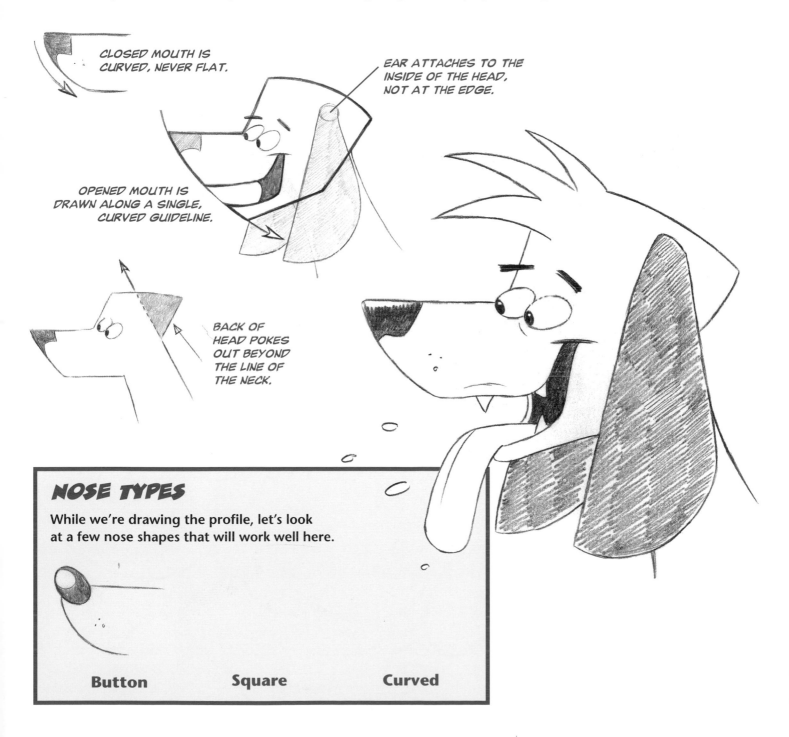

CLOSED MOUTH IS CURVED, NEVER FLAT.

EAR ATTACHES TO THE INSIDE OF THE HEAD, NOT AT THE EDGE.

OPENED MOUTH IS DRAWN ALONG A SINGLE, CURVED GUIDELINE.

BACK OF HEAD POKES OUT BEYOND THE LINE OF THE NECK.

NOSE TYPES

While we're drawing the profile, let's look at a few nose shapes that will work well here.

Button **Square** **Curved**

THE CLASSIC DOG WALK

Where do you position the legs when you draw a dog walking on all fours? If you were to fire off a ton of sequential pictures of a dog walking, you would see a zillion different positions in the dog's walk. But many of the positions are too subtle to make good poses for drawing. For example, poses in which one leg crosses in front of the other obscure the action. The pose on this page is the classic pose, because it reads the clearest. The two legs closest to the reader are positioned together, while the two legs farthest from the reader are drawn apart. It's that easy to remember.

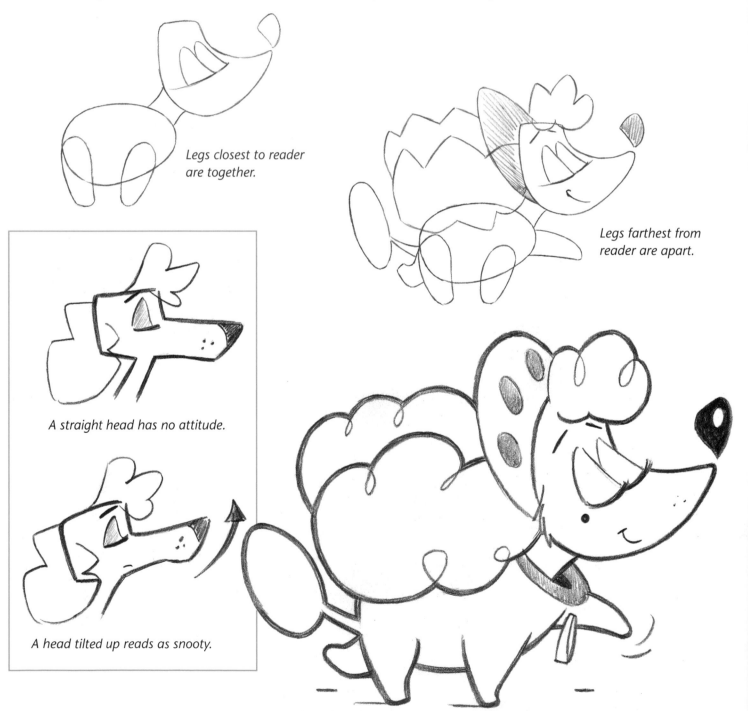

Legs closest to reader are together.

Legs farthest from reader are apart.

A straight head has no attitude.

A head tilted up reads as snooty.

THE RIDICULOUS DOGGY RUN

Humorous, stylized animals, like the ones in this book, and the types you see on TV, need to have motions that are as funny and extreme as their character designs. I love drawing gigantically overweight dogs, with tiny little legs, doing a full-out gallop.

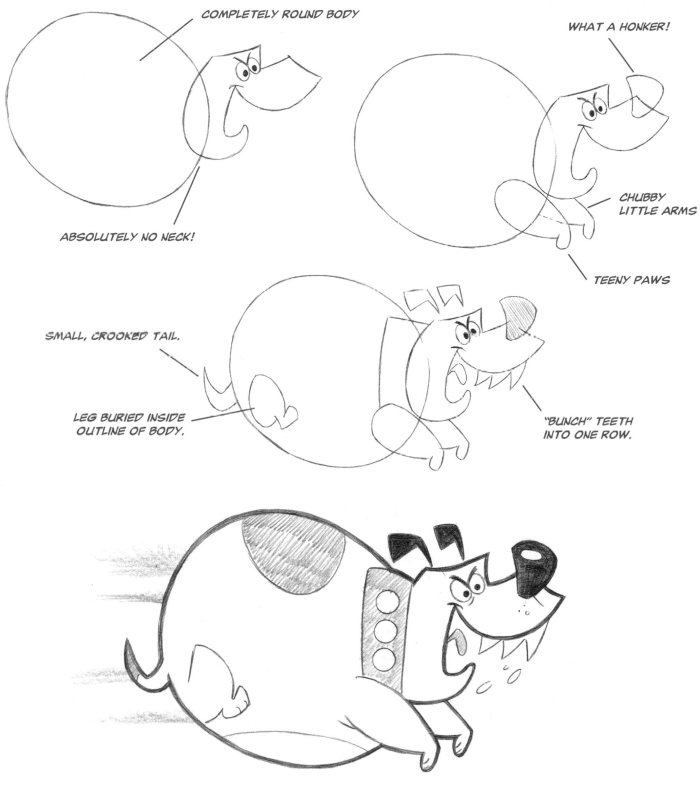

COMPLETELY ROUND BODY

ABSOLUTELY NO NECK!

WHAT A HONKER!

CHUBBY LITTLE ARMS

TEENY PAWS

SMALL, CROOKED TAIL.

LEG BURIED INSIDE OUTLINE OF BODY.

"BUNCH" TEETH INTO ONE ROW.

WACKY DOGS

Here's where we go a little bananas. Dogs have been drawn in so many animated TV shows and comic strips that every cartoonist is looking for a new, edgier way to design the next one. Don't be afraid to push the envelope! What breed is this dog? Heck if I know. I'm not sure he even qualifies as a mutt! But he's fun, wacky, and certainly a canine, even if he's wearing a turtleneck and slacks (and notice that the pants become the shoes without any break at the ankles—a retro design if ever there was one).

Part of the wackiness of this character is that the far eye pops out by itself, with his floating eyebrow hovering over it. Also, the head is huge, which *should* indicate that he's a youngster, but the dimensions of the body are not those of a kid. The tongue is way too big for the head, but so what? It's funnier that way. And how can we possibly be concerned about "realistic proportions" of a tongue when we've got a dog in pants salivating at a 6-foot-tall mirage of a bone!?

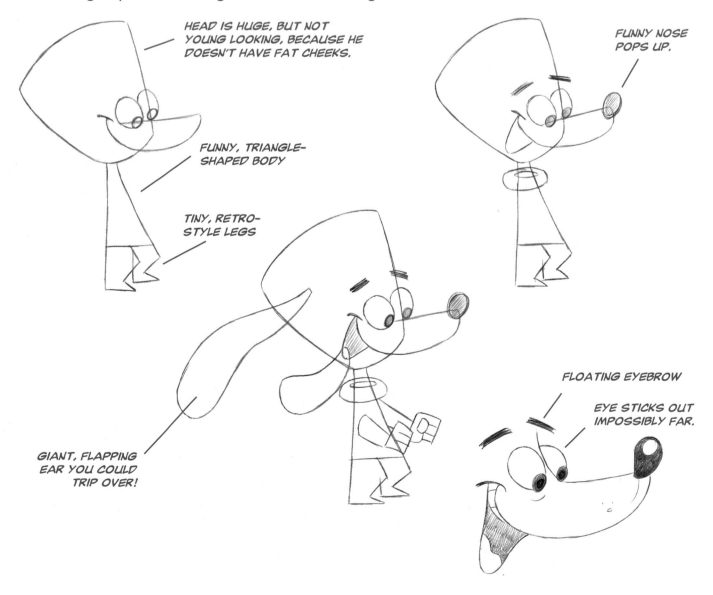

HEAD IS HUGE, BUT NOT YOUNG LOOKING, BECAUSE HE DOESN'T HAVE FAT CHEEKS.

FUNNY NOSE POPS UP.

FUNNY, TRIANGLE-SHAPED BODY

TINY, RETRO-STYLE LEGS

GIANT, FLAPPING EAR YOU COULD TRIP OVER!

FLOATING EYEBROW

EYE STICKS OUT IMPOSSIBLY FAR.

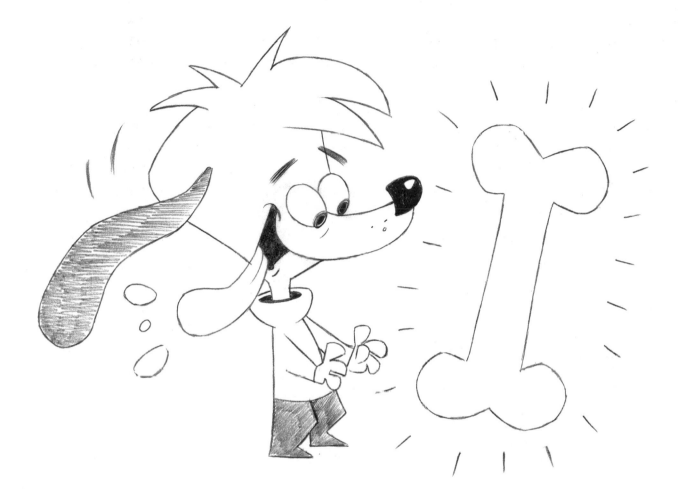

SPECIAL EFFECTS

Those little fantasy lines that surround the bone give it a magical quality as it hovers, ever so tantalizingly, above the ground. Look at the dog's fingers, each one in motion, just itching to have at it! The dog's posture is slightly back. He almost seems to have been pushed back by the force of the magnificence and the majesty that is the chew-bone.

The size of his eyes is almost matched by the size of the droplets of drool. But having seen too many cartoons, I have a terrible feeling that the bone is going to go POOF! the moment he reaches for it!

BRAVE DOGS

Yes, we know that the dog is man's best friend. Noble, courageous, loyal to a fault. But an action hero? Isn't this taking it a bit too far? But why not? We're cartoonists. We're *supposed* to take it a bit too far! It's fun to have a dog that's clearly lacking in the strength department, standing heroically, with a useless cape flapping in the wind. Remember, in comedy, the hero has to be small, cowardly, or inept. I don't think this guy is cowardly, and he looks pretty "ept" to me. Small—bingo!

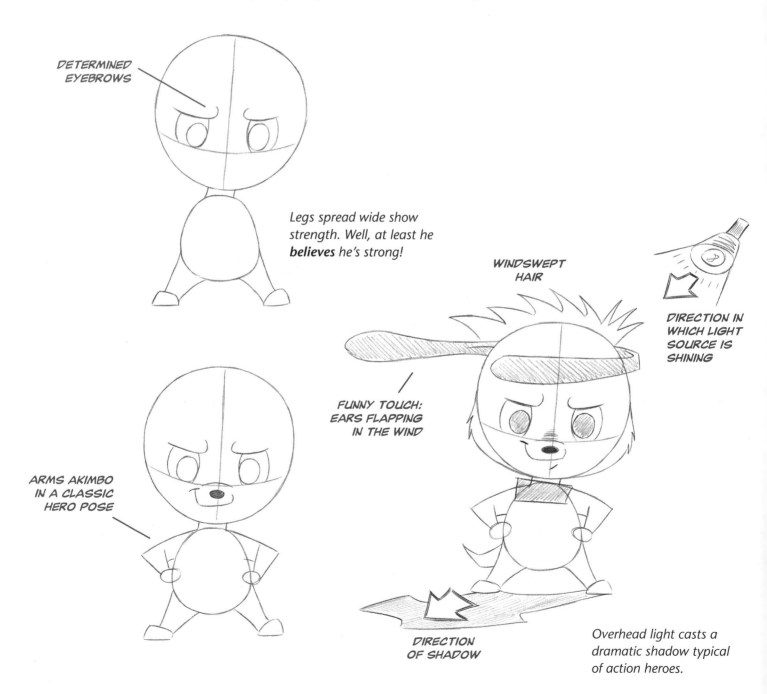

DETERMINED EYEBROWS

Legs spread wide show strength. Well, at least he **believes** he's strong!

WINDSWEPT HAIR

DIRECTION IN WHICH LIGHT SOURCE IS SHINING

FUNNY TOUCH: EARS FLAPPING IN THE WIND

ARMS AKIMBO IN A CLASSIC HERO POSE

DIRECTION OF SHADOW

Overhead light casts a dramatic shadow typical of action heroes.

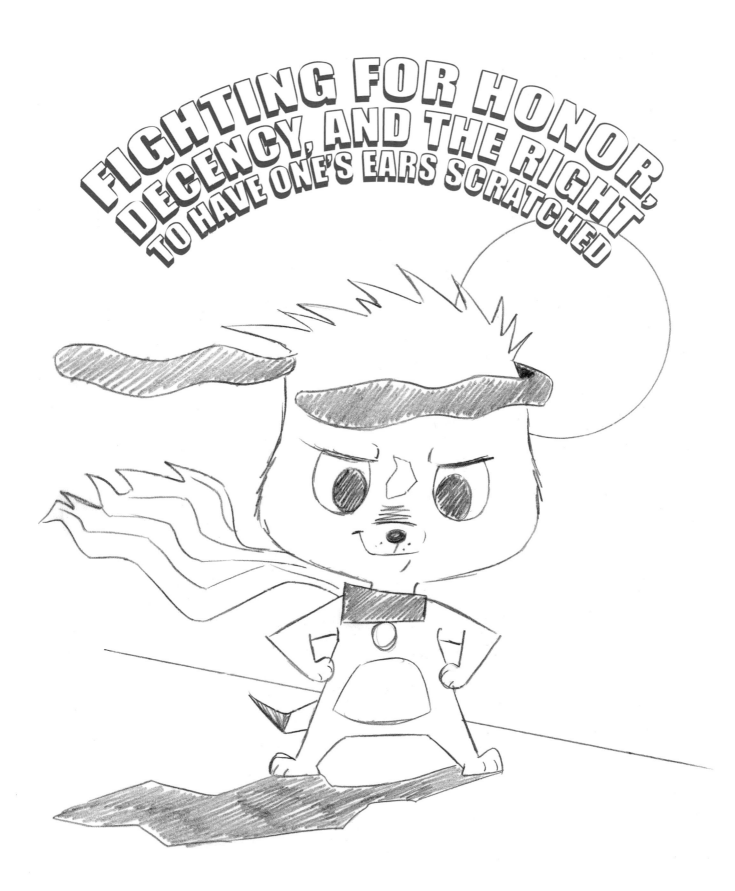

FIGHTING FOR HONOR,
DECENCY, AND THE RIGHT
TO HAVE ONE'S EARS SCRATCHED

LOVEABLE BUDDY

He means well, he really does, but he can't go five minutes without getting into trouble. He's got bright ideas by the dozen. The only problem is . . . he's not that bright! A character like this often has a smaller, smarter pal and works as part of a comedy team.

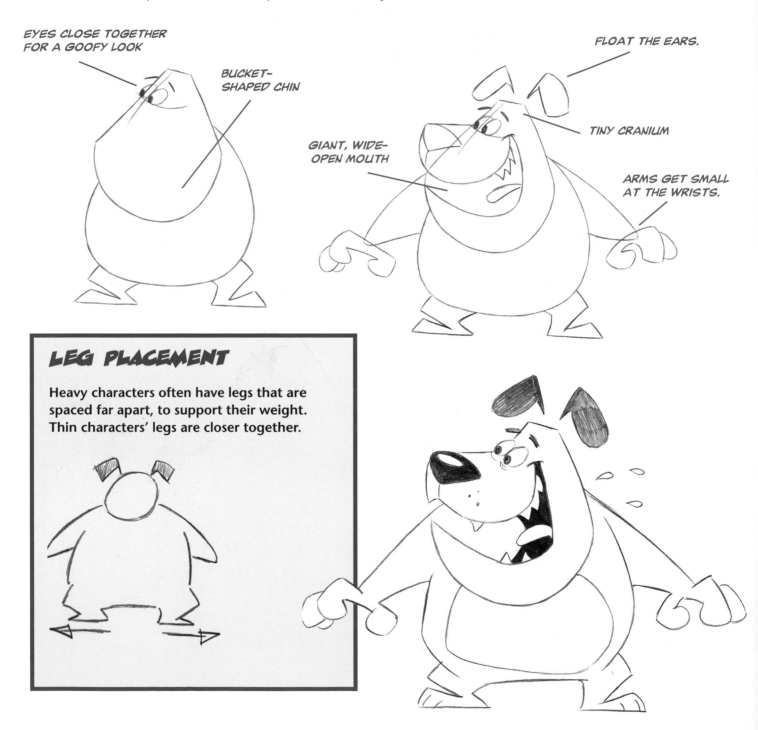

EYES CLOSE TOGETHER FOR A GOOFY LOOK

BUCKET-SHAPED CHIN

FLOAT THE EARS.

TINY CRANIUM

GIANT, WIDE-OPEN MOUTH

ARMS GET SMALL AT THE WRISTS.

LEG PLACEMENT

Heavy characters often have legs that are spaced far apart, to support their weight. Thin characters' legs are closer together.

BULLDOG

The bulldog is a staple in the cartoonist's gallery of characters. He's got a huge chin, sharp canines, a flat head, and a squat body. Usually, he's working on a short fuse. A little Napoleon. Those circles under his eyes show his irritation with the world. They don't give bulldogs a spiked collar for nothin'.

As we've shown on the previous page, it's natural for a heavy character to stand with his legs apart to support his weight. But if we want to ratchet the style up another notch, we can do it by sticking this heavy dog's legs together. Sometimes breaking the rules gives a cartoon a cool, retro look.

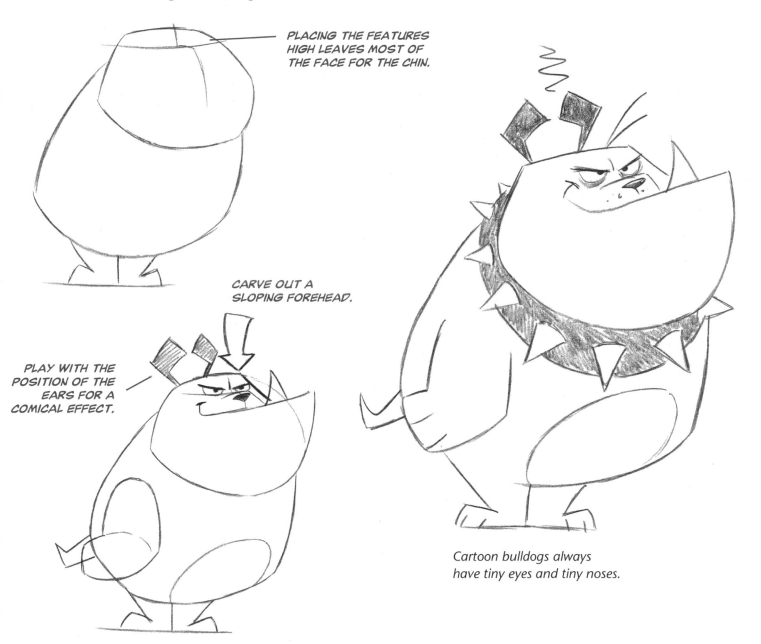

PLACING THE FEATURES HIGH LEAVES MOST OF THE FACE FOR THE CHIN.

CARVE OUT A SLOPING FOREHEAD.

PLAY WITH THE POSITION OF THE EARS FOR A COMICAL EFFECT.

Cartoon bulldogs always have tiny eyes and tiny noses.

DRAWING MUTTS

I like mutts. My first dog was a mutt, although you couldn't convince him of that fact. Cartoon mutts are, by and large, scrappy looking, with some ruffled hair that makes them look as if they haven't been to a top-notch groomer in . . . ever! The most important thing about drawing a mutt is to be inventive. You don't want him or her to resemble a specific breed too closely, or it will look as though you tried and missed your target.

Here's a nice 3/4 view of a cute mutt for you to practice on. That shaggy mop of a hairstyle is the perfect indication that he's no society hound!

EYEBROWS ACT LIKE MUSCLES TO CRUSH DOWN ON THE EYES.

DROOPY EARS FOR A "STREET DOG" LOOK

The center line of the head becomes the part in the hair.

TOY POODLE

When you have a toy dog, emphasize its tiny size to make it funny. To do that, exaggerate the size of its head and greatly reduce the size of its body to a ridiculously diminutive proportion! It's silly, but still cute—a good combination for a cartoon character.

Poodles have bumpy hair (it's actually hypoallergenic, for those of you looking for a sneeze-free dog). When a dog is this small, don't indicate ANY joints in the limbs. Keep the legs stiff, like a wind-up toy's!

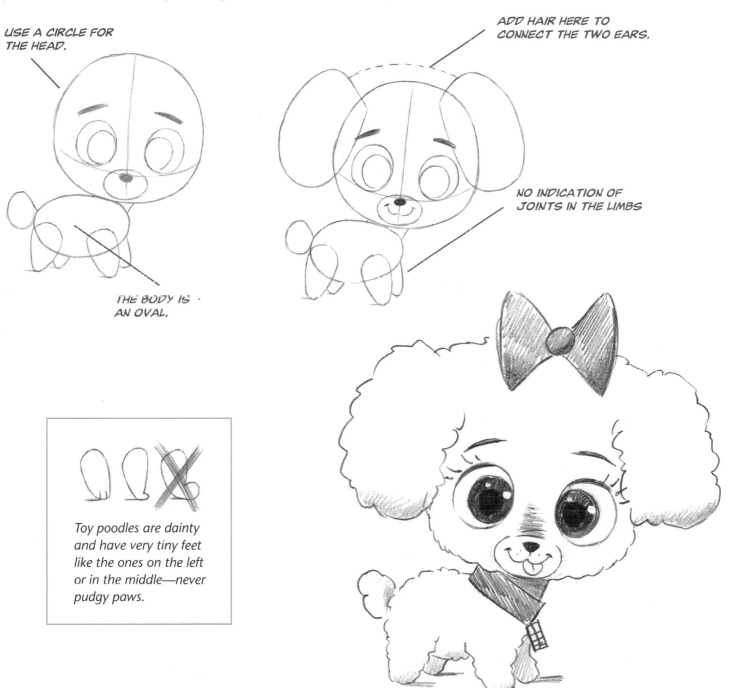

USE A CIRCLE FOR THE HEAD.

THE BODY IS AN OVAL.

ADD HAIR HERE TO CONNECT THE TWO EARS.

NO INDICATION OF JOINTS IN THE LIMBS

Toy poodles are dainty and have very tiny feet like the ones on the left or in the middle—never pudgy paws.

HOUNDS!

Hounds are the goofy, good-natured breed of the dog world. They are recognizable for their big round snouts, long ears, floppy limbs, and sloppy gait. Not an athlete, but a happy-go-lucky type.

Seated Pose

This one has lots of personality, which is created by putting a lot of action into his posture—made possible because of his flexibility, a key trait of this breed. If you take it step-by-step, you can create this same pose. Give it a try!

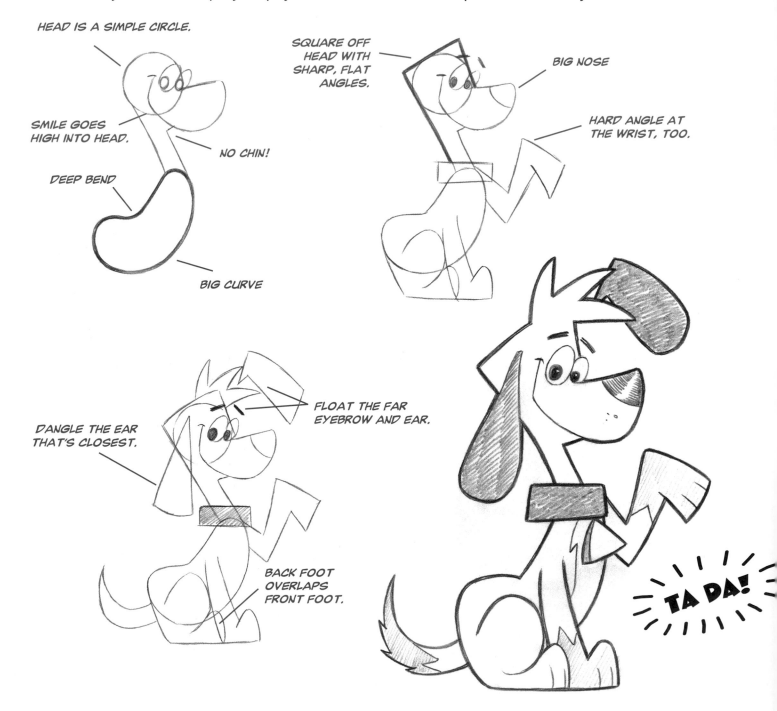

HEAD IS A SIMPLE CIRCLE.

SMILE GOES HIGH INTO HEAD.

DEEP BEND

NO CHIN!

BIG CURVE

SQUARE OFF HEAD WITH SHARP, FLAT ANGLES.

BIG NOSE

HARD ANGLE AT THE WRIST, TOO.

DANGLE THE EAR THAT'S CLOSEST.

FLOAT THE FAR EYEBROW AND EAR.

BACK FOOT OVERLAPS FRONT FOOT.

TA DA!

Standing on All Fours

A real hound is quite athletic. The cartoon version, on the other hand, is not exactly built for much more than sneaking into the pantry after everyone's gone to bed. If the fact that his rump is larger than his shoulders is not enough to give you the impression that he's out of shape, consider that his rump is also *higher* than his shoulders!

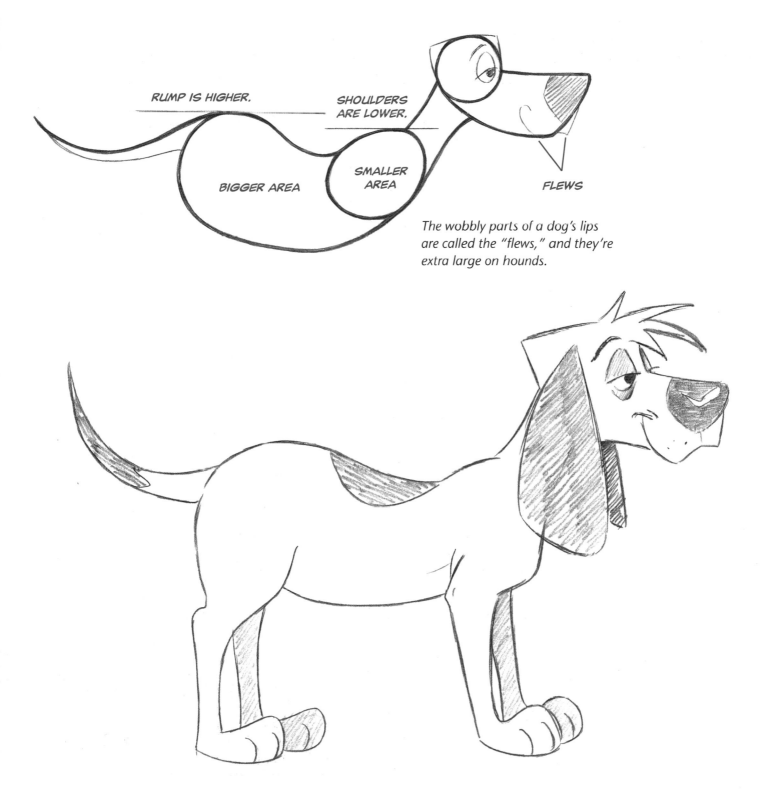

RUMP IS HIGHER.

SHOULDERS ARE LOWER.

BIGGER AREA

SMALLER AREA

FLEWS

The wobbly parts of a dog's lips are called the "flews," and they're extra large on hounds.

GERMAN SHEPHERD YOUNGSTER

As we've already established, toy dogs and pups should be drawn with *tiny* feet. But pups that will grow up to be BIG dogs should be drawn with *oversized* paws. A German shepherd, which is by nature more aggressive and territorial, is never going to be as cute a pup as, for example, a lab or a beagle. Therefore, don't try to make very masculine breeds super-cuddly, with giant heads and small bodies, as you would caricature a five- or six-year-old human. Instead, draw them as if they were about age eight to twelve. This approach will still give them a youthful and eager look—and they'll appear more natural, too.

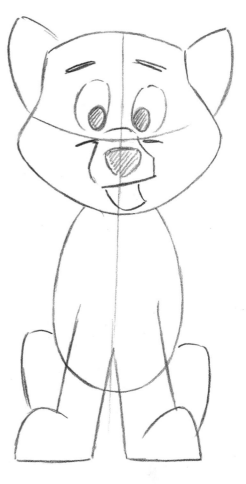

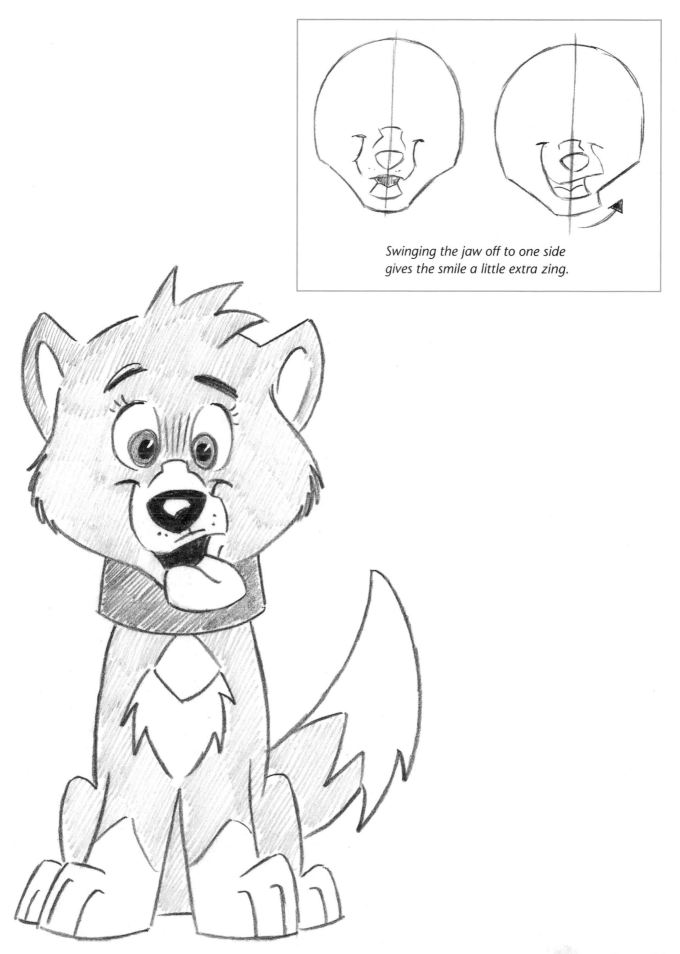

Swinging the jaw off to one side
gives the smile a little extra zing.

CHIHUAHUA

The Chihuahua is a great character to use in comic situations. Note the big ears and famous droopy whiskers. The body is compact and round. The tail is ratlike, and so are the snout and nose. But the eyes should be bright and alert.

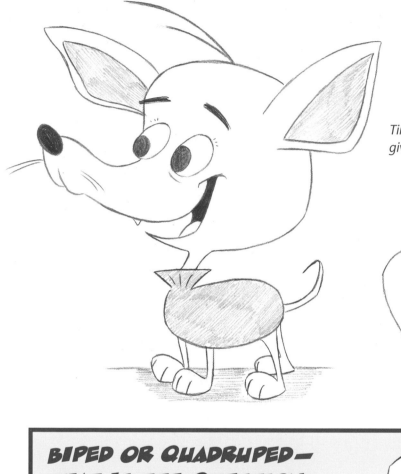

Tiny dogs get cold easily, so give him a doggy sweater!

BIPED OR QUADRUPED— THAT IS THE QUESTION!

Ah yes, my friends, the question that has plagued man since the dawn of . . . um . . . the '80s? Should your cartoon animal walk on two legs (biped) or four (quadruped)? Or three, if he's gotten into a really bad road accident. The answer is (drum roll, please) . . . both! It's easier to give cartoon animals human characteristics if you stand them upright on two legs, but they look more like pets or wild animals if they support themselves on four. Both ways are fun, though, and both are commonly used. So if you only draw dogs standing on two legs, because it's easier, then you ought to try a few the other way, too, just to broaden out your skills.

A poncho adds a little zest to this friendly fella.

DACHSHUND: THE "HOT DOG" DOG

If you really want to have fun standing a dog upright on two feet, then go with a dog that has a hard time walking on *four* feet! The body of the fabulous dachshund (which, by the way, has one of the sweetest faces of any breed) can be stretched to ridiculous proportions. The key to making it funny is to stretch *only* the torso, while leaving the head, limbs, and tail *exactly the same size.*

The torso has to be gently curved. It's too long to be drawn straight. It would look like a rectangular block.

Because of its exaggerated length, the back sways slightly in the middle.

WOLVES

The cartoon wolf is the mangy, sneaky cousin of the cartoon dog. Think of it as a dog who sells used cars and hasn't had a bath in a month. If you compare them visually, you'll notice that wolves are generally bonier, with pointy ears, pointy cheeks, bushier tails, and more fur. We sometimes draw them with their claws showing, especially if we want to depict them with a twinge of evil intention, as shown here. Their snouts are always long and a bit on the droopy side.

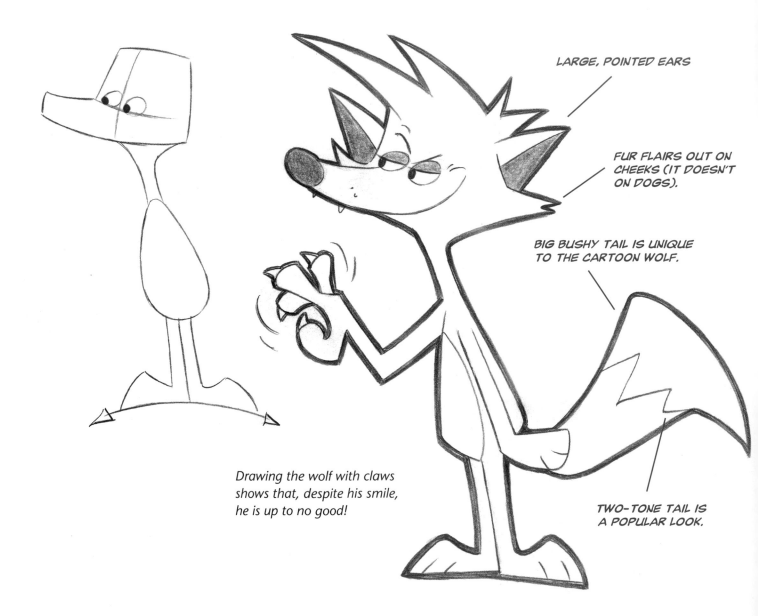

LARGE, POINTED EARS

FUR FLAIRS OUT ON CHEEKS (IT DOESN'T ON DOGS).

BIG BUSHY TAIL IS UNIQUE TO THE CARTOON WOLF.

Drawing the wolf with claws shows that, despite his smile, he is up to no good!

TWO-TONE TAIL IS A POPULAR LOOK.

Wolf Posture vs. Dog Posture

Wolves not only look different than dogs, they *stand* differently, too. Rather than a noble posture, with the chest held out, the cartoon wolf has an arched back and sunken chest, giving it a craven appearance.

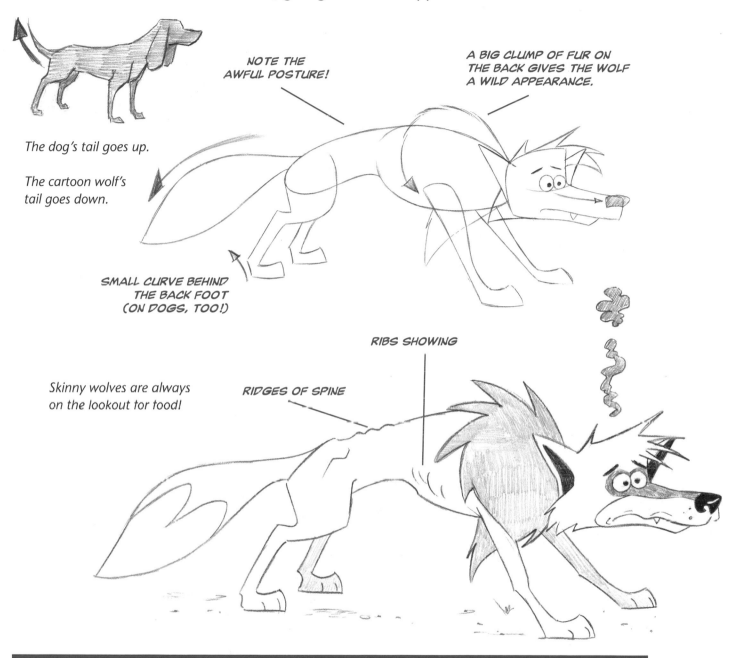

NOTE THE AWFUL POSTURE!

A BIG CLUMP OF FUR ON THE BACK GIVES THE WOLF A WILD APPEARANCE.

The dog's tail goes up.

The cartoon wolf's tail goes down.

SMALL CURVE BEHIND THE BACK FOOT (ON DOGS, TOO!)

RIBS SHOWING

RIDGES OF SPINE

Skinny wolves are always on the lookout for food!

DON'T BELIEVE EVERYTHING YOU SEE IN A CARTOON

Although the wolf is most often caricatured as a villain in cartoons, please don't let that influence your opinion of real-life wolves. Like dogs, real wolves are proud animals that are sociable with their own kind and deserving of our respect. Researchers and scientists find them admirable subjects of study in the wild. For too long, they were the object of ignorant stereotypes, which pushed them to the brink of extinction.

CATS & KITTENS: PURRRRRFECT FOR CARTOONING!

These little bundles of fluff are different from the bears and dogs we've drawn thus far in that their muzzles are always small, giving them fairly flat, subtle faces. They are lightly boned, flexible animals. Their visual hallmarks are 1. pointed ears, 2. whiskers, 3. a tiny triangle nose, and 4. cheeks with fluffy, pointy ends (a few varieties of cats may not have pointy cheeks, but they always have full cheeks).

And while there is the powerful grizzly bear and the bullying bulldog, there is no equivalent forceful personality among cartoon cats. They are usually cute, cunning, street-wise, or dopey.

THE VERSATILE CAT HEAD

There may not be as many different breeds of cats as there are of dogs, but that doesn't mean they come in fewer sizes and shapes. Because people are familiar with only a smattering of cat breeds, we can make up our own, and audiences will accept them as legitimate breeds. Oh yes, the deviousness of cartoonists knows no bounds. The cat's face makes a particularly good subject for character design. Because of the more subtle bone structure, it can be stretched, squashed, and adjusted to create all sorts of different looks.

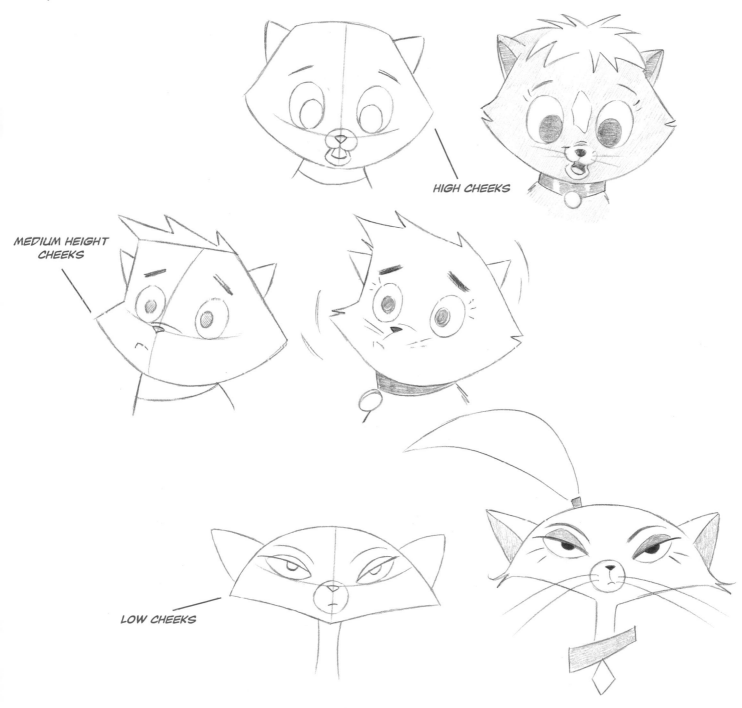

HIGH CHEEKS

MEDIUM HEIGHT CHEEKS

LOW CHEEKS

STANDING ON ALL FOURS

Cats have a funny type of posture, different from dogs. When they stand on all fours, cats—real cats, that is—bend their hind legs to a considerable degree. This causes their rump to slump, which is a funny look, especially if you exaggerate it in a cartoon. If you want to make a point that the rump is *slumping,* then give the cat a perky, *upright* head. It will highlight the contrast. See the cat's long, upright neck, and how it offsets the sagging hindquarters? Put both elements together and you've got a funny cat posture.

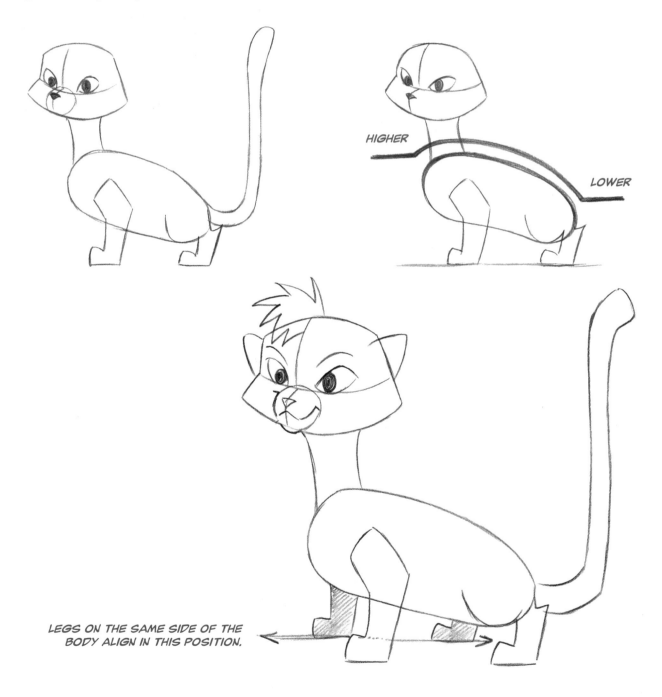

HIGHER

LOWER

LEGS ON THE SAME SIDE OF THE BODY ALIGN IN THIS POSITION.

THE DIFFERENCE BETWEEN BOY AND GIRL CATS

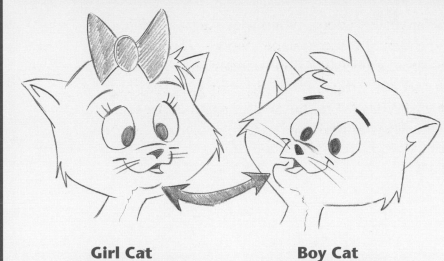

**Girl Cat
(Recessed Chin)**

**Boy Cat
(Jutting Chin)**

Oh sure, we add bows, eyeliner (don't ask me where a cat gets mascara!), long lashes, and maybe even a little bit of a "do" to make a cat look more feminine, but don't overlook the chin.

When cartooning the cat, the male's chin should jut out slightly; but the female's, on the other hand, should be recessed. Notice the difference on these two cat characters, and how it underscores the male and female genders.

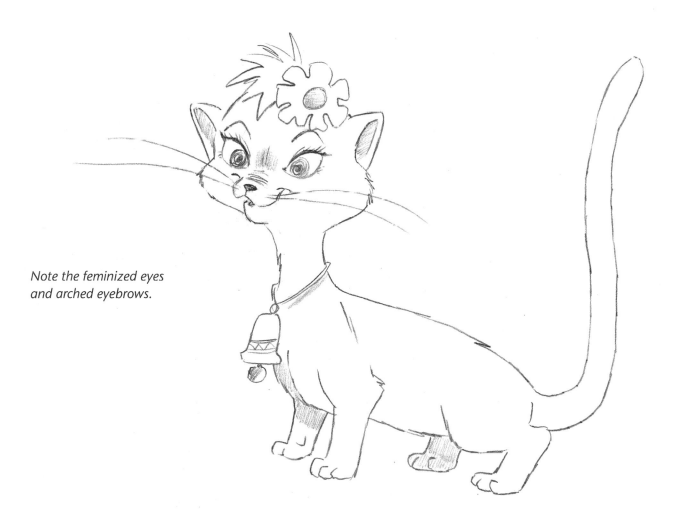

*Note the feminized eyes
and arched eyebrows.*

THE CLASSIC SITTING POSITION

Here's where we take all the mystery out of a pose that might look tricky at first but isn't. It's easy, once it's broken down into its basic elements. Often, when we look at a pose, we concentrate on all of it, which can make it look challenging to draw, when all we really need to do is single out the *primary factors* that create the pose. Once we've done that, everything else will fall easily into place.

Front View

Side View

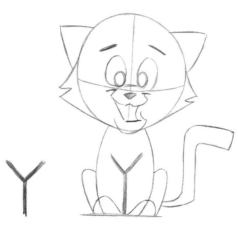

A Y shape creates the right look for the torso in the front view.

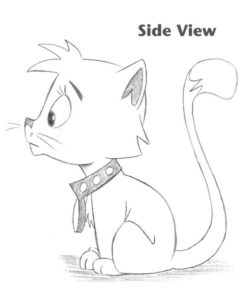

A half-moon, slightly tilted forward, is all that's needed to establish the side view of the body.

THE PART BELOW GROUND LEVEL GETS ERASED.

LITTLE KITTEN

To make the kitten fluffy-cute, draw the head so big it looks like you grew it in a lab experiment! Real kittens have big ears—they haven't quite grown into them yet. But in cartoons, it works better to make kitten ears tiny and dainty, which accentuates the size of the head by comparison.

 I don't like to define the paws or feet on kittens—it looks cuter if the forearms and legs just taper down to the ends without a break. Remember how we drew the classic dog walk? It works for cats, too. The near legs are placed together, and the far ones are spaced apart.

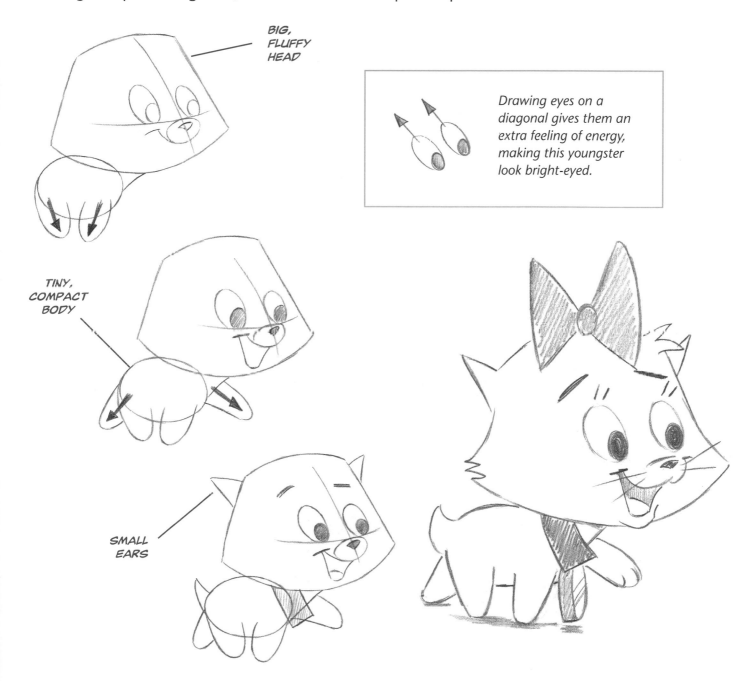

BIG, FLUFFY HEAD

Drawing eyes on a diagonal gives them an extra feeling of energy, making this youngster look bright-eyed.

TINY, COMPACT BODY

SMALL EARS

MISSING HIS MOMMY

I don't know why it's so, but kids love to see heart-wrenching, cute but sad cartoons. Big eyes welling up is a sure winner. Geez, I feel sorry for this little fella—and I drew him! Okay, I'm going to tell you the secret that makes him so dear. Yes, the face is precious, but it's the body that's the real icing on the cake, particularly those arms and legs. They're hopelessly useless, making him only good for a squeeze and a hug!

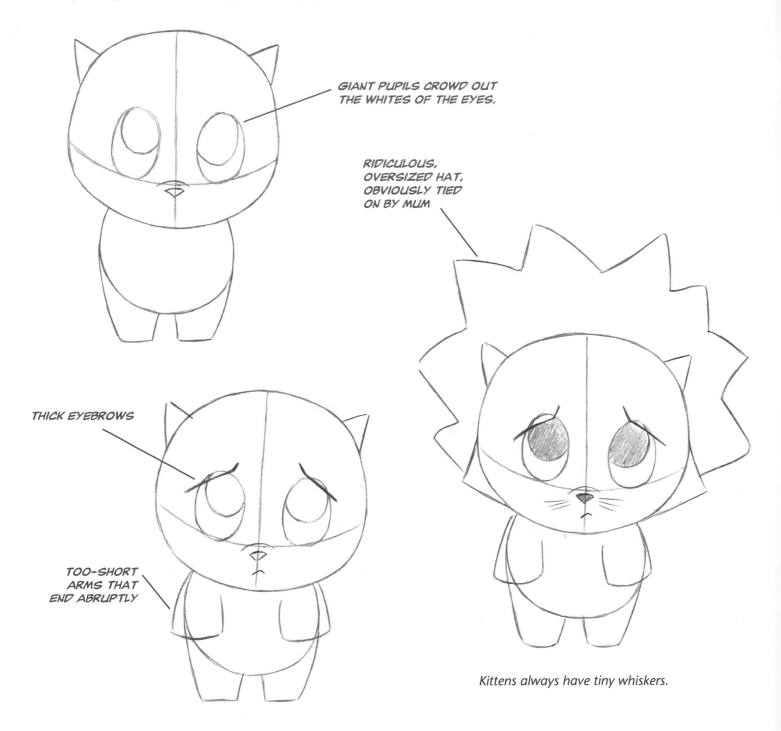

GIANT PUPILS CROWD OUT THE WHITES OF THE EYES.

RIDICULOUS, OVERSIZED HAT, OBVIOUSLY TIED ON BY MUM

THICK EYEBROWS

TOO-SHORT ARMS THAT END ABRUPTLY

Kittens always have tiny whiskers.

BABY KITTY PROPORTIONS

This plump little kitty is one and a half "heads" tall. This is how cartoonists measure proportions. They use the character's own head as a form of measurement. In this way, you can keep the proportions the same for a particular character, no matter how large or small you draw the figure, and no matter what angle it is viewed from.

You can also see that the head takes up a much larger proportion of the overall length of the character's height than the body. This is typical of babies and youngsters. The opposite holds true when a character matures and becomes a teen or an adult.

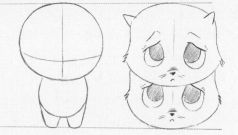

This character is one and a half heads tall.

Most of the overall height of this character is taken up by the head.

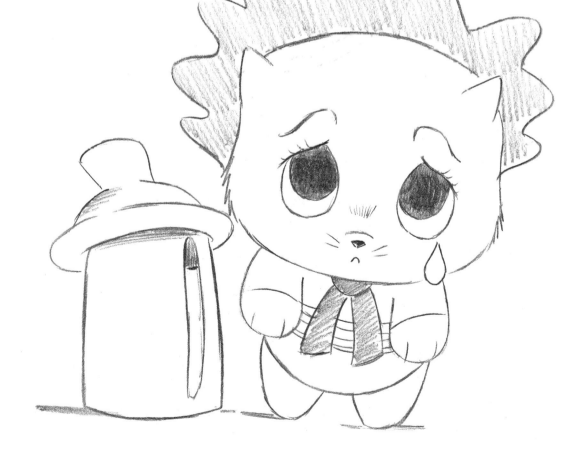

CAT EYE VARIATIONS

There is a variety of ways to draw funny cartoon cat eyes. All are easy to do, but you've got to choose the right type of eyes for the right type of character. If you draw goofy eyes on a sincere character, it's going to look awkward. You should use bright eyes on him. Let's look at the three popular variations.

Goofy Eyes
These eyes are drawn close together, sometimes even touching one another. They have small pupils.

Bright Eyes
Bright eyes work well on an earnest, or sincere, character. These eyes are spaced apart. The pupils are larger but not huge. Often, there is a "shine" in the pupils.

Cute Eyes
The pupils of cute eyes are *gigantic.* Two or three small eyelashes float off the eyeballs. Shines are sometimes placed in the pupil, sometimes not.

Siamese Cat

To my knowledge, there has never been a Siamese cat in the cartoon world that has been cast as anything other than a villain. I had a relative with a Siamese cat when I was a kid. It bit everyone. I didn't understand why this relative kept the cat. Maybe he wanted to keep it around until he got the chance to bite it back.

The Siamese has distinctive black markings, evil eyes, a slinky body, and a long, serpentine tail. It gives the impression of hating people and other cats, which makes it a funny character.

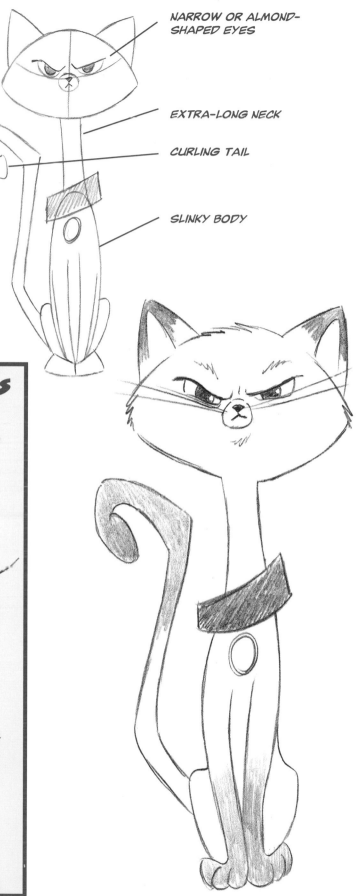

NARROW OR ALMOND-SHAPED EYES

EXTRA-LONG NECK

CURLING TAIL

SLINKY BODY

The Placement of Markings

A Siamese cat's dark markings are one of its most distinctive features. It's very important to include them in just the right places.

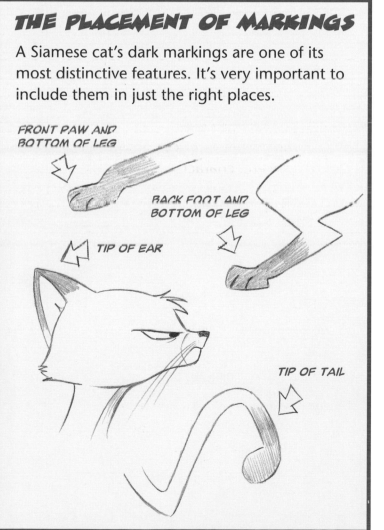

FRONT PAW AND BOTTOM OF LEG

BACK FOOT AND BOTTOM OF LEG

TIP OF EAR

TIP OF TAIL

PERSIAN CAT (THE SCRUNCHY-FACED CAT)

This is a very popular breed of cat. Rich people love it. It's vain, entitled, aloof, and ungrateful. Just what one looks for in a pet. The muzzle has to be drawn differently from that of other cats. It's bigger and overhangs the chin on both sides.

This cat's all fluff—virtually blow-dried—and gives the appearance of having a personal groomer, which it probably does. Some bows, ribbons, or even a piece of jewelry are nice touches for this Park Avenue pedigree.

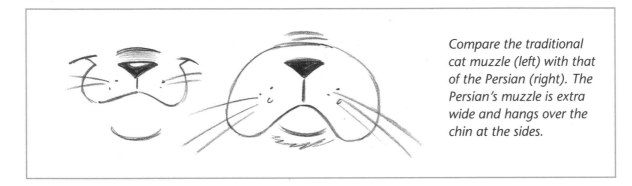

Compare the traditional cat muzzle (left) with that of the Persian (right). The Persian's muzzle is extra wide and hangs over the chin at the sides.

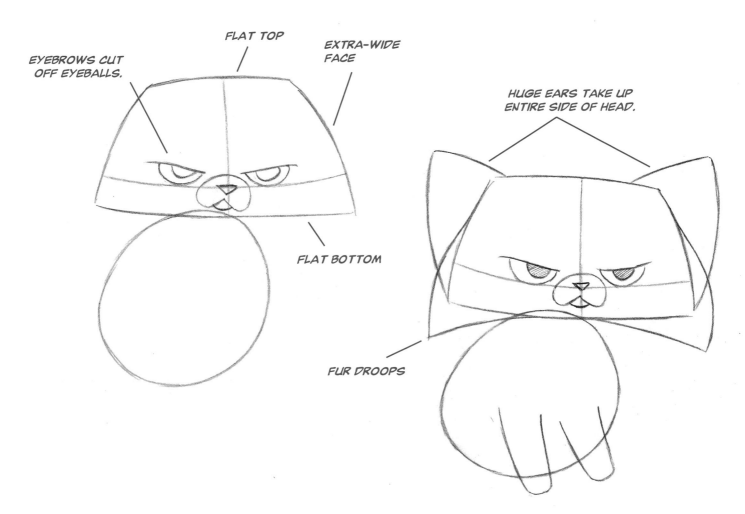

EYEBROWS CUT OFF EYEBALLS.

FLAT TOP

EXTRA-WIDE FACE

FLAT BOTTOM

HUGE EARS TAKE UP ENTIRE SIDE OF HEAD.

FUR DROOPS

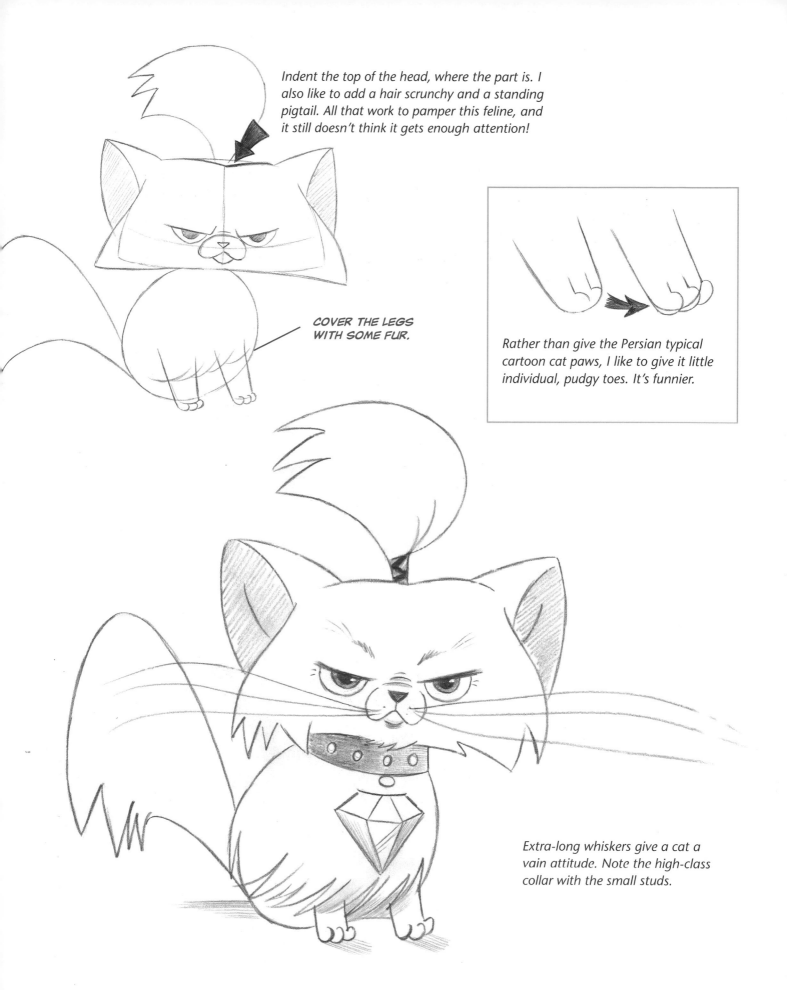

Indent the top of the head, where the part is. I also like to add a hair scrunchy and a standing pigtail. All that work to pamper this feline, and it still doesn't think it gets enough attention!

COVER THE LEGS WITH SOME FUR.

Rather than give the Persian typical cartoon cat paws, I like to give it little individual, pudgy toes. It's funnier.

Extra-long whiskers give a cat a vain attitude. Note the high-class collar with the small studs.

ALLEY CAT

Version 1

This boy was born to roam! From garbage can to garbage can, that is. He's a wise-guy character, a favorite among audiences. And fun to draw. He usually has a very human posture and is skinny, with a scruffy appearance. He lives by his wits, so he's got bright eyes, but he's also goofy, so those bright eyes should be placed close together (see page 72 for a look at eye types).

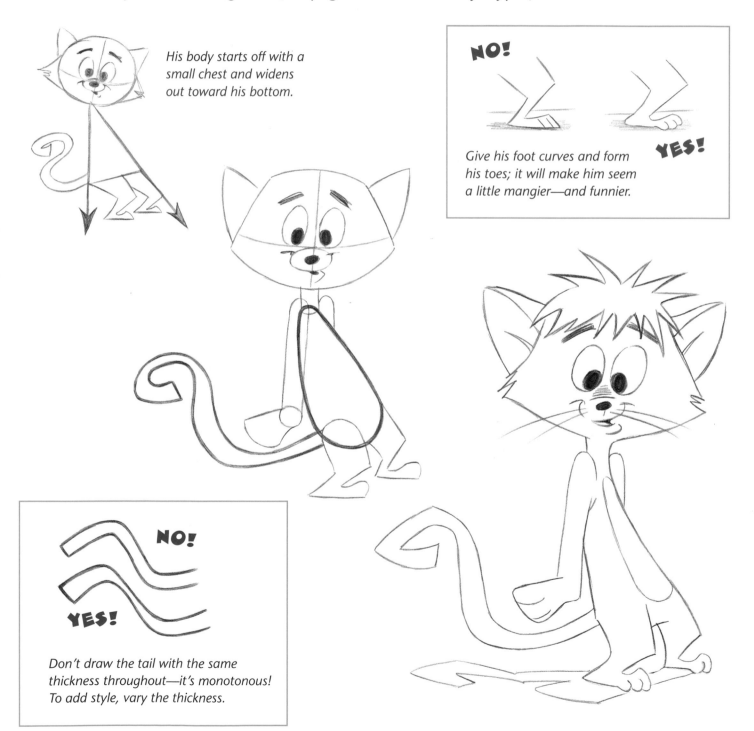

His body starts off with a small chest and widens out toward his bottom.

NO!

YES!

Give his foot curves and form his toes; it will make him seem a little mangier—and funnier.

NO!

YES!

Don't draw the tail with the same thickness throughout—it's monotonous! To add style, vary the thickness.

Version 2

This version of the alley cat has rounded cheeks, instead of pointed ones, and just a few strands of hair on top, instead of a mop-top. He's taller and lankier—more of a leader than a loner, unlike the prior one. Yes, an alley cat can be a leader among a bunch of city strays. It's a virtual comedy team: a group of totally incompetent scavengers, who are always debating the rules of the group, as if it were some sort of union!

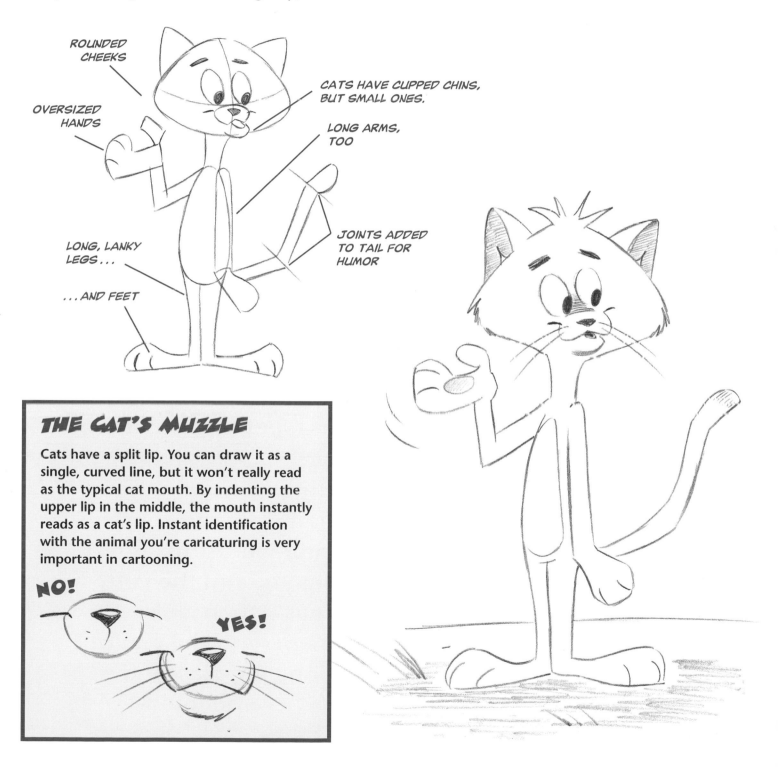

ROUNDED CHEEKS

OVERSIZED HANDS

CATS HAVE CUPPED CHINS, BUT SMALL ONES.

LONG ARMS, TOO

LONG, LANKY LEGS...

JOINTS ADDED TO TAIL FOR HUMOR

...AND FEET

THE CAT'S MUZZLE

Cats have a split lip. You can draw it as a single, curved line, but it won't really read as the typical cat mouth. By indenting the upper lip in the middle, the mouth instantly reads as a cat's lip. Instant identification with the animal you're caricaturing is very important in cartooning.

NO!

YES!

PENGUINS: EVERYONE'S FAVORITE BIRD

These chubby fellas have waddled their way into more cartoons than any other beaked characters. Because all penguins have the same black-and-white color pattern, chubby builds, and flipper "hands," you might assume that they're all drawn pretty much the same. But actually, the opposite is true. It's because penguins share such famous, common features that we're free to create all different types of penguin characters.

If we simply include the three instant "recognizers"— the black-and-white "tuxedo," the flipper hands, and the stiff, chubby physique—then we're free to experiment with the rest of it, really stretching and changing, and it will still read as a penguin!

PENGUIN BASICS

Well, for a penguin, it doesn't take much to bundle up for a snowstorm. But even a mother penguin is known to nudge her child to wear a hat!

While you can create a variety of penguin characters, there is one caveat: Penguins have to be cute! Even if you're drawing evil penguins, they have to be cute-evil. It's a rule. If you break it, you'll get hate mail from penguin lovers all over the world.

Here's an important hint that is sure to make them look cute: *Penguins have almost no legs!* Their bodies are basically plopped down on their large flat feet. They're all tummy! This gives them a stubby, adorable look, even though they've got a long torso, because the torso is always abruptly cut off at the feet.

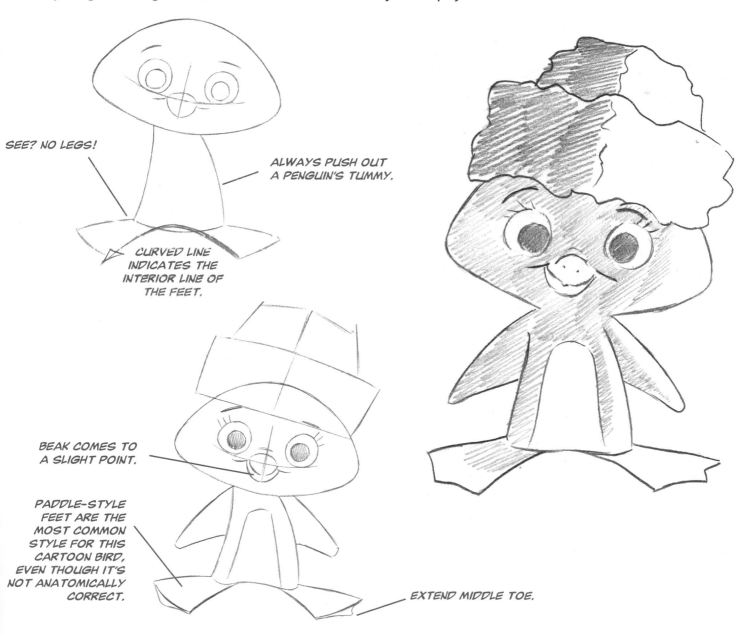

SEE? NO LEGS!

ALWAYS PUSH OUT A PENGUIN'S TUMMY.

CURVED LINE INDICATES THE INTERIOR LINE OF THE FEET.

BEAK COMES TO A SLIGHT POINT.

PADDLE-STYLE FEET ARE THE MOST COMMON STYLE FOR THIS CARTOON BIRD, EVEN THOUGH IT'S NOT ANATOMICALLY CORRECT.

EXTEND MIDDLE TOE.

ADULT PENGUIN

Adult penguins are built differently from young penguins, such as the one shown on the previous page. Yet, they are also cute. Part of the reason is that their heads are placed low on their bodies, making them look endearingly stubby.

Note that the wings double as arms, although they don't look extremely flexible (they're not supposed to!). And the tips of the wings turn into mittens, but never show individual fingers—just an occasional thumb.

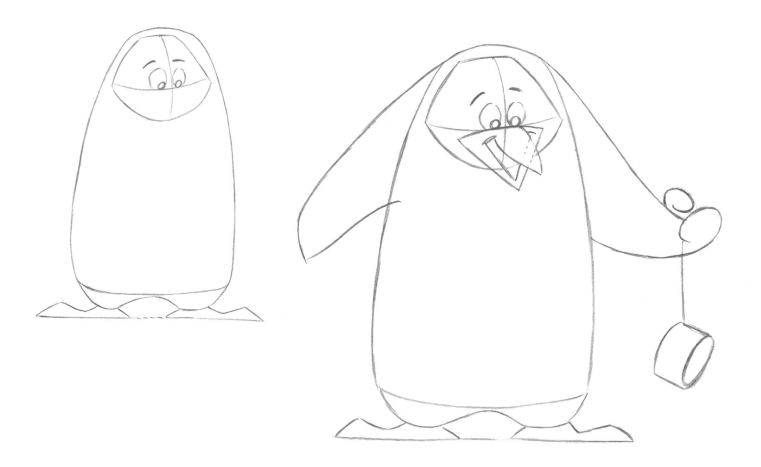

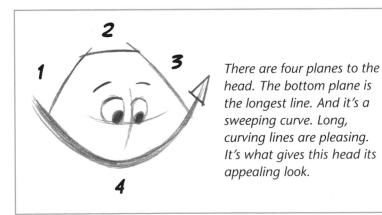

There are four planes to the head. The bottom plane is the longest line. And it's a sweeping curve. Long, curving lines are pleasing. It's what gives this head its appealing look.

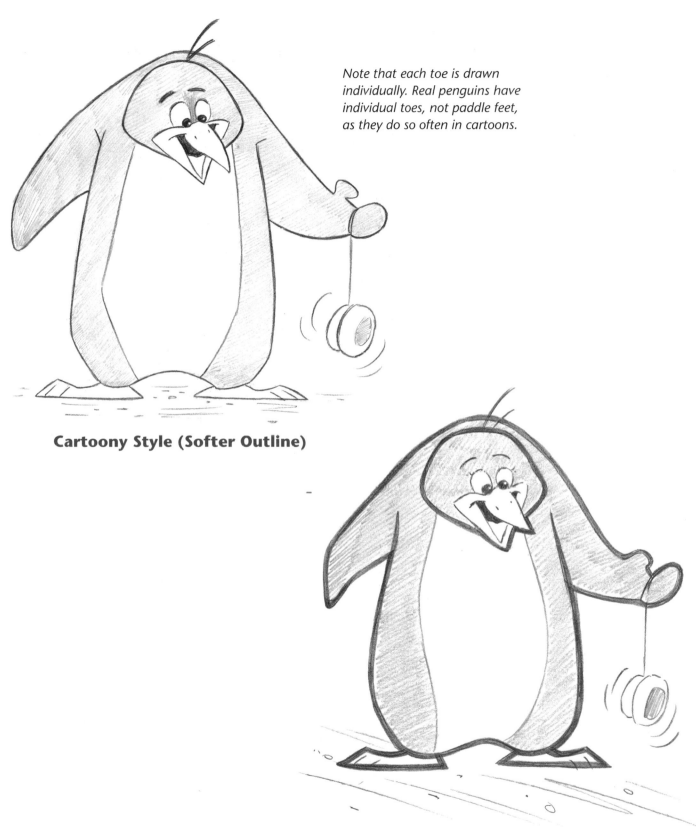

Note that each toe is drawn individually. Real penguins have individual toes, not paddle feet, as they do so often in cartoons.

Cartoony Style (Softer Outline)

Retro Style (Thick Outline)

PENGUIN WINGS

The gently curving wing of the penguin must look natural and relaxed. That's hard to pull off if you're struggling to figure out which way it bends. Let's take a look.

Simplified Wing Anatomy

The penguin's wing doesn't curve just once, but *twice.* Let's clear it up by comparing it to the human arm. In the relaxed position, the penguin's wing remains pasted close to its side. Even when it moves, it remains fairly inflexible. You can achieve this look by retaining the double-bend configuration, seen here, even when the wing is outstretched (you'll see what I mean in the next couple sets of penguin drawings).

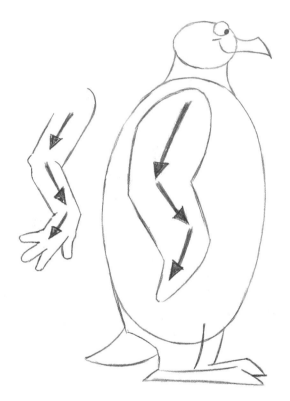

*The penguin's wing, like the human arm, bends **forward** at the elbow, and then **back** at the wrist.*

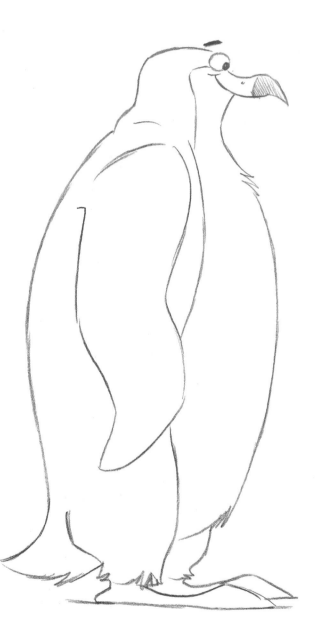

Maintaining the Natural Wing Bends

By keeping the natural bends in the wings, you show the wings as inflexible paddles. This lack of flexibility is one of the penguin's most endearing characteristics, so accentuate it. People love the way these little guys waddle!

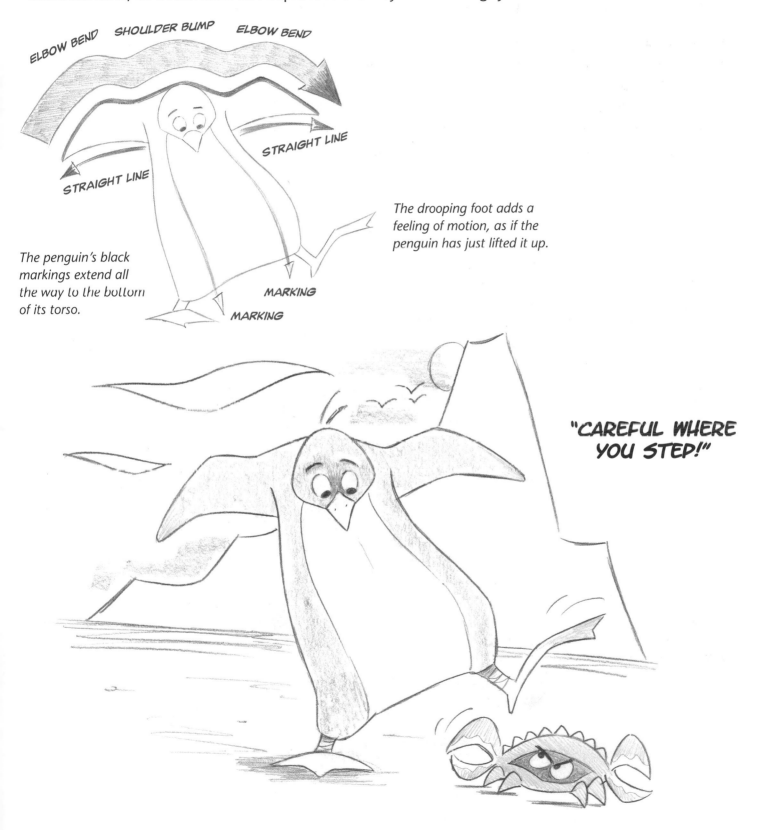

ELBOW BEND SHOULDER BUMP ELBOW BEND

STRAIGHT LINE

STRAIGHT LINE

The penguin's black markings extend all the way to the bottom of its torso.

The drooping foot adds a feeling of motion, as if the penguin has just lifted it up.

MARKING

MARKING

"CAREFUL WHERE YOU STEP!"

THE CHUBBERY-RUBBERY PENGUIN FACE

The penguin face can be almost any shape: round, oval, even a rounded-off square. It's that rubbery. But if you want to make a penguin's face extra-chubby, you have to draw its cheeks so that they appear to be drooping on either side of the beak. This will also enhance its "cute-appeal."

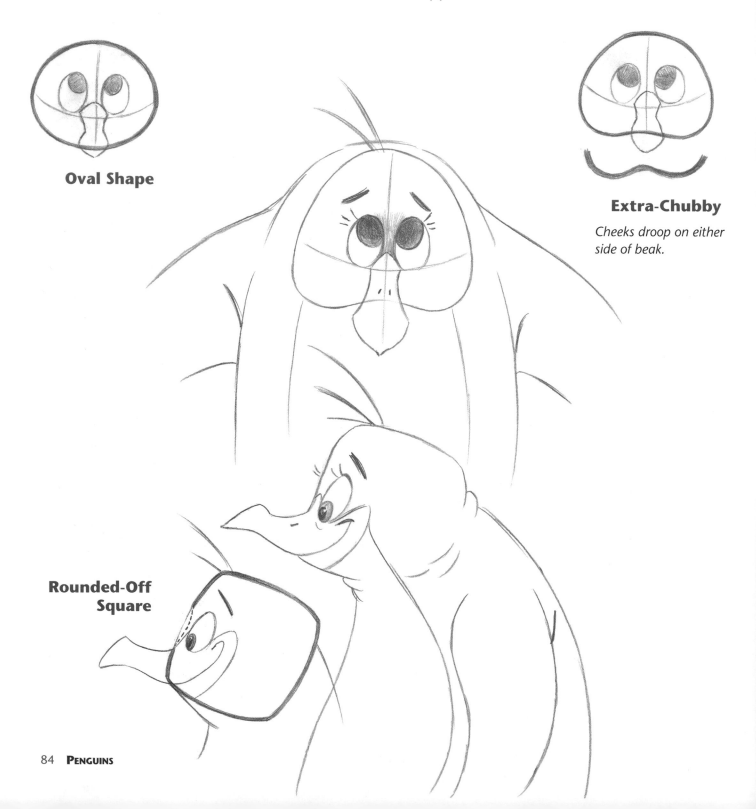

Oval Shape

Extra-Chubby

Cheeks droop on either side of beak.

Rounded-Off Square

CHARACTER DESIGN: EYES ON TOP OF THE HEAD

Here's a popular look in cartoon character design. It's kind of extreme, but it works well with birds, because the beak is a natural place for it. Put both eyes together, on top of the head, with the beak in the middle. The eyes "break" the outline of the face, a physical impossibility, I know. But I got a note from a zoologist, so it's okay.

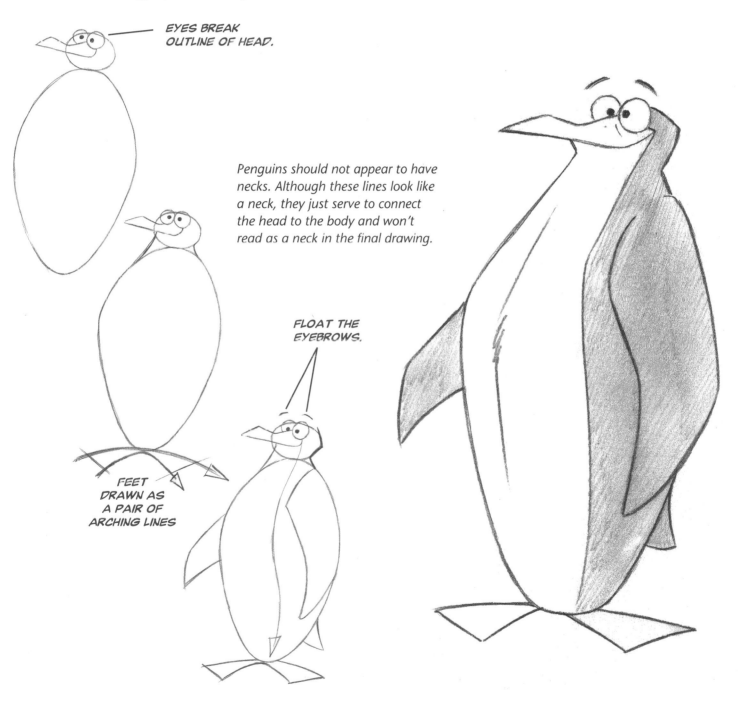

EYES BREAK
OUTLINE OF HEAD.

Penguins should not appear to have necks. Although these lines look like a neck, they just serve to connect the head to the body and won't read as a neck in the final drawing.

FLOAT THE
EYEBROWS.

FEET
DRAWN AS
A PAIR OF
ARCHING LINES

RETRO-STYLE PENGUIN

Most retro-style penguins have super-round, exaggerated heads. As with all retro-style cartoon animals, the heavy outside line is very important.

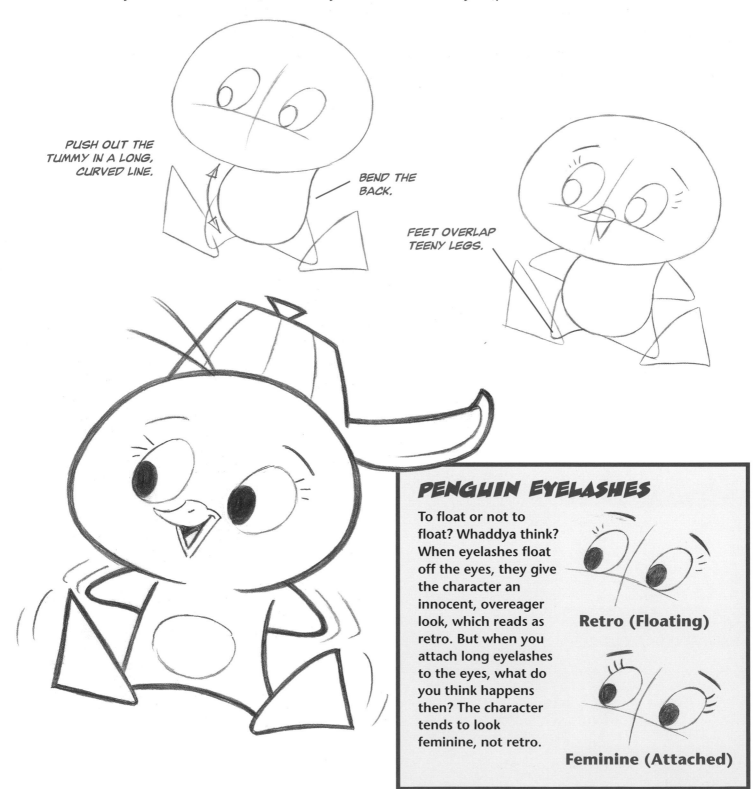

PUSH OUT THE TUMMY IN A LONG, CURVED LINE.

BEND THE BACK.

FEET OVERLAP TEENY LEGS.

PENGUIN EYELASHES

To float or not to float? Whaddya think? When eyelashes float off the eyes, they give the character an innocent, overeager look, which reads as retro. But when you attach long eyelashes to the eyes, what do you think happens then? The character tends to look feminine, not retro.

Retro (Floating)

Feminine (Attached)

A NATURAL-BORN ICE SKATER

Winter sports accessories are a fun look for penguins. Posing animals in classic human shots is a great way to create humor. You could draw this little guy skating along in any number of awkward positions, to show him being klutzy. But the classic Olympic skater pose is immediately funny, because we like to see animals imitating humans. We're a pretty vain species, unlike penguins, who aren't particularly interested in watching us waddle.

Note how the cap and scarf trail in the wind. This underscores the feeling of motion. Without it, the penguin would look as if he were standing still, even with the addition of speed lines.

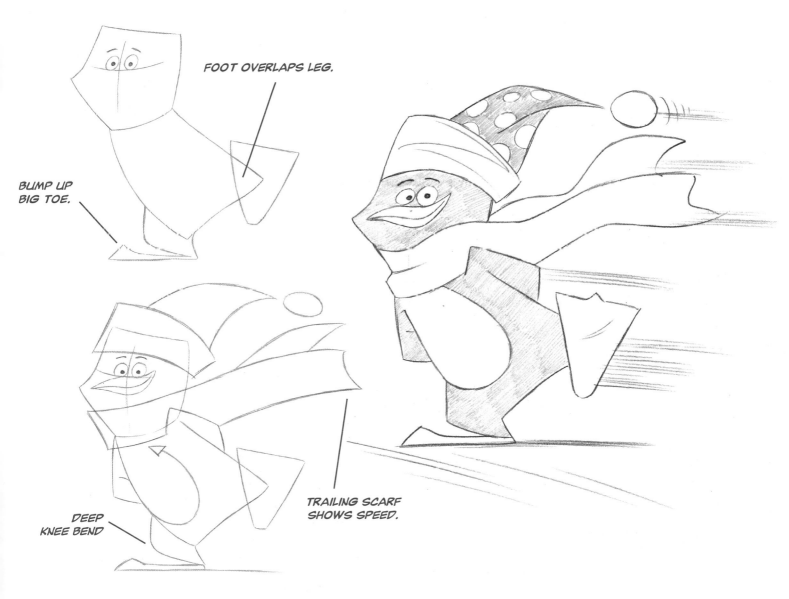

FOOT OVERLAPS LEG.

BUMP UP BIG TOE.

DEEP KNEE BEND

TRAILING SCARF SHOWS SPEED.

Character should lean far forward to add to the sense of motion.

SCIENCE EXPERIMENT VICTIM

This is what happens when one transfers the brain of an evil genius into the head of a penguin. Not that anyone would ever want to. Still, in cartoons, you never know; it might come in handy. Penguins are as likely to take over the world as anyone else. Wait a minute—isn't that just too silly? A penguin getting a brain transplant? Penguins ruling the world? Yeah, I buy it.

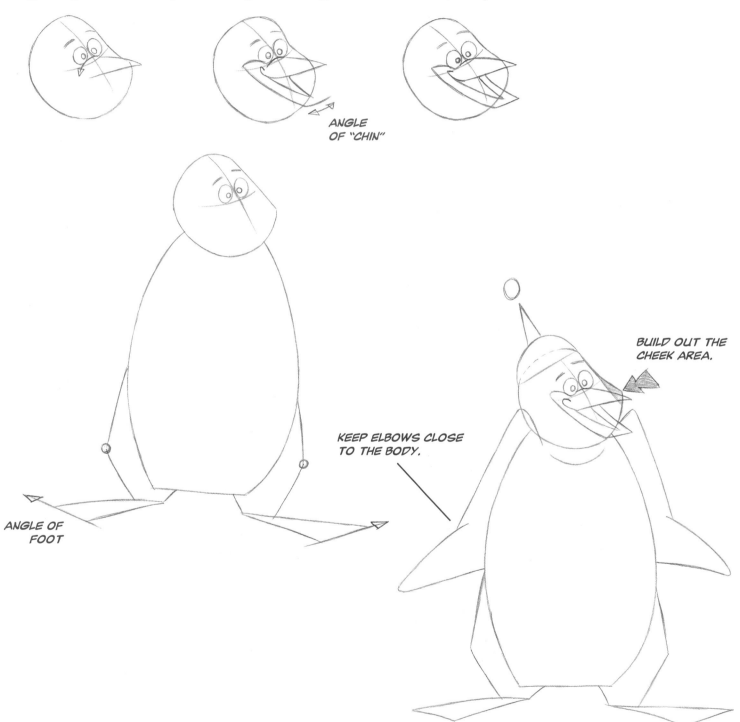

ANGLE
OF "CHIN"

BUILD OUT THE
CHEEK AREA.

KEEP ELBOWS CLOSE
TO THE BODY.

ANGLE OF
FOOT

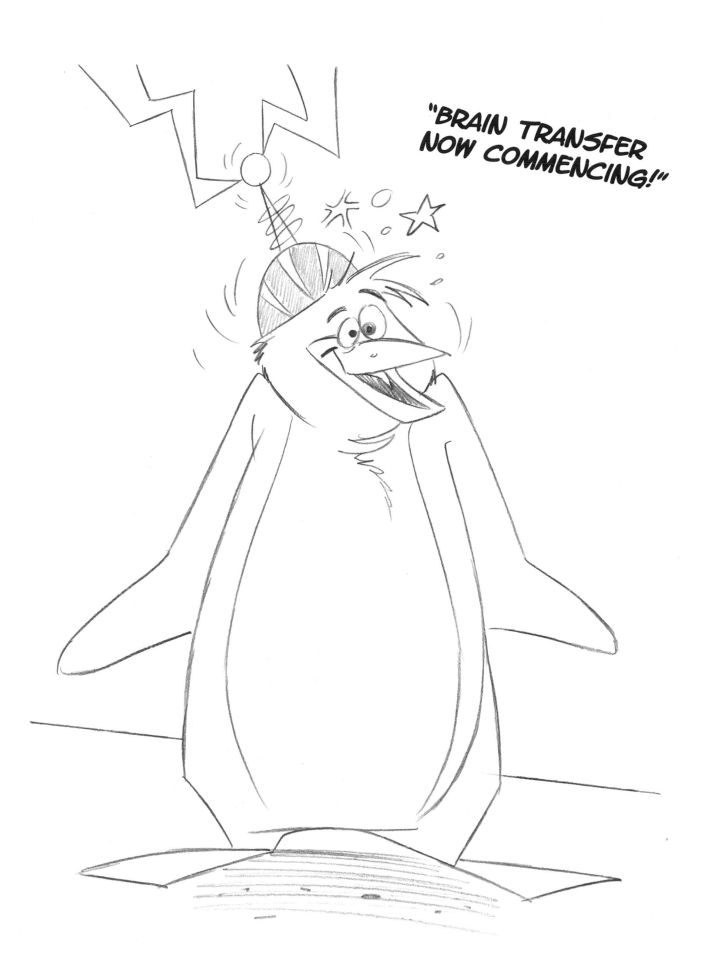

GOOFY-TYPE PENGUIN

Like the shoulder action? Even though penguins have limited mobility, in that they're not gifted athletes on land, they're actually pretty rubbery. Very few right angles on these little fellas. Notice how, in a variation on the typical character design, this penguin's head is based on a square.

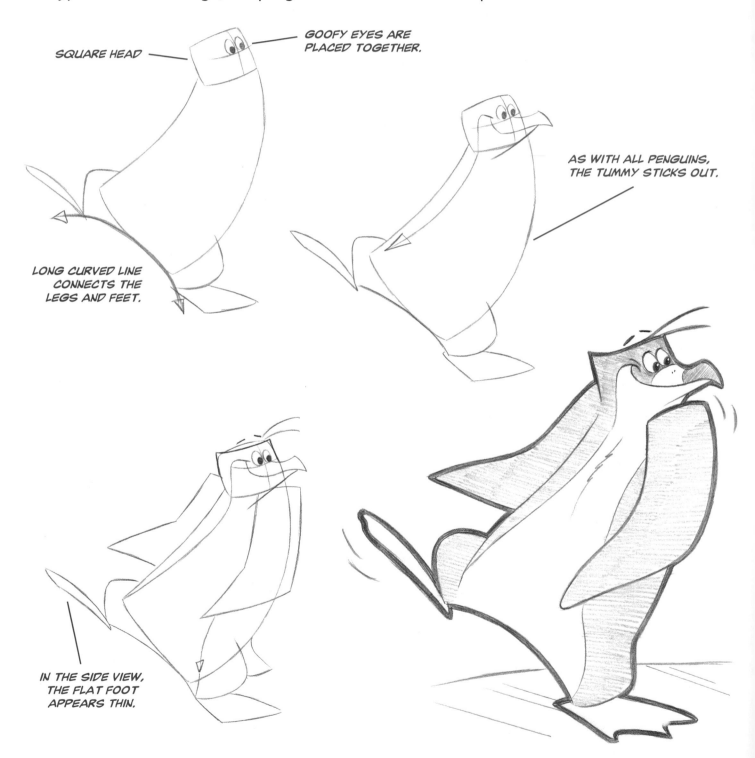

SQUARE HEAD

GOOFY EYES ARE PLACED TOGETHER.

AS WITH ALL PENGUINS, THE TUMMY STICKS OUT.

LONG CURVED LINE CONNECTS THE LEGS AND FEET.

IN THE SIDE VIEW, THE FLAT FOOT APPEARS THIN.

MORE PENGUIN SHAPES & SIZES

Here are just a few more variations, to give you an idea of the many different things you can do with this elastic cartoon animal.

Beach Blanket Birdy

Flappy-Feet Toddler

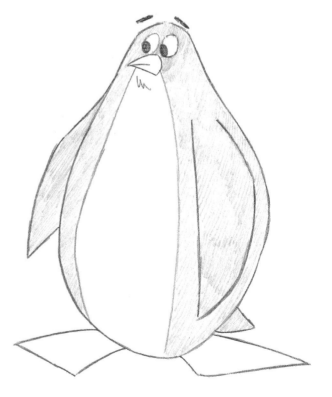

Roly-Poly Penguin

HORSING AROUND WITH HORSES

If you've tried to draw realistic horses in the past and found them challenging, your experience in drawing cartoon horses will likely be totally different. Get ready to really massacre the actual anatomy of horses when you turn them into cartoons. Have no mercy! Mold them into funny shapes. Push the envelope to get laughs. We'll start off with the basic horse's head, then the simplest body type for cartoon horses—standing upright like a person. Chances are, you've never before drawn an easier horse, or one with more personality.

HORSE'S HEAD: SIDE VIEW

To draw the horse's head in a side view, we break it down into very basic parts, or sections. Then we sort of smooth out the lines that connect the sections, and the entire cartoon falls into place pretty quickly. I think you'll be surprised how well it works—once you have the basic shapes in place. But don't skimp on the foundation.

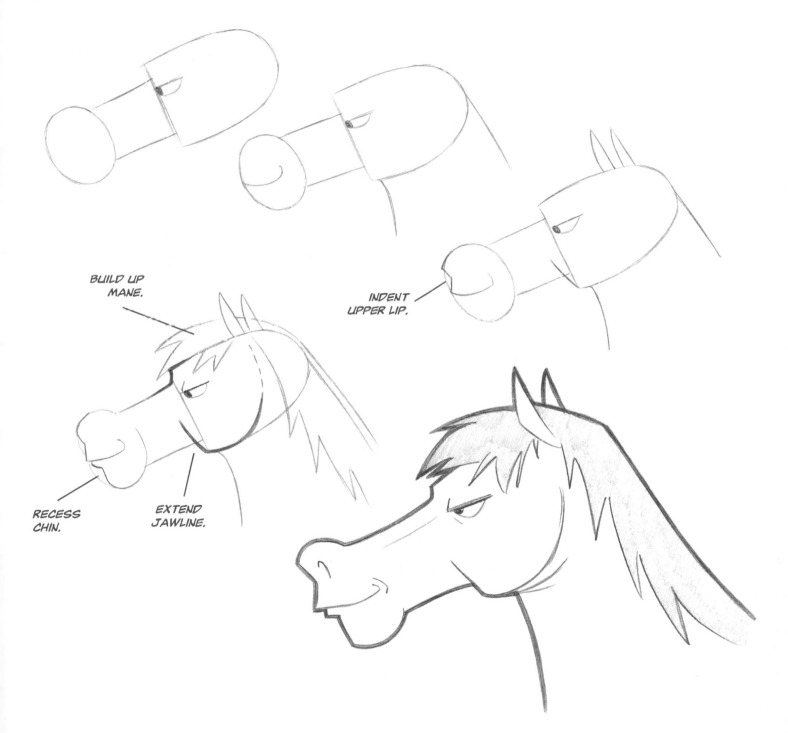

BUILD UP MANE.

INDENT UPPER LIP.

RECESS CHIN.

EXTEND JAWLINE.

STANDING ON TWO LEGS: SIDE VIEW

We tend to think of horses as strong animals, with thick, muscular necks, shoulders, and thighs. But heck, we're cartoonists—we can do anything we want! For example, this guy is a goofy horse. So we'll take away some of his brawn to make him goofier looking. The backward bend of his locked legs works well over that potbelly of his. With his skinny arms and neck, the only work he's good for is making wisecracks. (The shaggy mane and tail indicate that he's not a thoroughbred, in case you couldn't guess!)

Unless you scratch in some pencil shading, the mane and tail will come across as being blond, which may be your choice. But I strongly recommend darkening the hooves as a matter of course for all of your horses. A shaded eyelid will give your character a *sly* look. Note the extra-long eyelashes, which enhance his goofy attitude.

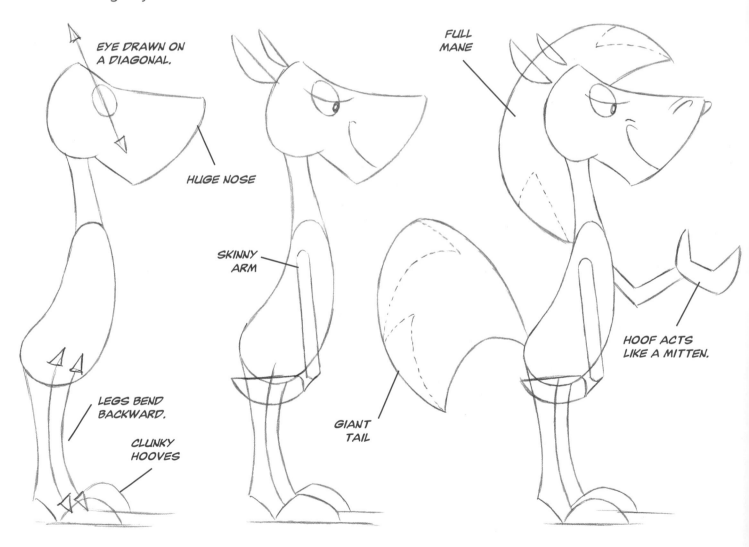

EYE DRAWN ON A DIAGONAL.

HUGE NOSE

SKINNY ARM

LEGS BEND BACKWARD.

CLUNKY HOOVES

GIANT TAIL

FULL MANE

HOOF ACTS LIKE A MITTEN.

Flat Look

Showing just the near nostril makes the drawing look two-dimensional.

Three-Dimensional Look

Drawing the far nostril peeking out from the other side of the face adds a sense of depth to the image.

HORSES STANDING ON FOUR LEGS

Now we'll look at horses that actually stand like *horses.* But even so, we're going to twist the anatomy a bit so that they'll be cartoony.

Basic Body Shape

Any animal that walks on all fours and that has a long torso is going to have a belly that sags to some degree. It's not an excess of chips and soda. Blame it on gravity! Now, if the belly dips, the back has also got to follow suit.

The downward sway of the back runs smack into a shoulder hump at the base of the horse's neck. Every horse has this bump, whether the horse is husky or scrawny. Of course, if you're drawing a highly stylized horse, where you're totally stretching and manipulating the anatomy to extremes, you can alter almost anything, even eliminate the hump entirely, if you want to.

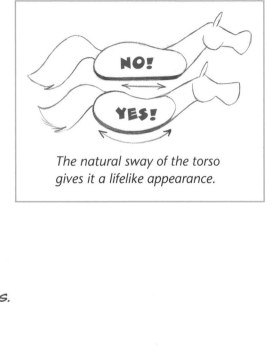

The natural sway of the torso gives it a lifelike appearance.

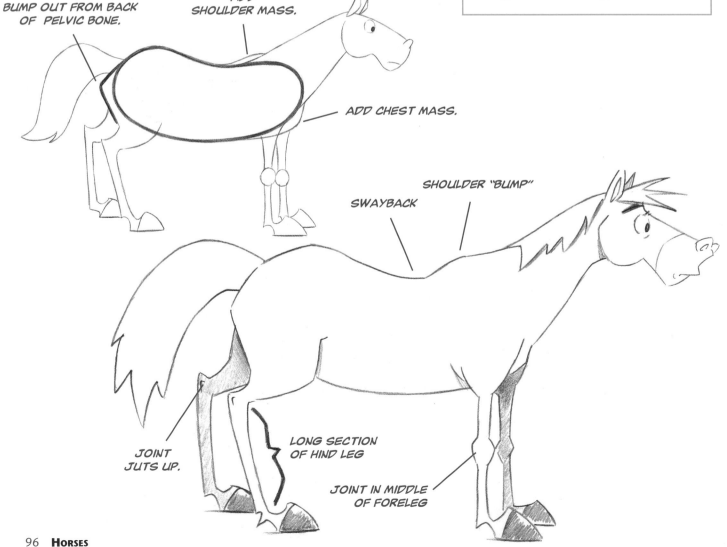

Simplified Skeleton

Here's a simplified look at the horse's skeleton, so you can see the direction in which the bones go. This will take some of the mystery out of the anatomy. Now, I'm going to give the bones and joints their accurate labels, which is going to really freak you out, because it's going to look as if they're all wrong. For example, the joint that you probably always thought was the knee is actually the ankle. But does it really matter? Not for our purposes. What matters is that you can see which way it bends. Take a look.

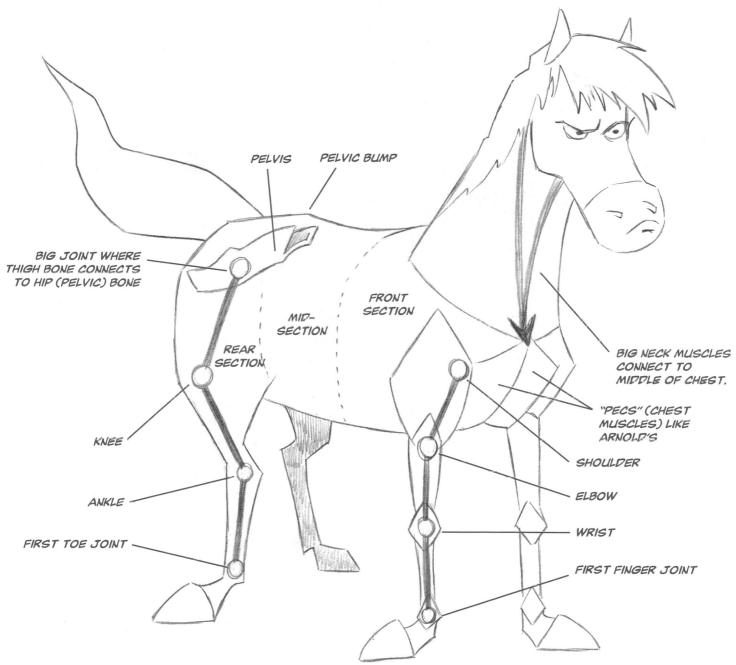

PELVIS

PELVIC BUMP

BIG JOINT WHERE THIGH BONE CONNECTS TO HIP (PELVIC) BONE

FRONT SECTION

MID-SECTION

REAR SECTION

BIG NECK MUSCLES CONNECT TO MIDDLE OF CHEST.

"PECS" (CHEST MUSCLES) LIKE ARNOLD'S

KNEE

SHOULDER

ANKLE

ELBOW

FIRST TOE JOINT

WRIST

FIRST FINGER JOINT

HOOVES FACE OUT FOR A COMICAL LOOK.

THE POINT OF THE SHOULDER

The most prominent joint on cartoon horses is probably the shoulder, which, when boldly drawn, gives the horse a proud, courageous look. To help you visualize it as the point of the shoulder that it is, I am comparing it, here, to the same position on a person.

A full, muscular shoulder helps to create the impression of a powerful character, whether it's a horse or a human. Keep it angular, as it should retain the shape of the shoulder blade (which is a bone), under the surface of the skin.

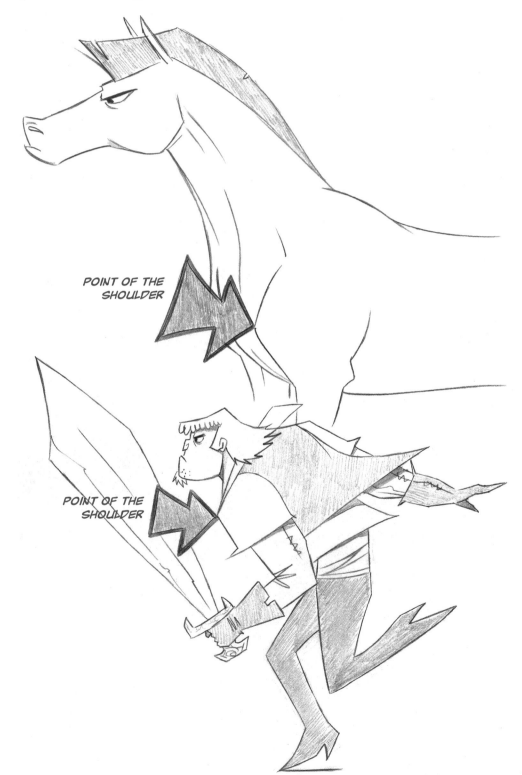

POINT OF THE SHOULDER

POINT OF THE SHOULDER

FUNNY LEGS

These are super-simplified hind legs. In fact, this fella has no joints at all in his legs. We've even removed any semblance of kneecaps! You can stretch the horse's form pretty far. That said, it's still got to look like a horse—a ridiculous horse, perhaps, but still, a horse. And that's one of the reasons why that small indentation just above the hoof is so important—it prevents the horse's legs from looking too human.

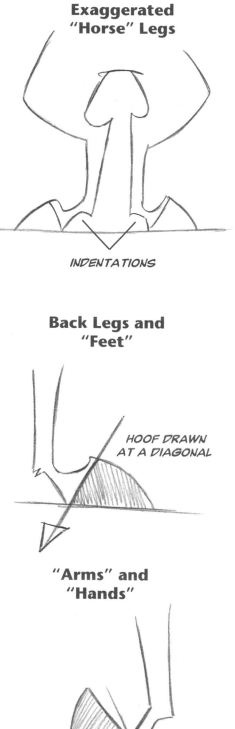

Exaggerated "Horse" Legs

INDENTATIONS

Back Legs and "Feet"

HOOF DRAWN AT A DIAGONAL

"Arms" and "Hands"

DIAGONAL

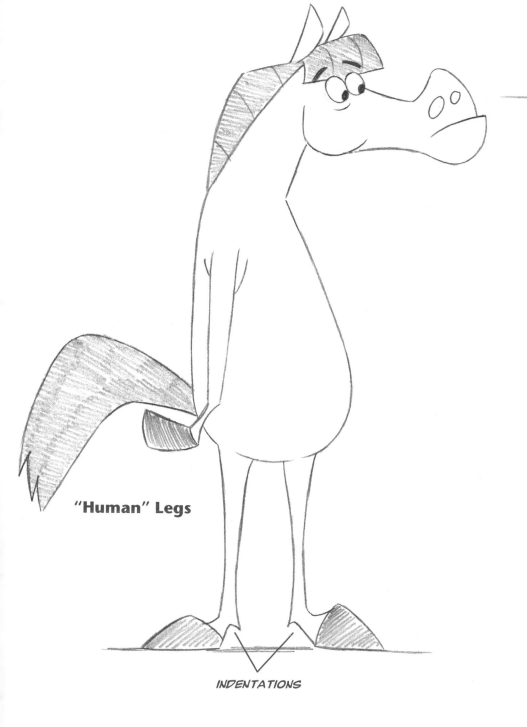

"Human" Legs

INDENTATIONS

TYPES OF MANES

Just like a person's hairdo—or perhaps even *more so*—a horse's mane adds personality to a character. There are a wide variety of cartoon manes, and I've illustrated a few for you. But you don't have to stop there. You can make up your own design. For now, have a look at some classics.

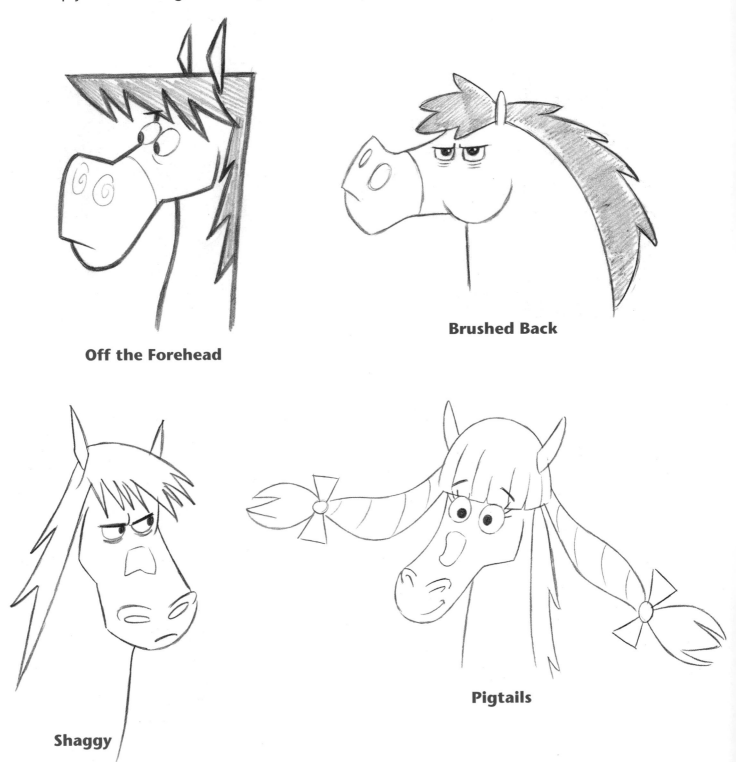

Off the Forehead

Brushed Back

Shaggy

Pigtails

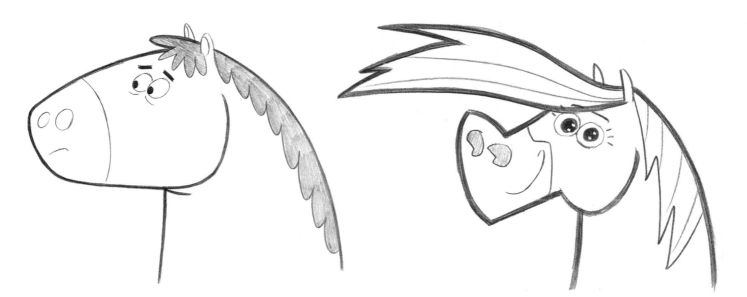

Smoothed Back

The Long Comb-Out

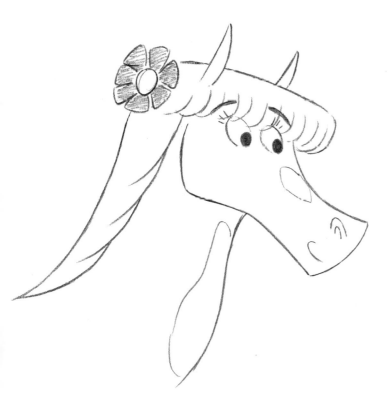

The "Daisy" Look

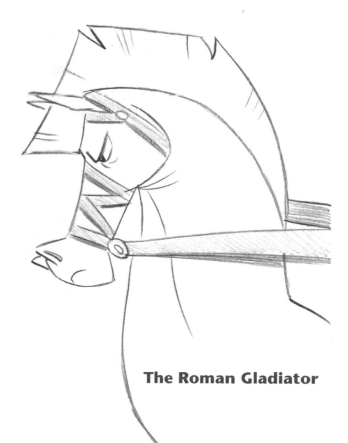

The Roman Gladiator

ANGRY HORSE

I don't know why he's angry, but I'm not going to ask! Maybe he caught another stallion running around with his mare or stealing his hay. Because of this horse's long neck, his posture creates a particularly long line from the top of his crown all the way down to his tail, as indicated by the arrow along his back. The curve in the back (as opposed to a straight line, which would be much less interesting) makes the pose dynamic.

Counterbalancing the concave line of the back is the convex line of the tummy. Notice, too, that the head is tilting down. Here's a general rule for positioning heads: *Angry heads tilt down; happy heads tilt up.*

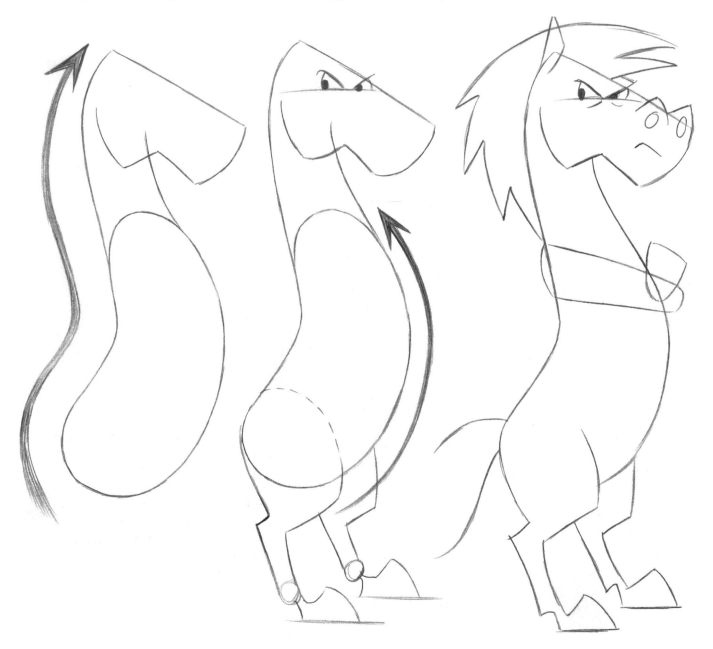

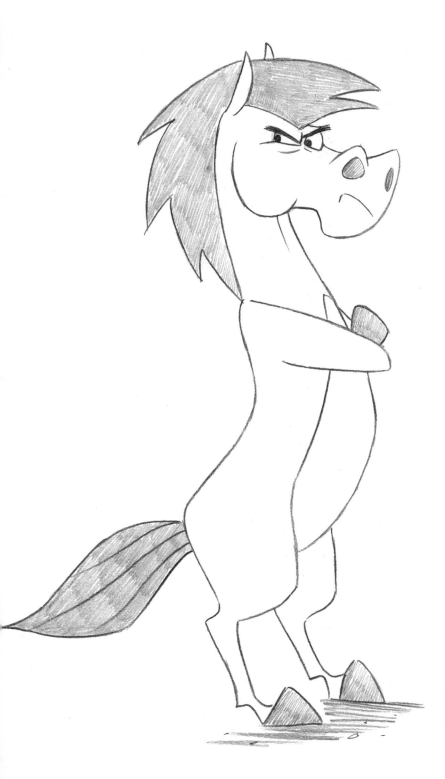

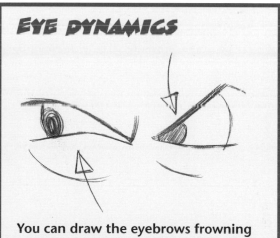

EYE DYNAMICS

You can draw the eyebrows frowning evenly on both eyes. That's a perfectly good expression, and there's nothing wrong with it. But a nice variation is to avoid too much symmetry by having one eye squint, while the other opens. The eye on the left is pushed up by the bottom eyelid, while the eye on the right is crushed by the eyebrow.

KNOCK-KNEED HORSE: FRONT VIEW

Here's a funny look you can use for an upright horse on two legs. Stick the upper legs together and fan out the lower legs at the "knees." It's sure to give your character a goofy stance.

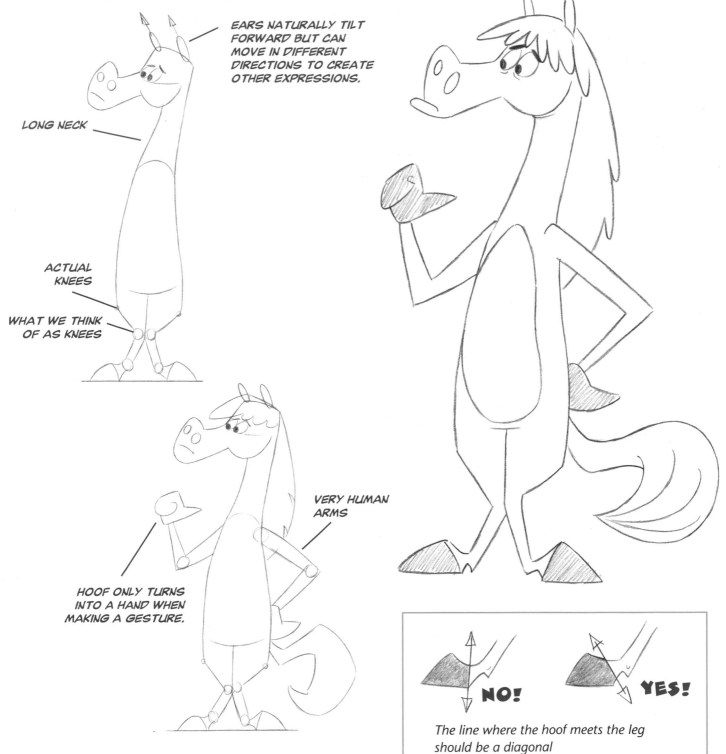

EARS NATURALLY TILT FORWARD BUT CAN MOVE IN DIFFERENT DIRECTIONS TO CREATE OTHER EXPRESSIONS.

LONG NECK

ACTUAL KNEES

WHAT WE THINK OF AS KNEES

VERY HUMAN ARMS

HOOF ONLY TURNS INTO A HAND WHEN MAKING A GESTURE.

NO!

YES!

The line where the hoof meets the leg should be a diagonal

NOT THE SHARPEST TOOL IN THE SHED—OR BARN!

He may be firing on all cylinders as he tries to figure something out, but unfortunately, he's only got two cylinders to begin with! So it's going to take a while before that noggin comes up with any bright ideas. The dopey but well-meaning horse is a fun character—always drawn with a big nose and a recessed chin. The ears are slightly oversized, making him look a little like a donkey. Remember what we learned earlier about goofy characters? It's an effective technique to draw their eyes close together.

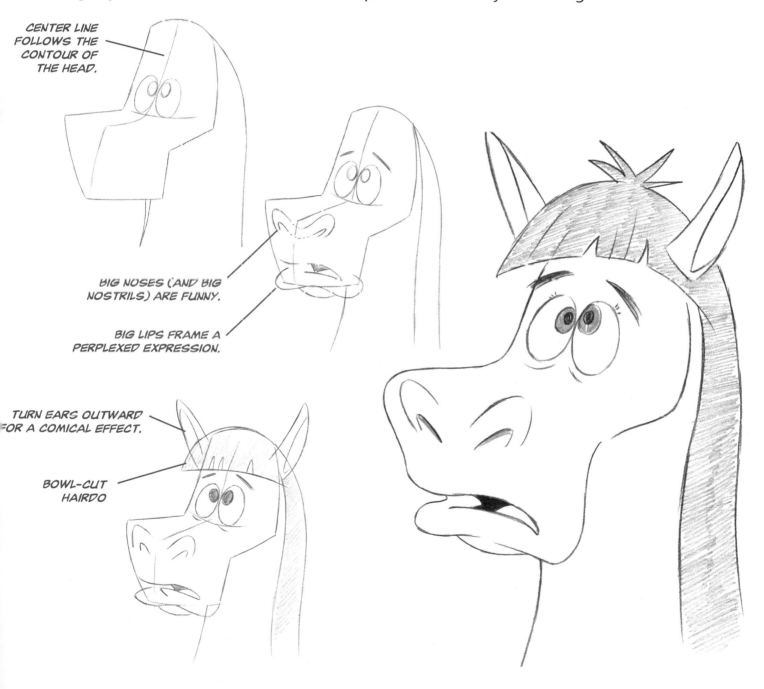

CENTER LINE FOLLOWS THE CONTOUR OF THE HEAD.

BIG NOSES (AND BIG NOSTRILS) ARE FUNNY.

BIG LIPS FRAME A PERPLEXED EXPRESSION.

TURN EARS OUTWARD FOR A COMICAL EFFECT.

BOWL-CUT HAIRDO

DRAWING THE HEROIC HORSE

With its naturally massive jaw (I'm not talking about the chin, mind you) and forward-leaning angle of the neck, the horse makes a perfect candidate for a noble character. In fact, in the Middle Ages, it was the steed that delivered the knight into battle. In cartoons, we have only to make a few, simple adjustments to our basic horse to bring out the courageous aspects of his personality.

The Heroic Head

The heroic horse's head emphasizes three basic elements:

- Oversized, well-defined jaw
- Long snout area (thinner than on other cartoon horses)
- Determined eyes, with heavy eyebrows (eyes wedge deeply into forehead)

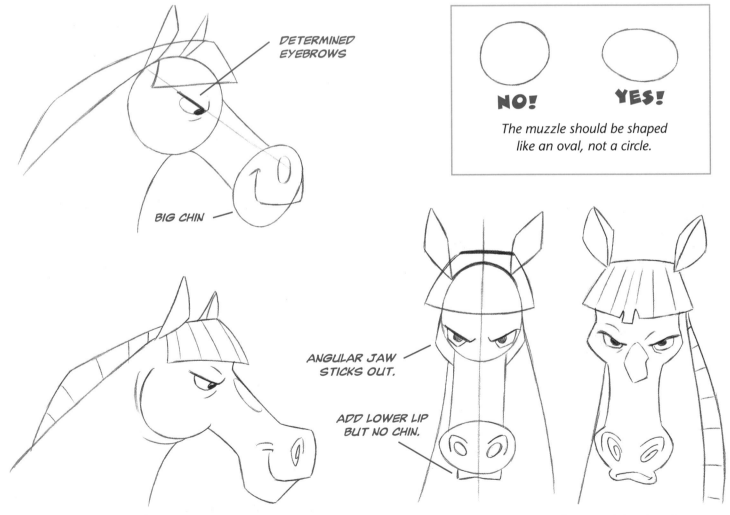

DETERMINED EYEBROWS

BIG CHIN

NO! YES!

The muzzle should be shaped like an oval, not a circle.

ANGULAR JAW STICKS OUT.

ADD LOWER LIP BUT NO CHIN.

I like to add lines (striations) to the interior of the mane. It makes the heroic horse look groomed, as if it were owned by a knight. It's a sharp look—and combat-ready.

In the front view, I have eliminated the chin, for a cleaner look. You can still keep it if you like, but I find that it makes the horse look slightly goofy, which I want to avoid with the heroic character.

The Heroic Neck

The neck is all-important in creating a heroic, noble steed. The back of the neck should be drawn with a significantly curved line that attaches to the tip of the skull. And right at that point, where the skull and neck attach, is where the ears should go.

The underside of the neck is adjustable. *The more heroic the horse, the farther out you should place that line.* If you want him to be really, really heroic, draw a straight line from the jaw directly down. If you want him to be slightly less heroic—for example, a younger steed—place the line farther back.

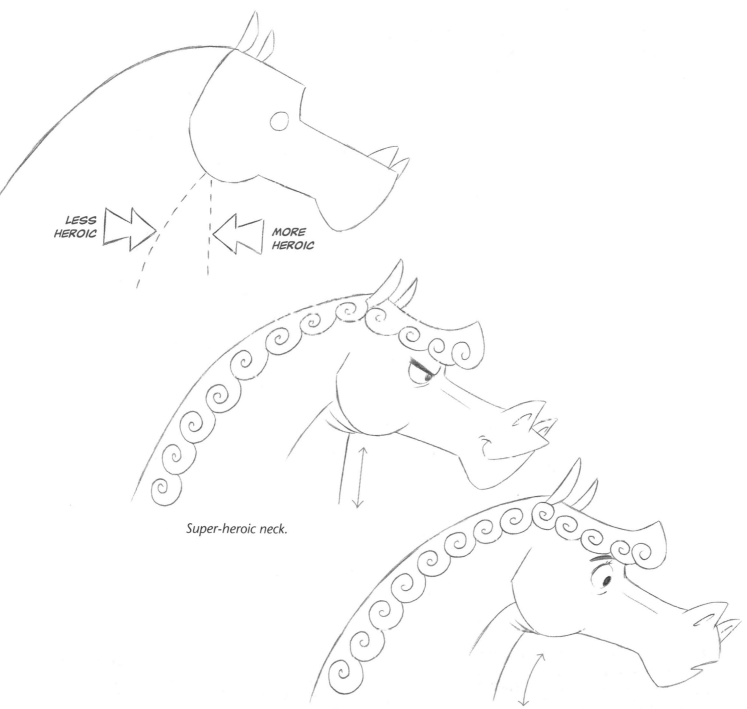

LESS HEROIC

MORE HEROIC

Super-heroic neck.

Younger, less heroic version.

Horse in Armor

I'm sorry! I couldn't help it. I had to make him funny looking. I think it's a lot more amusing to create a battle-ready horse who takes himself way too seriously than to draw a representational one. So I like to push the envelope to the point where he's somewhere between brawny and fat, with tiny little legs. Delicate legs on top of a beefy body is always a funny look for powerful cartoon characters.

Note that this horse doesn't need a ton of armor to sport an effective costume. Too much is overkill and would hide its form. In fact, real medieval horses didn't wear all that much of it. Enemy knights went after the horseback rider, not so much the horse.

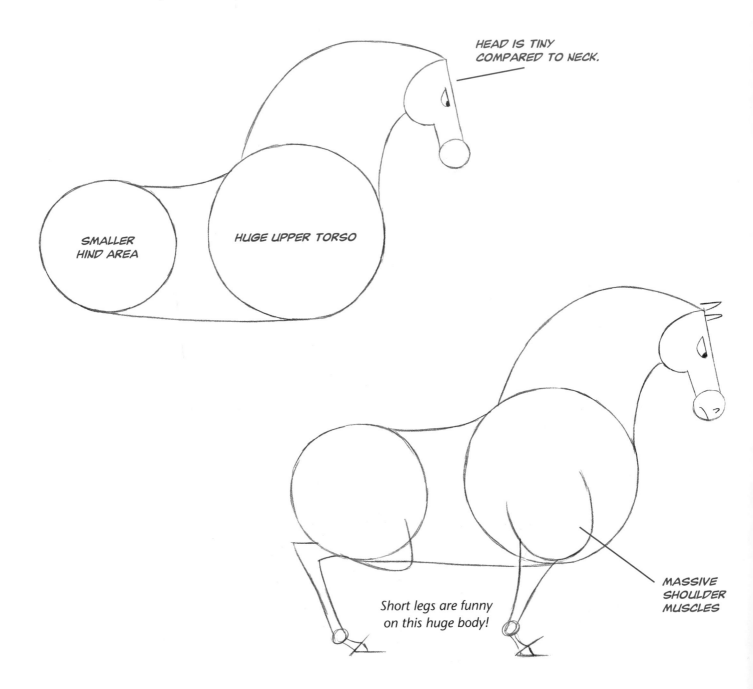

HEAD IS TINY COMPARED TO NECK.

SMALLER HIND AREA

HUGE UPPER TORSO

MASSIVE SHOULDER MUSCLES

Short legs are funny on this huge body!

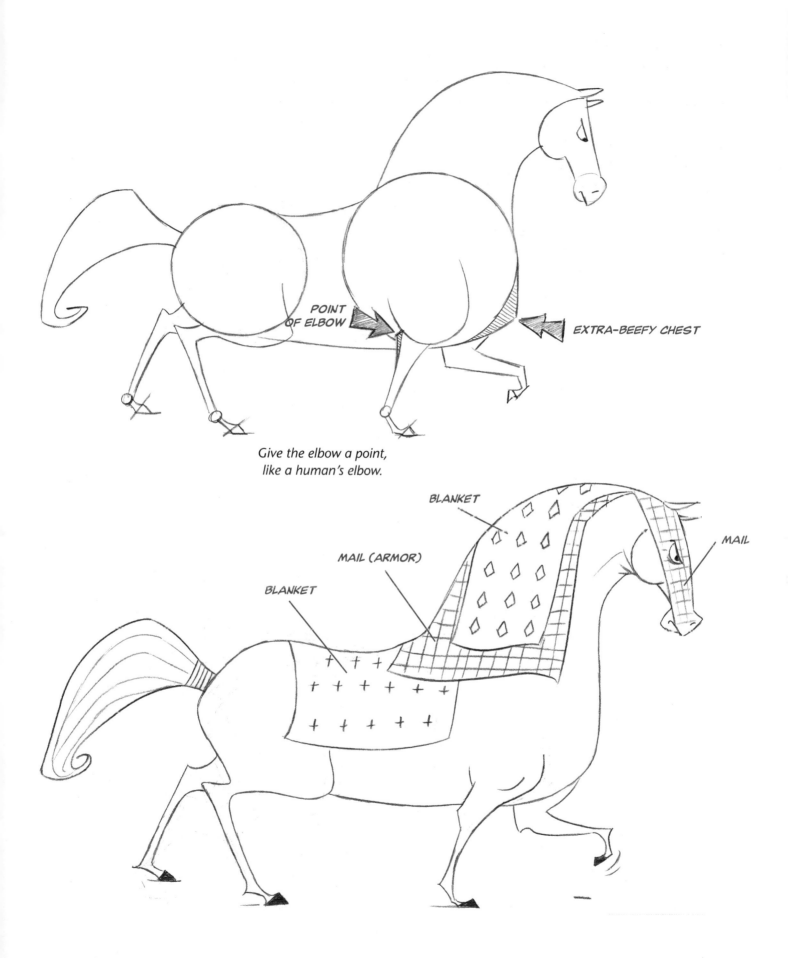

POINT
OF ELBOW

EXTRA-BEEFY CHEST

*Give the elbow a point,
like a human's elbow.*

BLANKET

MAIL (ARMOR)

BLANKET

MAIL

CLOTHES HORSES

In TV animation, the newest shows go to great lengths to push the boundaries in designing the looniest characters. One way to do that is to give animals improbable people costumes. The more random you make it, the funnier it becomes. If ever there was an animal that looks weird in people clothes, it's the horse. Which is exactly what makes it irresistible fodder for cartoonists.

Fashionista

Oh yeah, she's one fine-looking . . . um . . . horse? Notice how the costume in the final drawing "pops" because we alternate lots of black areas with white areas.

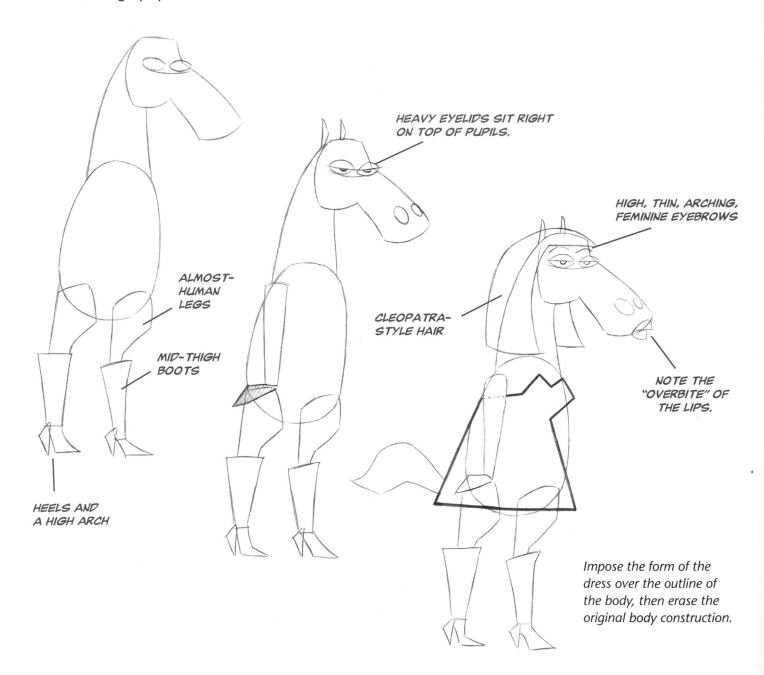

HEAVY EYELIDS SIT RIGHT ON TOP OF PUPILS.

HIGH, THIN, ARCHING, FEMININE EYEBROWS

ALMOST-HUMAN LEGS

CLEOPATRA-STYLE HAIR

MID-THIGH BOOTS

NOTE THE "OVERBITE" OF THE LIPS.

HEELS AND A HIGH ARCH

Impose the form of the dress over the outline of the body, then erase the original body construction.

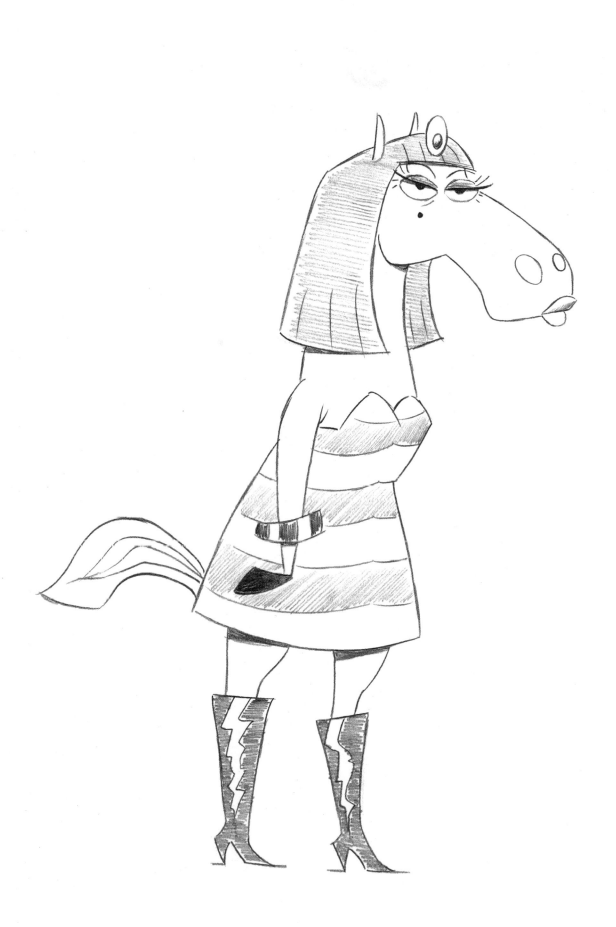

Secret Agent Horse

Someone stole a rare, billion-dollar bale of hay, and he's got to track it down before it gets into the wrong hooves. Dark glasses, trench coat, and a no-nonsense stare. He makes the perfect secret agent. Plus, he can sleep standing up.

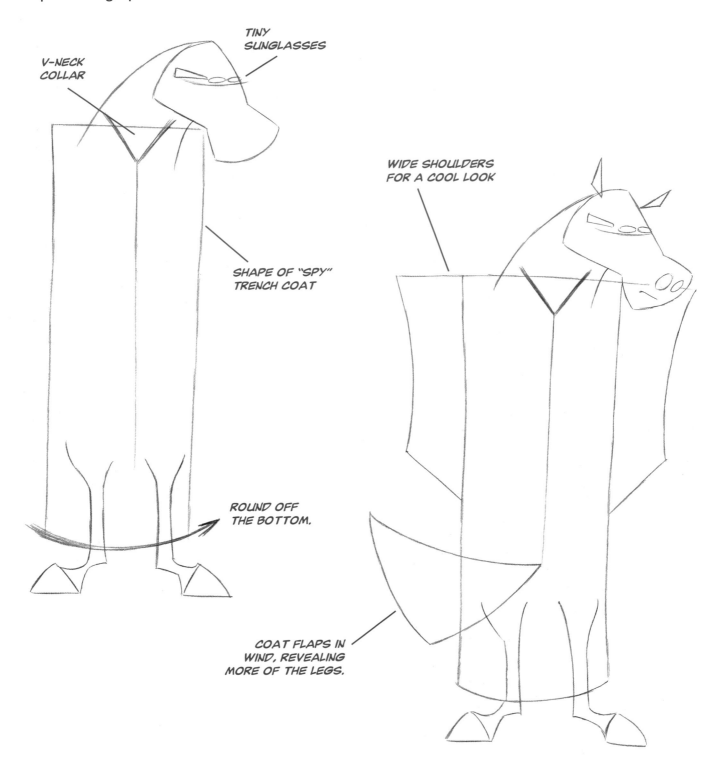

TINY
SUNGLASSES

V-NECK
COLLAR

WIDE SHOULDERS
FOR A COOL LOOK

SHAPE OF "SPY"
TRENCH COAT

ROUND OFF
THE BOTTOM.

COAT FLAPS IN
WIND, REVEALING
MORE OF THE LEGS.

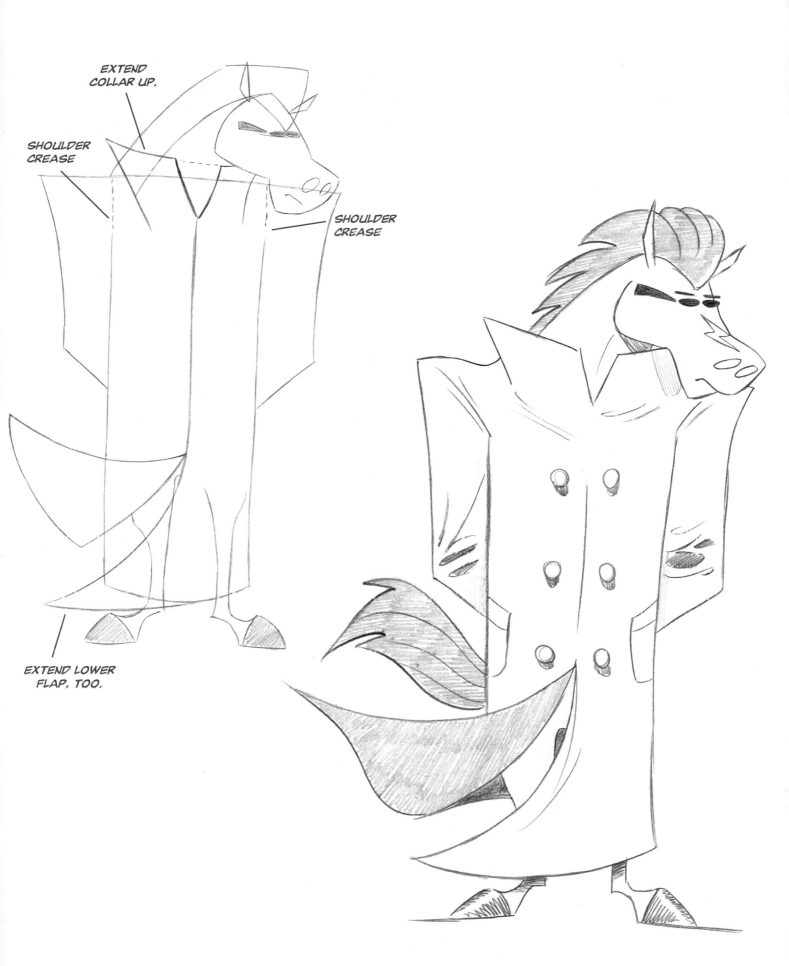

EXTEND
COLLAR UP.

SHOULDER
CREASE

SHOULDER
CREASE

EXTEND LOWER
FLAP, TOO.

FUNNY GALLOPS & TROTS

Horses are born to run. And cartoon horses are born to run *funny.* I've found that the most amusing way to show a horse in a hurry is in a "people pose," clenched fists and all. However, I still like to maintain the basic horse anatomy of the hind legs, which makes the animal look incredibly awkward when running upright on two legs.

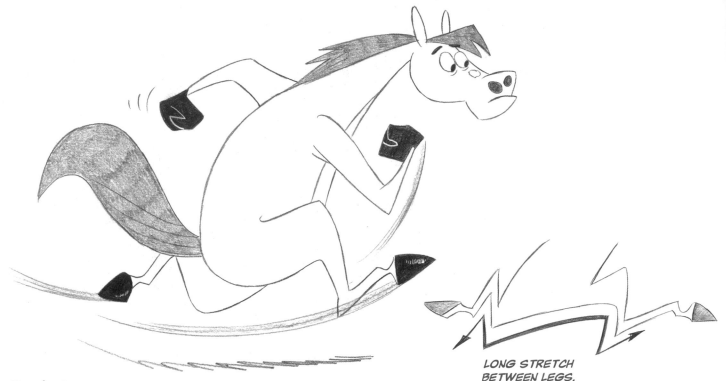

LONG STRETCH
BETWEEN LEGS.

Sprint
Really move the arms and have him lean forward, with the head leading the way! This is a funny "wrong run," in that the arm and leg on the same side are moving together. People actually run so that when the left arm is forward, the left leg is back, and so on, as I'm sure you know.

Long-Distance Runner
Draw this guy taking big, stretched-out strides with his arms held in close to the body, showing more self-control.

NOTE THE
BENT WRISTS.

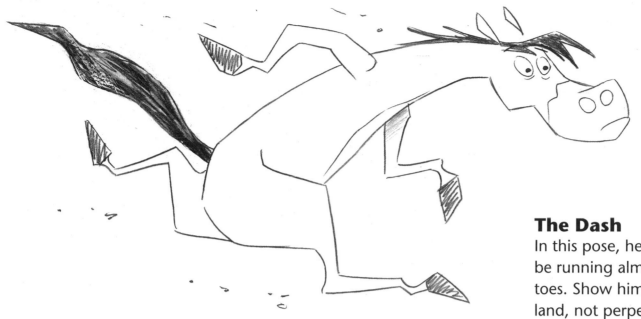

The Dash
In this pose, he should be running almost on his toes. Show him about to land, not perpetually airborne as in the sprint.

Tip-Toe Trot
Trying to make it out of the barn without waking up the guard dog. This motion is more vertical than horizontal.

LIONS: KINGS OF THE CARTOON JUNGLE

The male cartoon lion—the one with the mane—is usually goofier than the female version. And that's actually the way it is in the animal kingdom, too. The female is the hunter. The male is the couch potato. How'd the male get such a sweet setup? Some guys have all the luck. We'll draw both, with plenty of funny variations.

SIMPLE LION HEAD

The mane is an overpowering visual on the lion. But don't let that distract you. It doesn't have anything to do with the basic construction of the character. You shouldn't even draw the mane until you have the outline of the head in place.

Here's a friendly little lion. (The rounder a lion's head is, the friendlier the lion.) We'll base his head on an oval. Then we'll ruffle the fur on the edges of his face (as in cartoons of domestic house cats). The guidelines help with the placement of the eyes and muzzle.

Front View

In the front view, it adds more character—a little "punch"—to tug the chin in one direction or the other when the mouth opens in a broad smile.

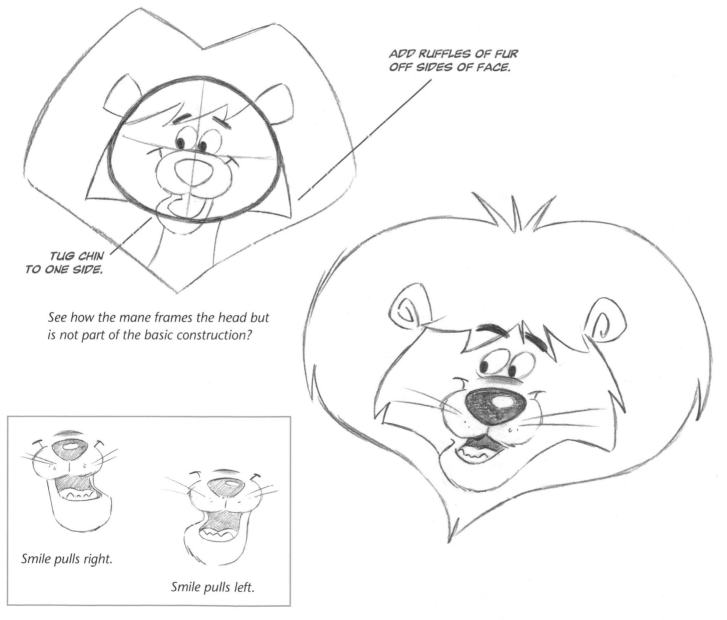

ADD RUFFLES OF FUR OFF SIDES OF FACE.

TUG CHIN TO ONE SIDE.

See how the mane frames the head but is not part of the basic construction?

Smile pulls right.

Smile pulls left.

Side View

As a rule, *a lion always has a hefty chin.* It juts out. To make it appear to do that, draw the line of the chin tilting back toward the mouth.

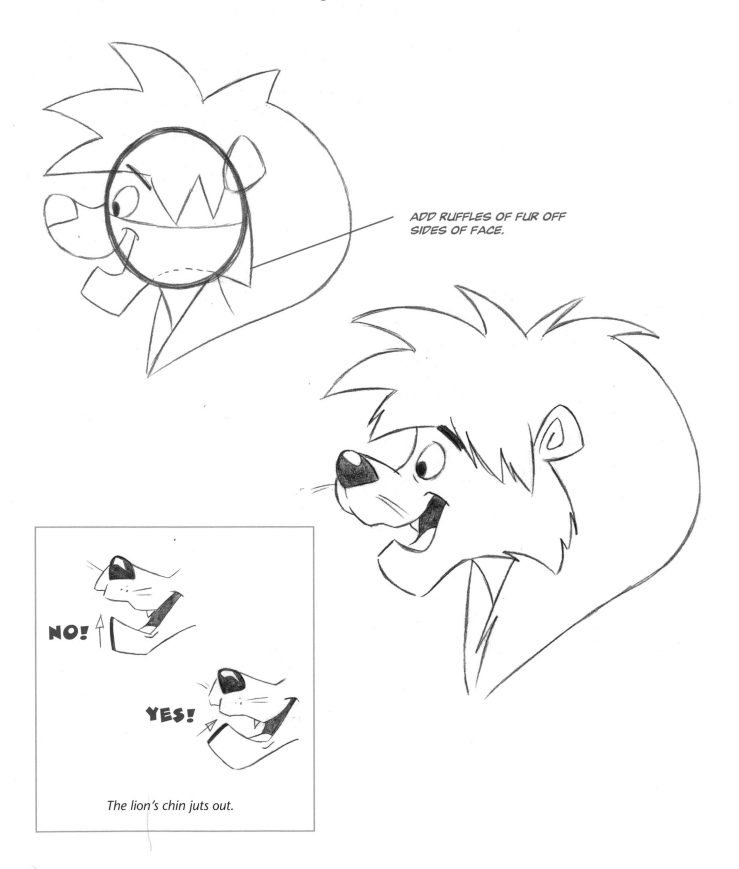

ADD RUFFLES OF FUR OFF SIDES OF FACE.

NO!

YES!

The lion's chin juts out.

ADULT LION HEAD

The older (more mature) the lion, the flatter its head will be. Maybe that's because we adults get stupider with age. At least, my kids tell me so. Be that as it may, when we flatten the head, we have to compensate for it somehow—and the natural way to do it is to widen out the face: *S-t-r-e-t-c-h* it! Let's go gradually, step-by-step, so you can see how we put all the elements together.

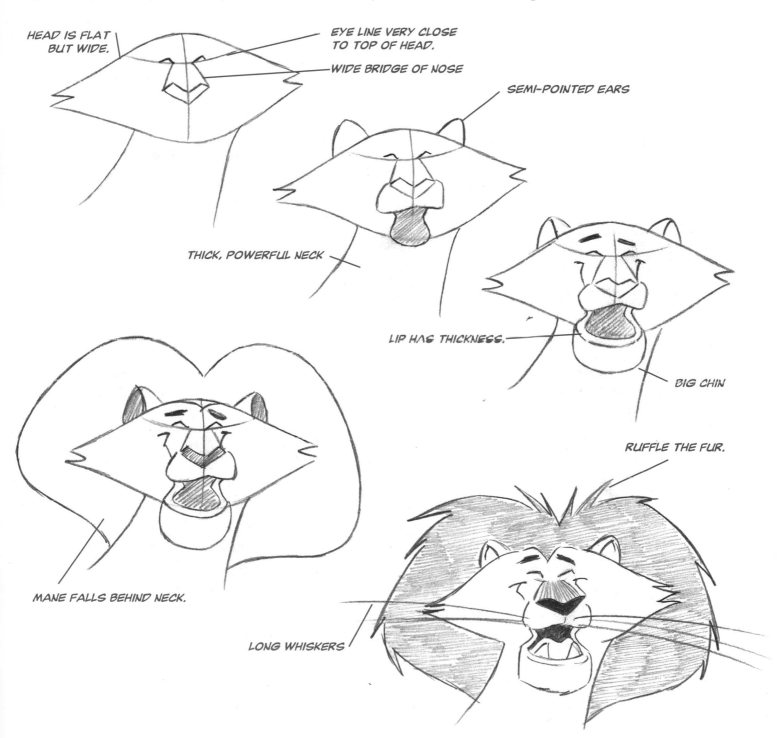

HEAD IS FLAT BUT WIDE.

EYE LINE VERY CLOSE TO TOP OF HEAD.

WIDE BRIDGE OF NOSE

SEMI-POINTED EARS

THICK, POWERFUL NECK

LIP HAS THICKNESS.

BIG CHIN

RUFFLE THE FUR.

MANE FALLS BEHIND NECK.

LONG WHISKERS

DON'T MESS WITH A LIONESS!

She is the original feminist. She hunts, defends, and nurtures the young. The only curious thing about her is why she keeps her good-for-nothing mate around. Well, some questions like these cross all species, I suppose . . .

The cartoon lioness is more than simply a male lion without his mane. The head is more angular, flatter on top, and with eyes that are more cunning. The chin also tends to be more pronounced. As for the body, it's certainly longer, and not so bottom heavy or top heavy.

Front View

When drawing the front view of the lioness, allow the muzzle and jaw to fall below the outline of the head.

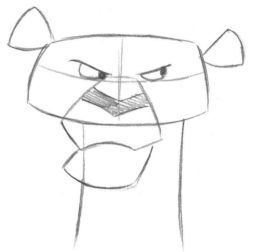

Start with a flat, blocky head shape. Something this simple is perfect. People ask me if I really start my drawings out like this or just show others to do it this way. I really start like this.

Place the eyes toward the top of the head to give the character a sinister look.

See how well the oversized chin works? Since we no longer have a mane to work with, the chin becomes the hallmark of the lioness. And always give her a thick neck.

Don't worry about making her look feminine, because she's a lioness. If you want her to look feminine, then you can draw a specific type of lioness (coming up later).

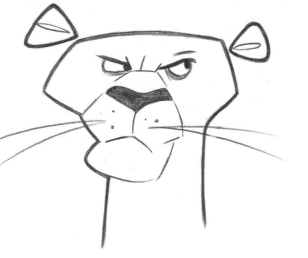

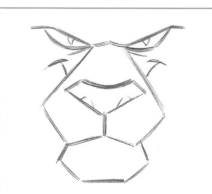

Notice the angles that make up the bridge of the nose, the muzzle, and the chin.

Side View

The side view is really a matter of setting up a few basic shapes and then, once in place, massaging them. You can do this.

Start with—nope, not a circle . . .

Yes, an oval. Usually, ovals have more character than circles. Although we sometimes do use circles, mostly for retro characters, we often use them as almost a satire on the form. More about that later . . .

The oval becomes the "squashed" skull shape. Add a vertical (up and down) oval for the muzzle, cut off the top along the line of the muzzle, and connect it to the skull with two lines. Now, that's pretty simple. But that's all it takes for the basic shape to be locked into place.

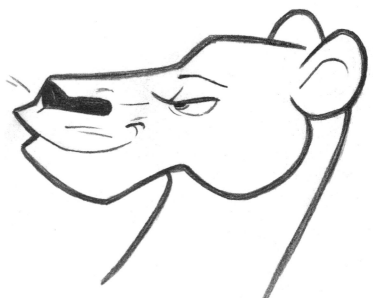

Angle the chin forward and square it out. Add a large jaw muscle—the same way you would on a horse. Give the upper lip an overbite. These are the types of finishing touches that turn basic shapes into a finished character.

LION YOUNGSTER

With his bushy head of hair, bright eyes, and round face, this 'tweenager is eager to get a start on the day. That is, until a wildebeest gives him a stern look, which sends him running for cover!

Look at the body construction I've set up. I can just hear what you're thinking: "Why should I draw all that stuff when it'll be covered by the mane anyway?" If you don't at least roughly sketch out the body first, you're gonna end up sticking the legs on the bottom of the lion's head—and it won't look right. But by roughing out the body first you can be confident that your placement will be correct.

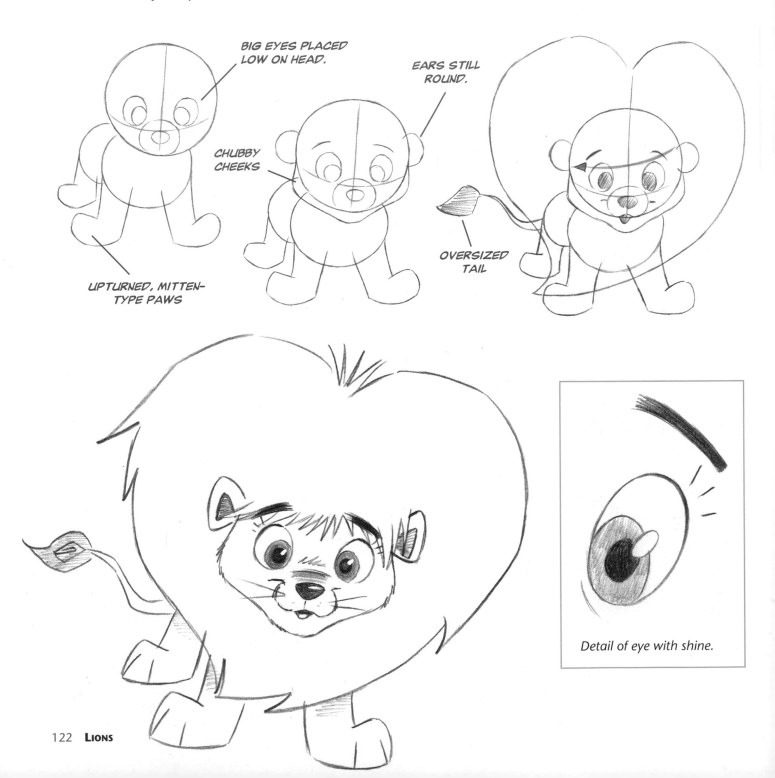

BIG EYES PLACED LOW ON HEAD.

CHUBBY CHEEKS

EARS STILL ROUND.

OVERSIZED TAIL

UPTURNED, MITTEN-TYPE PAWS

Detail of eye with shine.

LAID-BACK LION

He'd rather hang out than hunt. "Nothing that a good snooze won't cure," is his motto. Good thing that his brother is the leader of the pride. Isn't there a guy like this in every family? To draw the "schnook" character, give him a backward-leaning posture, bent at the knees, with a small chest and a belly pooched out from one too many onion rings.

Note that his eyes are covered by his mane. This is a fun convention in cartoons. Many famous cartoon characters have had their eyes covered by hair and hats, and it's always a goofy look.

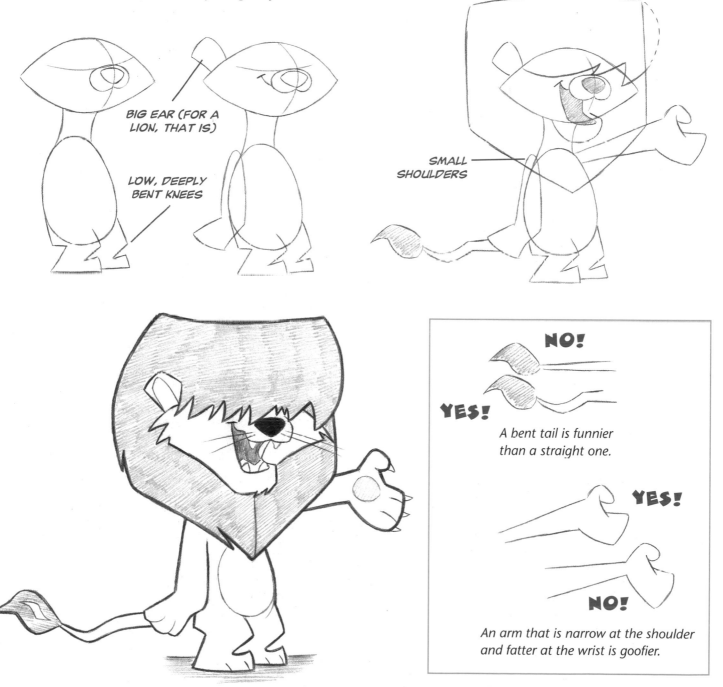

BIG EAR (FOR A LION, THAT IS)

LOW, DEEPLY BENT KNEES

SMALL SHOULDERS

NO!

YES!

A bent tail is funnier than a straight one.

YES!

NO!

An arm that is narrow at the shoulder and fatter at the wrist is goofier.

HE'S LARGE & IN CHARGE

Don't go messing with this cat. He doesn't answer to "Here, kitty, kitty." That V-shaped torso, the kind you see on caped action figures, also works on the king of beasts. He's built like a cartoon version of a bodybuilder, but with a bushy tail and a really ugly head. Well, there may be a few human bodybuilders with uglier heads, but that's another story . . .

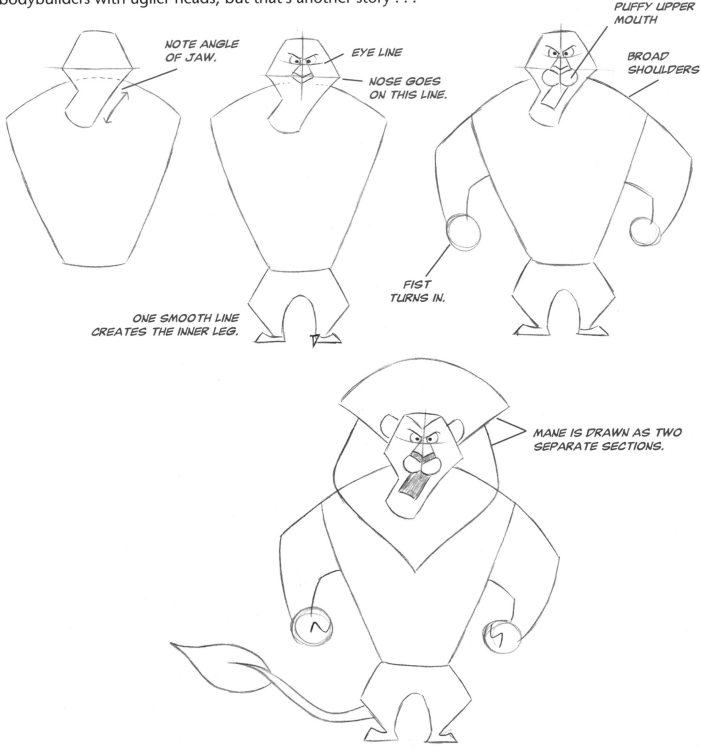

NOTE ANGLE OF JAW.

EYE LINE

NOSE GOES ON THIS LINE.

ONE SMOOTH LINE CREATES THE INNER LEG.

FIST TURNS IN.

PUFFY UPPER MOUTH

BROAD SHOULDERS

MANE IS DRAWN AS TWO SEPARATE SECTIONS.

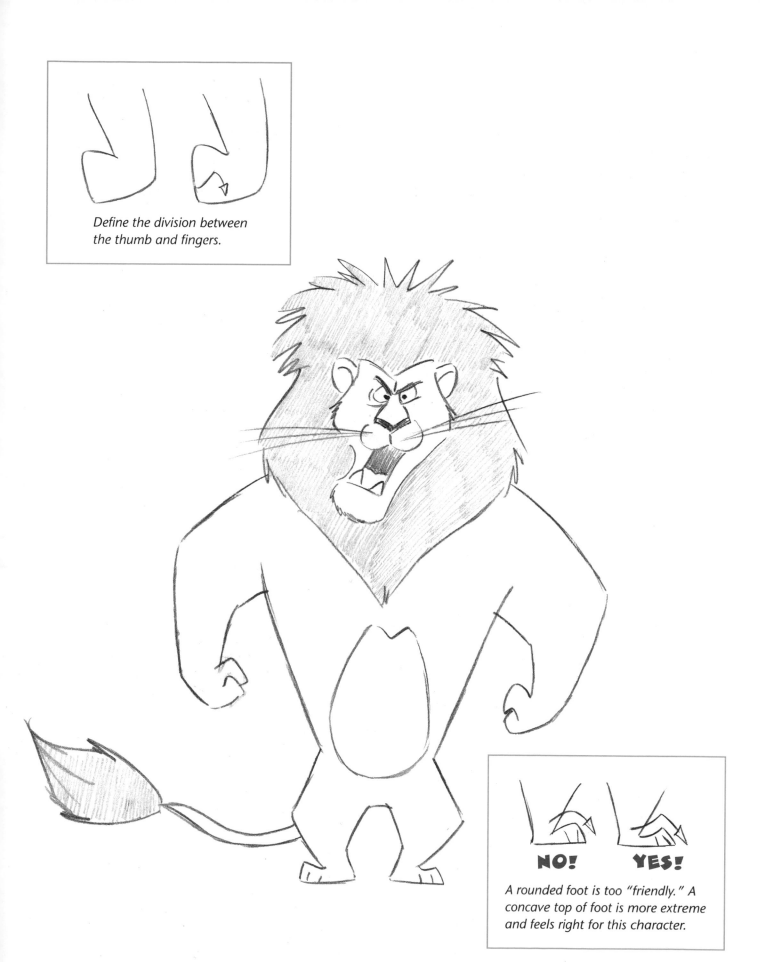

Define the division between the thumb and fingers.

NO! **YES!**

A rounded foot is too "friendly." A concave top of foot is more extreme and feels right for this character.

ANGRY LION EXPRESSIONS

The lion packs a one-two punch when he's supremely irritated. First, he growls. Then he roars. Either expression lets the reader know that this kitty is not a happy camper.

The Growl
The growl is done with the teeth clenched, but the upper lip raised, showing off those razor-sharp choppers.

GRRRR!

RRRROAR!

The Roar
When he roars, the lion opens his mouth wide, squinting his eyes hard, so that they close tight.

Clueless Lion

Here's another technique cartoonists use to create humorous characters: They design a personality that is the complete *opposite* of what the subject matter would suggest. In other words, you'd expect a lion to be brave, focused, and intimidating. So we'll turn it around and make this guy nervous, confused, and timid. A real squeeze-toy of a predator! No sharp teeth—no teeth at all, in fact. No claws and hardly any chest. And a skinny neck, to boot, which is a clear sign of a modest character, with no authority. You won't hear a roar out of this guy, only, "Yes, dear!"

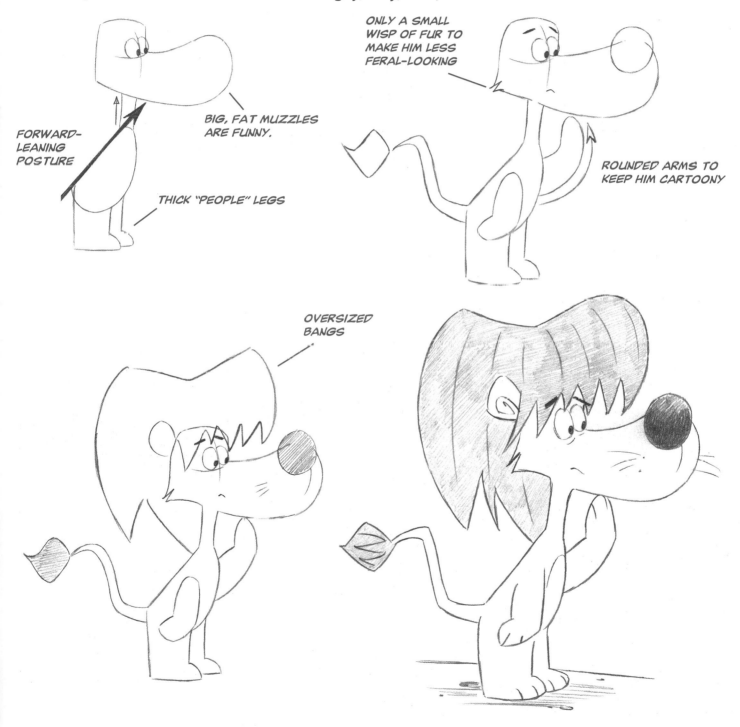

ONLY A SMALL WISP OF FUR TO MAKE HIM LESS FERAL-LOOKING

FORWARD-LEANING POSTURE

BIG, FAT MUZZLES ARE FUNNY.

THICK "PEOPLE" LEGS

ROUNDED ARMS TO KEEP HIM CARTOONY

OVERSIZED BANGS

BIG FAT BUDDY

This cartoon character type is popular as a fun-loving, protective, but not-too-bright pal. He comes in all animal types—as well as human cartoon characters. He's got a lot of weight to throw around, so he's not a pushover. But he's had a few too many cheeseburgers. And fries. And pickles. Shakes. Doughnuts. And antacids.

You don't have to draw the mane the same way each time. In fact, it's best to caricature it to make it as unique as the personality of the character itself. For this lion, I've created large, repeated bumps, which indicate ruffles of hair. It's a very *cartoony* look, which suits this ***very cartoony*** character.

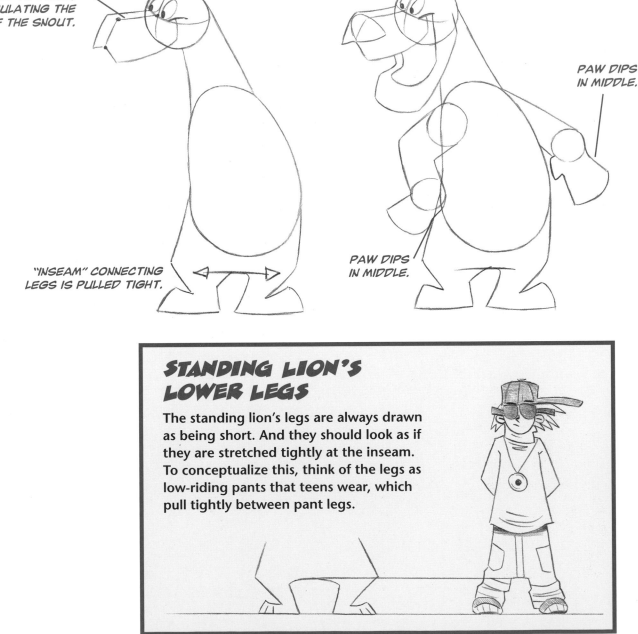

THE CENTER LINE GOES FROM POINT TO POINT, ARTICULATING THE CONTOUR OF THE SNOUT.

"INSEAM" CONNECTING LEGS IS PULLED TIGHT.

PAW DIPS IN MIDDLE.

PAW DIPS IN MIDDLE.

STANDING LION'S LOWER LEGS

The standing lion's legs are always drawn as being short. And they should look as if they are stretched tightly at the inseam. To conceptualize this, think of the legs as low-riding pants that teens wear, which pull tightly between pant legs.

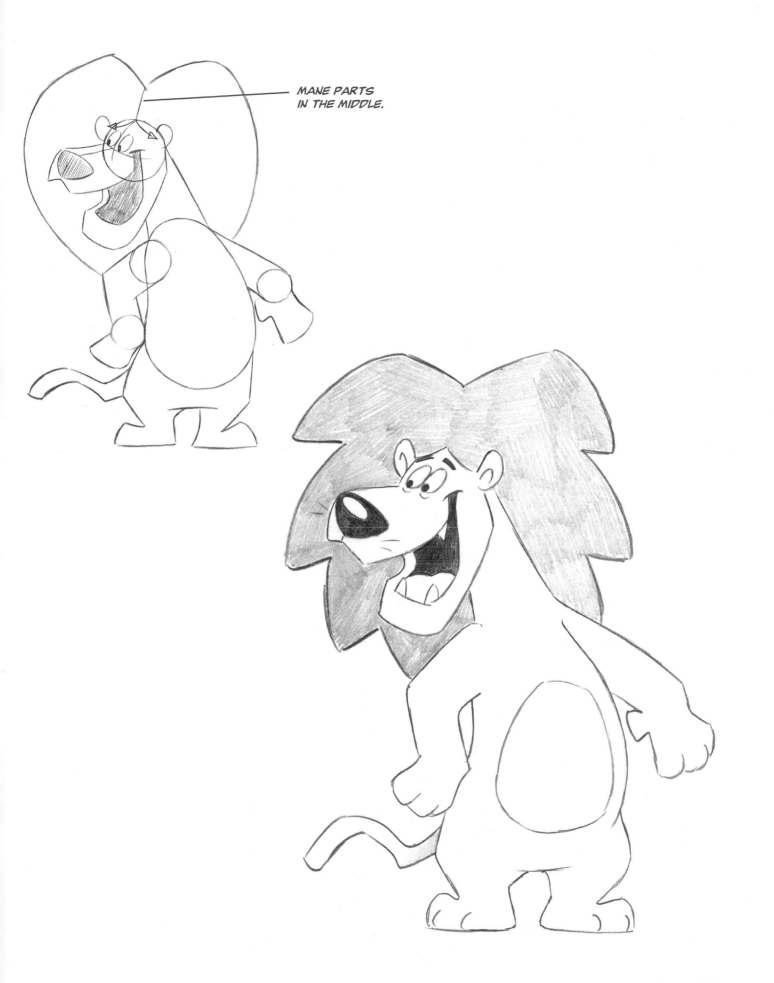

MANE PARTS
IN THE MIDDLE.

SUPER-TALL LION

This guy looks really tall because:

- We've made his legs small in comparison to the rest of his body.
- We've *s-t-r-e-t-c-h-e-d* out his body **and** made it curve, as if it is so long that he can't stand straight but has to bend and sway.
- He has to tilt his head down to look at anybody, because everyone else is shorter than he is.
- His tail is very close to the ground, which underscores the distance between the top of the lion and the bottom.

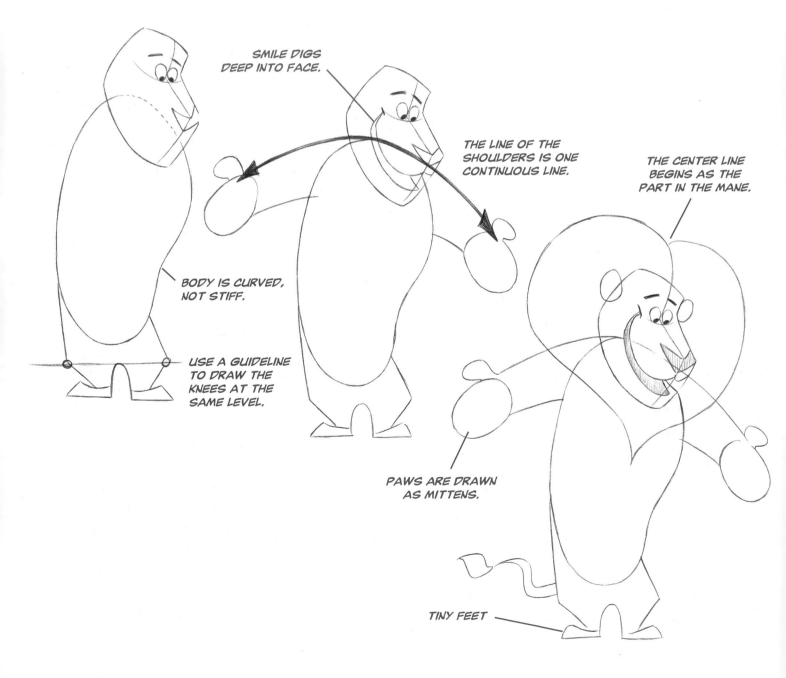

SMILE DIGS DEEP INTO FACE.

THE LINE OF THE SHOULDERS IS ONE CONTINUOUS LINE.

THE CENTER LINE BEGINS AS THE PART IN THE MANE.

BODY IS CURVED, NOT STIFF.

USE A GUIDELINE TO DRAW THE KNEES AT THE SAME LEVEL.

PAWS ARE DRAWN AS MITTENS.

TINY FEET

All of these elements reinforce the impression that this is a big fella. So remember—and this is important— it is **not enough** to draw a character big on the page. That's because it's all relative. You see, you could draw a short character but fill the page with it, or you could draw a tall character but make him really small on the page. Therefore, it's the **proportions** that make the character look small or tall, not how large you draw him on a piece of paper.

SITTING LION

In the seated, front view, a lion's body takes on the shape of a *teardrop.* It's true! Compare the shape of the baby's teardrops, below, to the shape of the lion's body. (And pray that you aren't seated behind this kid on a cross-country flight.)

This is a particularly easy pose to draw. A few simple steps and you'll have mastered it. Pencils out. Paper ready. Back straight. Don't slouch. If it's cold, wear a hat. Er, sorry. Early training . . .

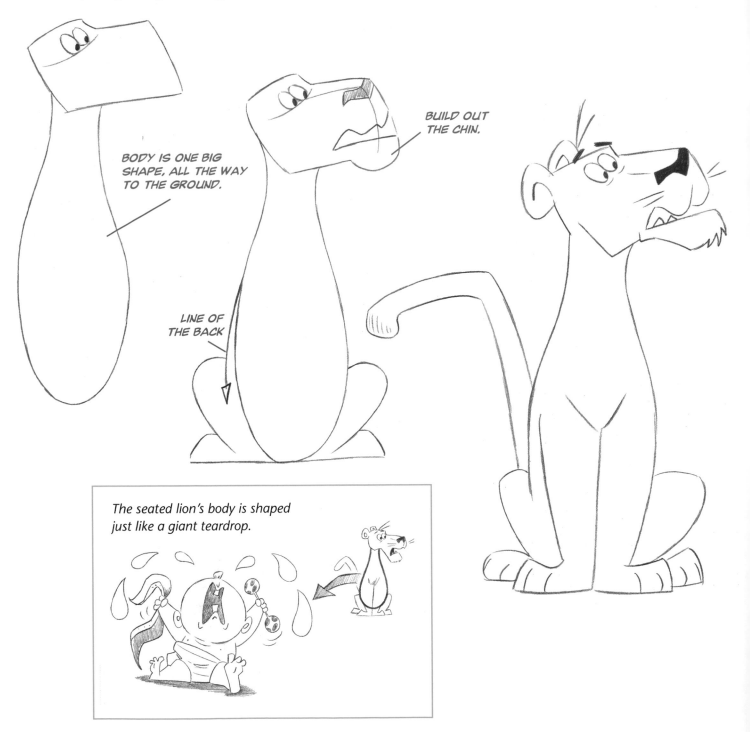

BODY IS ONE BIG SHAPE, ALL THE WAY TO THE GROUND.

BUILD OUT THE CHIN.

LINE OF THE BACK

The seated lion's body is shaped just like a giant teardrop.

STANDING ON FOUR FEET (HOW WEIRD IS THAT?)

The lion is one of the easiest characters to draw on all fours. It has no hooves, and, unlike the dog, its legs are thick and its paws are as floppy as mittens—so you don't have to be as specific in showing the joint configurations. (Do I hear any complaints from the audience . . . ?) We'll also simplify the bones, even eliminating some of them in the legs, to make them cartoonier. This simplified version is a good middle ground between how a real lion stands and a totally cartooned-out version.

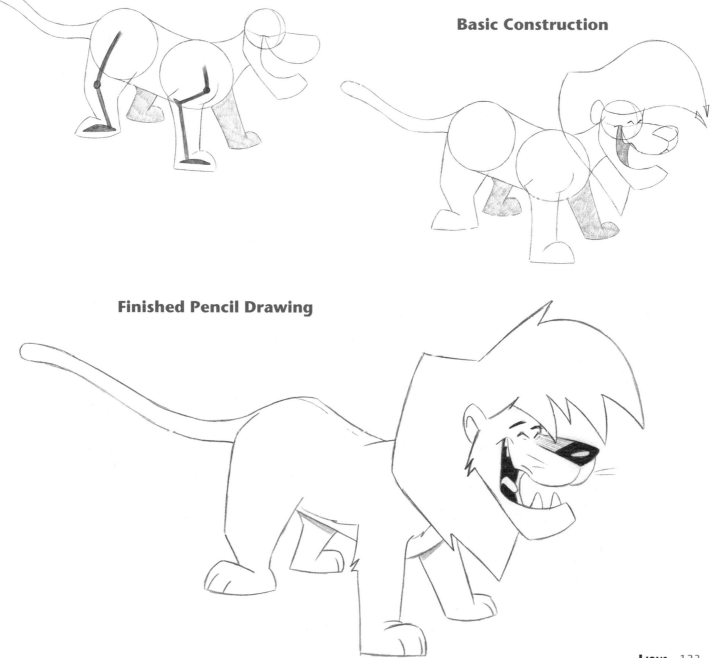

Simplified Cartoon "Bones"

Basic Construction

Finished Pencil Drawing

PUDGY-WUDGY LION—ON ALL FOURS

No one has to tell this guy to finish everything on his plate! In this version, we're giving the lion lots of "pudge" factor all around. Especially on the shoulders and haunches—really puffing them out. To make the character seem all the more chubby, taper the arms and legs down to itsy-bitsy feet, with round, little toes that are well defined.

To make him seem more belly-heavy, really sag the lower back and allow the belly to hover just above the ground. Mmmm, that must have been a delicious—and *slow*—gazelle.

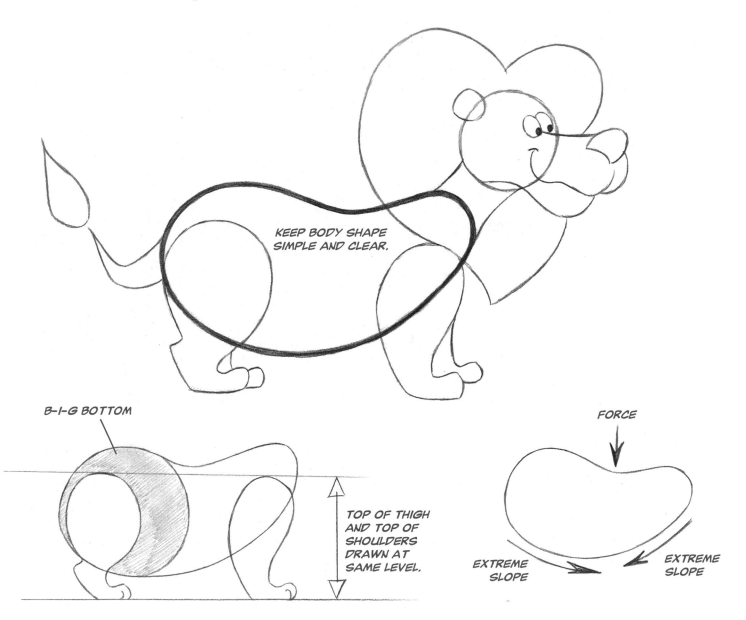

KEEP BODY SHAPE SIMPLE AND CLEAR.

B-I-G BOTTOM

TOP OF THIGH AND TOP OF SHOULDERS DRAWN AT SAME LEVEL.

FORCE

EXTREME SLOPE

EXTREME SLOPE

THE CORRECT WAY TO DRAW THE LION'S MOUTH

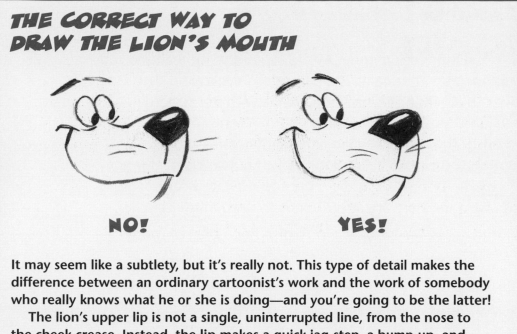

NO! YES!

It may seem like a subtlety, but it's really not. This type of detail makes the difference between an ordinary cartoonist's work and the work of somebody who really knows what he or she is doing—and you're going to be the latter!

The lion's upper lip is not a single, uninterrupted line, from the nose to the cheek crease. Instead, the lip makes a quick jag-step, a bump-up, and then continues its natural flow, into whatever expression it happens to be.

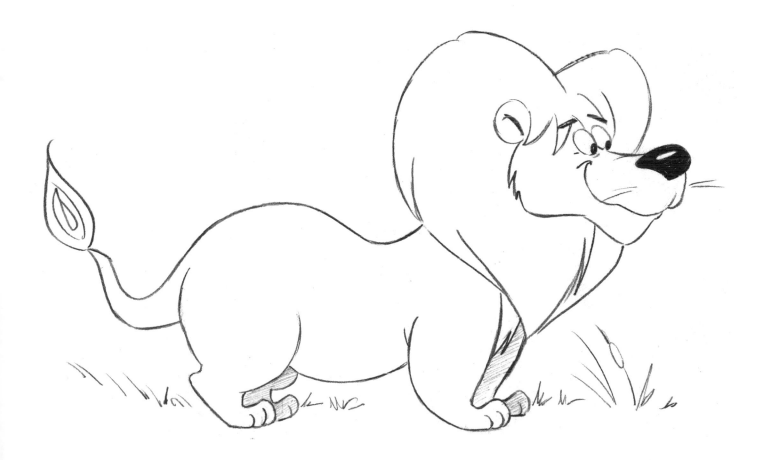

ALOOF LIONESS

Here's a picture of a lioness "talking" to someone. As the top of the food chain, you can see that she holds everyone else in disdain. The half-closed eyelid and the tugged-back mouth give her that "country club" impatience with her subordinates.

Sometimes, I think it's valuable to take a drawing through a series of steps with you, because I think you'll enjoy the result. You'll gain confidence, with the abundance of steps, and know you can do it, because it's laid out so clearly for you. And because it's so clear, we can attempt a slightly more sophisticated cartoon character. So let's give this one a try. Here are a few things to keep in mind:

- Since this character is slightly more realistic, we won't give her a big, cartoony nose area.
- See how far down the mouth dips? That's a sure sign of contempt.
- Connect the chin to the jaw with a graceful line.
- The thick neck practically swallows half of the skull's surface area. This makes the character exude strength.

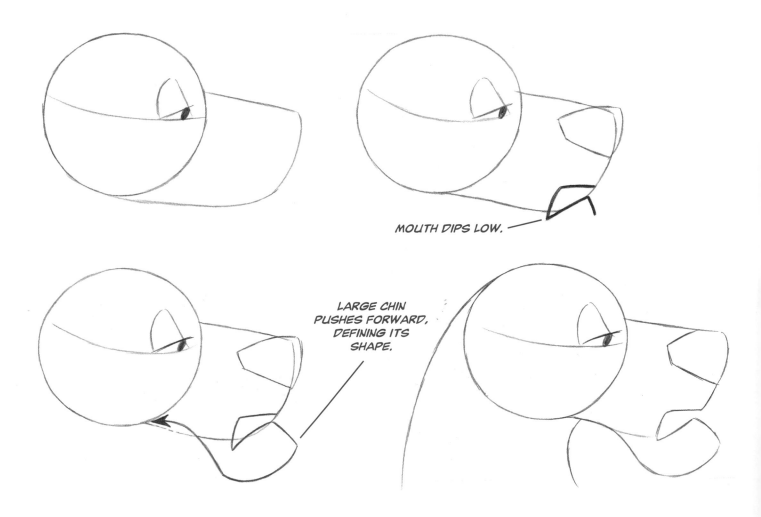

MOUTH DIPS LOW.

LARGE CHIN PUSHES FORWARD, DEFINING ITS SHAPE.

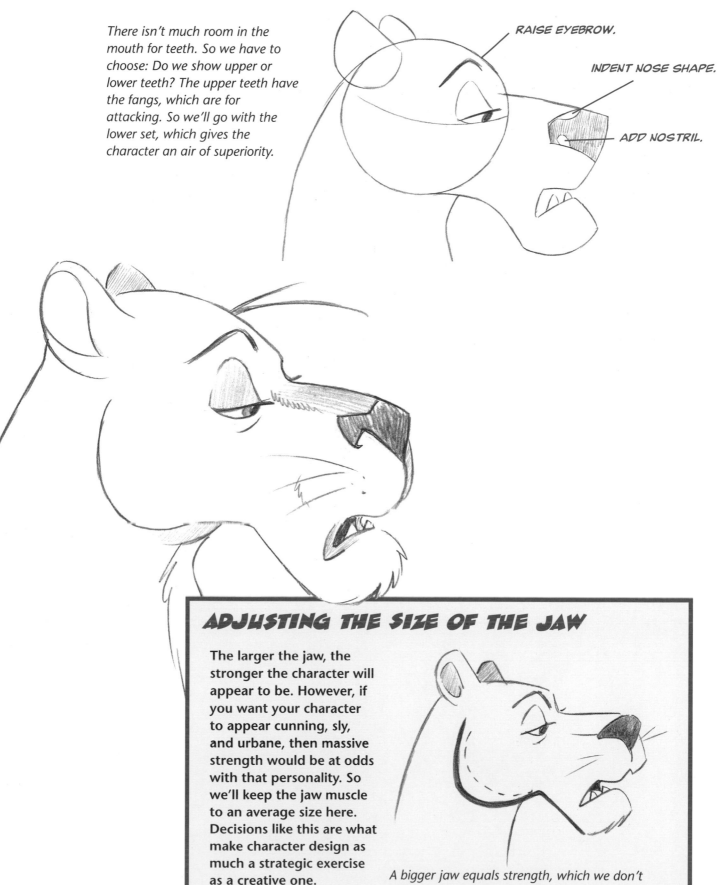

There isn't much room in the mouth for teeth. So we have to choose: Do we show upper or lower teeth? The upper teeth have the fangs, which are for attacking. So we'll go with the lower set, which gives the character an air of superiority.

RAISE EYEBROW.

INDENT NOSE SHAPE.

ADD NOSTRIL.

ADJUSTING THE SIZE OF THE JAW

The larger the jaw, the stronger the character will appear to be. However, if you want your character to appear cunning, sly, and urbane, then massive strength would be at odds with that personality. So we'll keep the jaw muscle to an average size here. Decisions like this are what make character design as much a strategic exercise as a creative one.

A bigger jaw equals strength, which we don't want in this case.

LADYLIKE LIONESS

A lioness is a female lion, and sometimes we want to show just that—that she's got a feminine side. A cartoon version can be pretty, flirtatious, with female charms. Because there is no domestication of the lion species, as there is with dogs, cats, and horses, you can't put a flower or ribbon in her hair to connote femininity. So it has to come from somewhere else. Take a look.

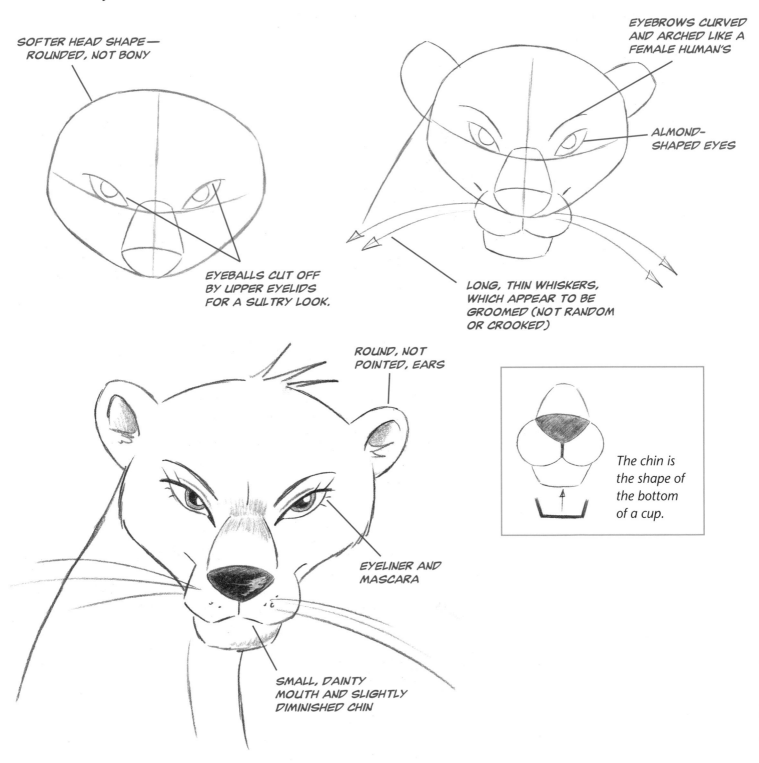

SOFTER HEAD SHAPE—
ROUNDED, NOT BONY

EYEBALLS CUT OFF
BY UPPER EYELIDS
FOR A SULTRY LOOK.

EYEBROWS CURVED
AND ARCHED LIKE A
FEMALE HUMAN'S

ALMOND-
SHAPED EYES

LONG, THIN WHISKERS,
WHICH APPEAR TO BE
GROOMED (NOT RANDOM
OR CROOKED)

ROUND, NOT
POINTED, EARS

EYELINER AND
MASCARA

SMALL, DAINTY
MOUTH AND SLIGHTLY
DIMINISHED CHIN

The chin is the shape of the bottom of a cup.

THE HUNTER

Here's a good example of a lion with bad intentions. Why do I call this a lion and not a lioness? Because when a lion looks this mean and nasty, we stop thinking of its gender. It's simply a cool lion character. I actually prefer drawing the lioness, even when femininity is not an issue. I simply find the character design more appealing. And by the way, you can turn the lioness into a panther merely by darkening her black and making her slightly thinner (slinkier).

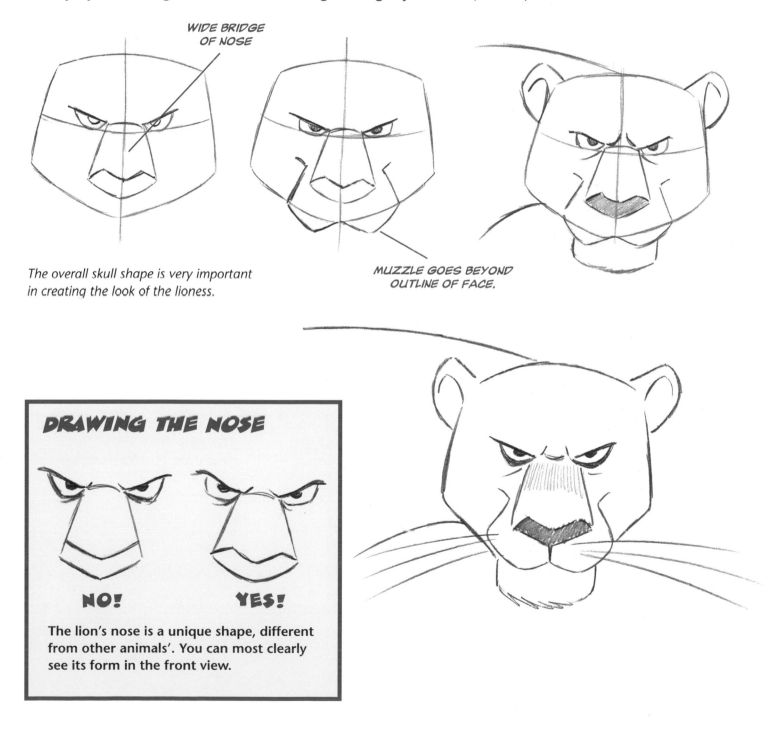

WIDE BRIDGE OF NOSE

The overall skull shape is very important in creating the look of the lioness.

MUZZLE GOES BEYOND OUTLINE OF FACE.

DRAWING THE NOSE

NO! **YES!**

The lion's nose is a unique shape, different from other animals'. You can most clearly see its form in the front view.

HYPERACTIVE LIONESS

We usually think of lions as sluggish daytime creatures, lolling around and napping in the afternoon sun. And this is exactly why cartoonists find it irresistible to break the mold! Here's a big game cat who is so enthusiastic about her next big idea that she's annoying the heck out of the pride, which just wants to sleep! Her new project? Wildebeest jerky!

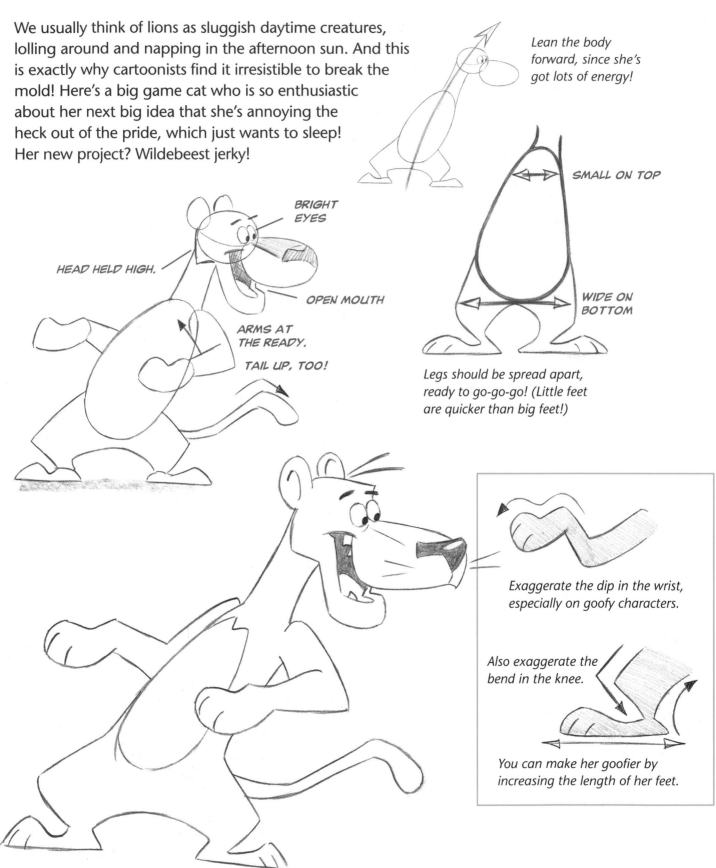

Lean the body forward, since she's got lots of energy!

BRIGHT EYES

HEAD HELD HIGH.

OPEN MOUTH

ARMS AT THE READY.

TAIL UP, TOO!

SMALL ON TOP

WIDE ON BOTTOM

Legs should be spread apart, ready to go-go-go! (Little feet are quicker than big feet!)

Exaggerate the dip in the wrist, especially on goofy characters.

Also exaggerate the bend in the knee.

You can make her goofier by increasing the length of her feet.

RETREATING LION

Here's an interesting pose you can add to your repertoire, and one you may not find in any other cartooning book: a four-legged character that is spooked or scared and is backing up. The expression helps to set the stage, of course, but it's the posture that really conveys what's going on in the scene. And for the character to look spooked, she has to look as if she is moving *backward*.

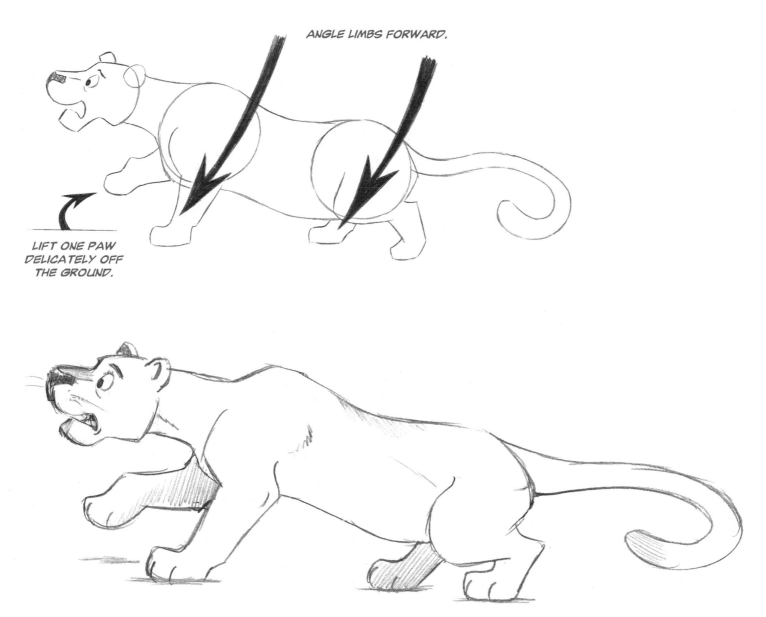

ANGLE LIMBS FORWARD.

LIFT ONE PAW DELICATELY OFF THE GROUND.

The chest should be higher than the rump. If the chest is low to the ground, the lion will appear to be stalking prey.

TIGERS: HOW CARTOONISTS EARN THEIR STRIPES

Tigers—just lions with stripes, right? Yeah, kinda, sorta. **Not!** Okay, maybe close, but we still have to make a few minor adjustments. I'll give you all the goods, so not to worry. And tigers are lots of fun to draw. You almost can't miss when cartooning tigers, because of their markings. They're more extreme than lions. You can go crazier with them, really push the boundaries, and they'll still look like tigers. Who doesn't like that?

THE TIGER'S HEAD

More than the male lion's or lioness's, the tiger's head shape resembles that of the cartoon house cat—with wide, pointed cheeks and a very low forehead. However, the giant bucket chin makes the tiger a unique cartoon construction.

Front View
The front view is the goofiest pose in which to draw tigers.

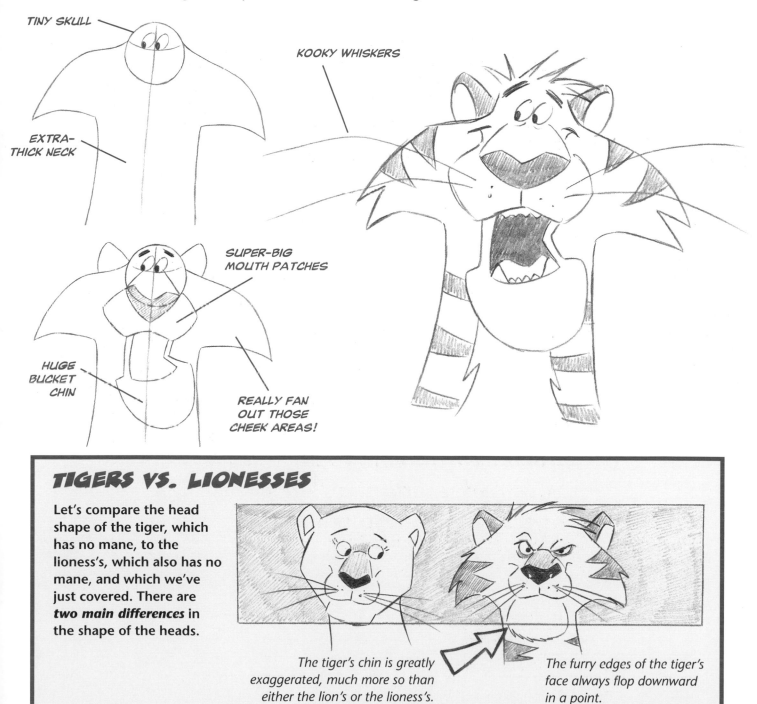

TINY SKULL

KOOKY WHISKERS

EXTRA-THICK NECK

SUPER-BIG MOUTH PATCHES

HUGE BUCKET CHIN

REALLY FAN OUT THOSE CHEEK AREAS!

TIGERS VS. LIONESSES

Let's compare the head shape of the tiger, which has no mane, to the lioness's, which also has no mane, and which we've just covered. There are **two main differences** in the shape of the heads.

The tiger's chin is greatly exaggerated, much more so than either the lion's or the lioness's.

The furry edges of the tiger's face always flop downward in a point.

Side View (Villain Tiger)

Tigers have very low foreheads. There's only a small shift as the line changes from the bridge of the nose to the forehead. This gives the character a mean, crafty look.

In the side view, look to make the upper and bottom lips slope inward and meet in the middle. This puts the accent on the protruding chin. Keep the "eye line" on the same level as the nose. It looks good to draw a small, sinister eye deep in the head, as if it were wedged tightly in there.

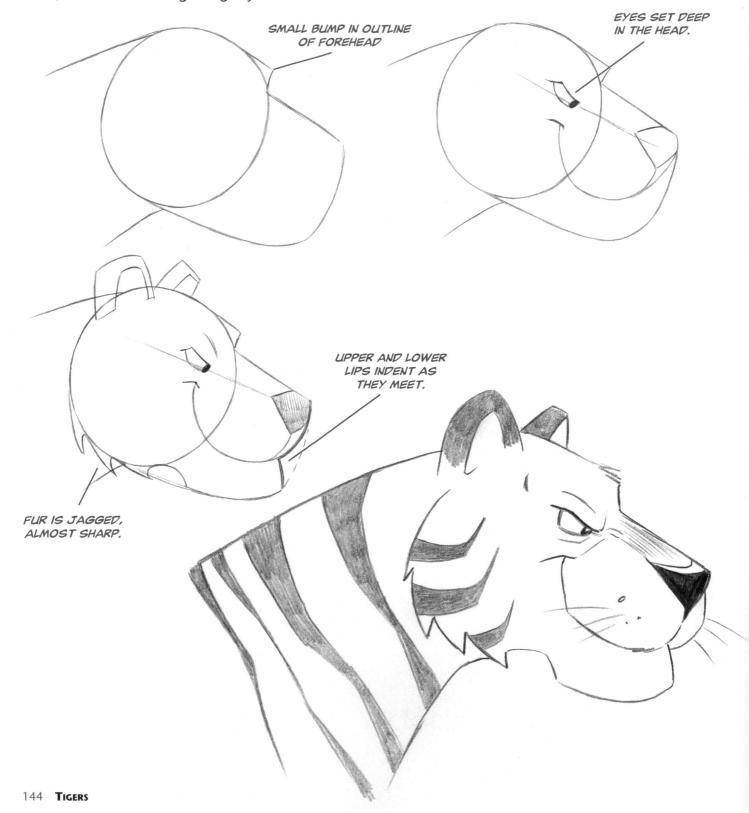

SMALL BUMP IN OUTLINE OF FOREHEAD

EYES SET DEEP IN THE HEAD.

UPPER AND LOWER LIPS INDENT AS THEY MEET.

FUR IS JAGGED, ALMOST SHARP.

Cute Little Tiger Cub

Young tigers are real cuties. Give them big, round heads, round ears, and skinny necks. The nose should be small, or they won't look cute.

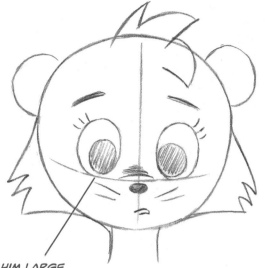

Whiskers on young tigers are always short and brush upward for an almost perky look.

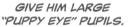

GIVE HIM LARGE "PUPPY EYE" PUPILS.

Young tigers, even boys, have small eyelashes that feather upward. Keyword: small!

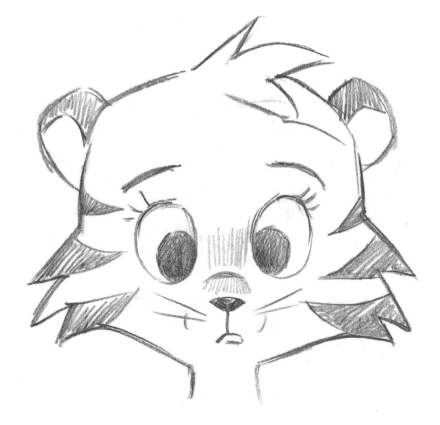

CLASSIC TIGER POSE: STALKING PREY

When a tiger stalks its prey, it severely bends its forelegs and hind legs to bring its body *close to the ground,* to stay below the top of the tall grass, which serves as cover from which it will pounce. This results in a particularly long, slinky pose, with a fluid *line of action,* as is demonstrated by the long arrow, which mirrors the line of its spine. The head and neck always stay *low* in this pose and *never* rise above shoulder level.

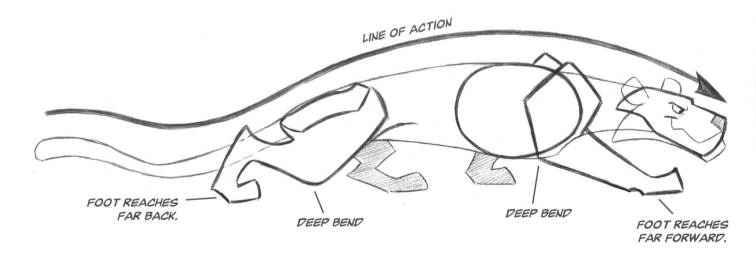

LINE OF ACTION

FOOT REACHES FAR BACK.

DEEP BEND

DEEP BEND

FOOT REACHES FAR FORWARD.

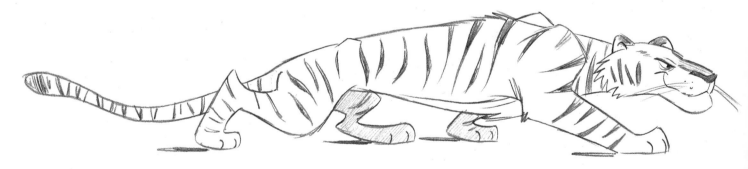

SAMURAI TIGER

This grandmaster sword fighter is surprisingly easy to draw, because he's really just a simple combination of a tiger's head on top of a human cartoon body, and the head is a snap, because it can be simplified into one basic shape. So let's step-by-step this guy into submission. Ready, my fellow cartoon warriors?

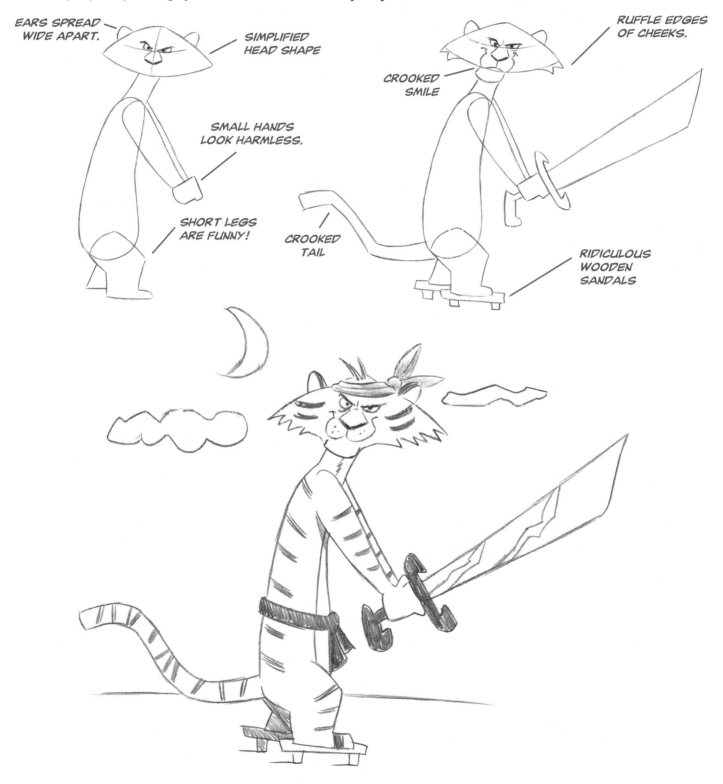

EARS SPREAD WIDE APART.

SIMPLIFIED HEAD SHAPE

SMALL HANDS LOOK HARMLESS.

SHORT LEGS ARE FUNNY!

CROOKED TAIL

RUFFLE EDGES OF CHEEKS.

CROOKED SMILE

RIDICULOUS WOODEN SANDALS

LOVESICK TIGER

What is love? All through the ages, it has defied a clear explanation by great poets and writers. But we cartoonists know exactly what it is: that feeling that makes you go all noodly in the legs. End of story. Want something more complicated? Go take a course from somebody who wears tweed.

Take it from me, my definition works, at least if you want to draw cartoons. Look at the ga-ga eyes on this tiger, that stupid "I'll get hit by a truck if I cross the street feeling this good" grin. And how the heck did he get up in that tree anyhow? More important, how's he going to get down? To you and me, those are important questions. But to him—who cares? He's in love!

It's best to draw through the face to get the correct placement of arms as they cross, or it could get tricky.

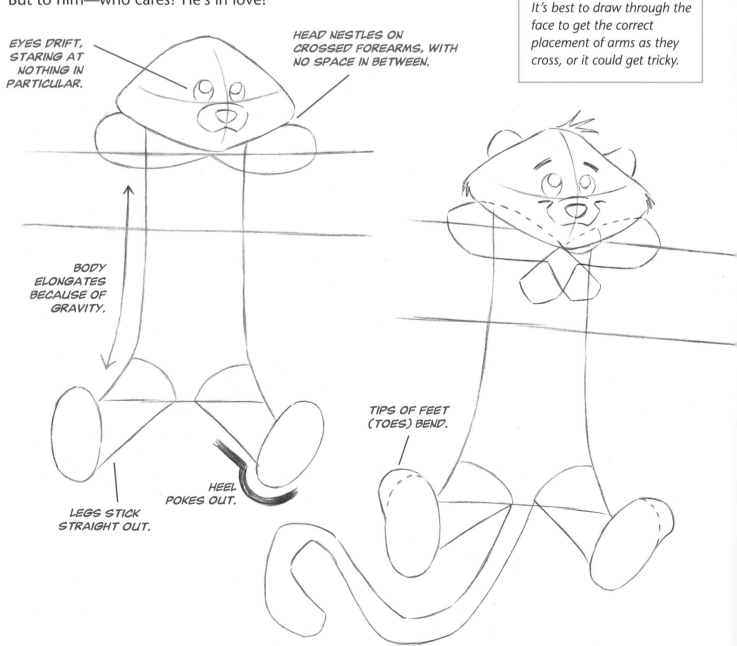

EYES DRIFT, STARING AT NOTHING IN PARTICULAR.

HEAD NESTLES ON CROSSED FOREARMS, WITH NO SPACE IN BETWEEN.

BODY ELONGATES BECAUSE OF GRAVITY.

LEGS STICK STRAIGHT OUT.

HEEL POKES OUT.

TIPS OF FEET (TOES) BEND.

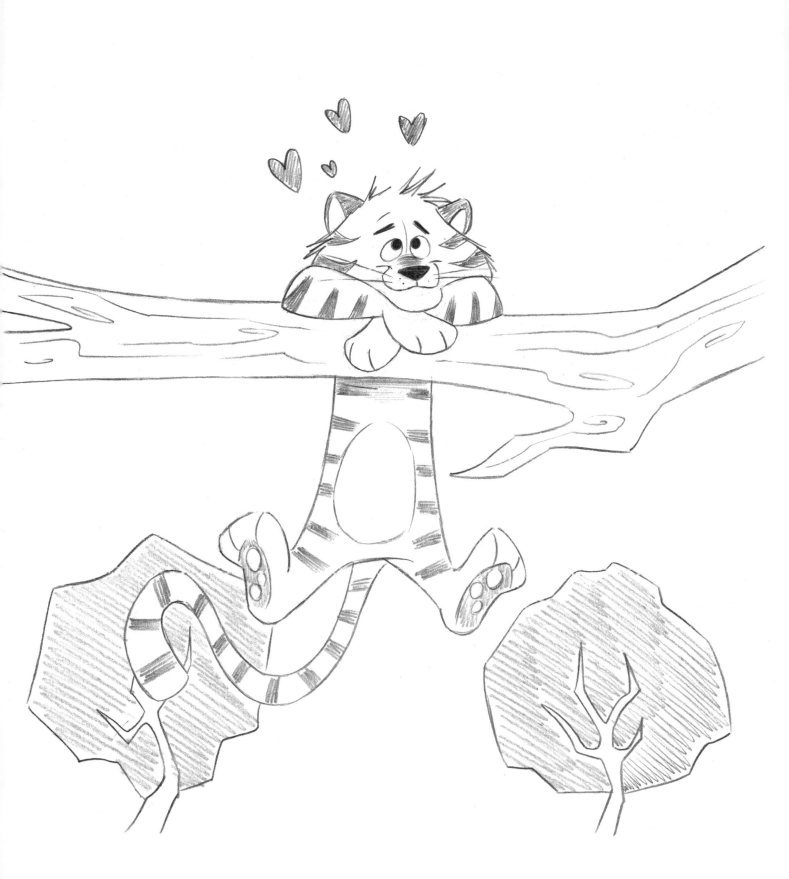

Hearts popping, hearts pounding. Oh boy, let's hope that she's not off somewhere with another tiger with nicer-looking stripes!

ELEPHANTS: THE WORLD'S BIGGEST TRUNK SHOW

Now we go from predators to pachyderms! I've always loved to draw elephants. When you combine 10,000 pounds, two tusks, and a 7-foot-long muscle for a nose, it tends to shake things up a bit. Even a lion gets out of the way when one of these guys walks by. But before you assume that they throw their weight around at will, be advised that cartoon elephants have personalities that run the gamut. They are everything from affable, to intimidating, to charming, to silly, to shy, to even babyish. The only type of character I have never seen portrayed by a cartoon elephant is a nervous-wreck type. But maybe you'll be the one to invent it!

SIMPLE ELEPHANT

A simple oval is all that's needed to create the body for this elephant. You don't even need to refine it. Draw the oval and you're done with the body. How easy is that?

 The legs shoot straight down from the body, like pipes, with big, fat pads at the ends for feet. Remember to add the guidelines on the head. Where the guidelines intersect, or cross, is where the trunk begins. We treat the trunk just like the bridge of the nose on the other animals we've been drawing.

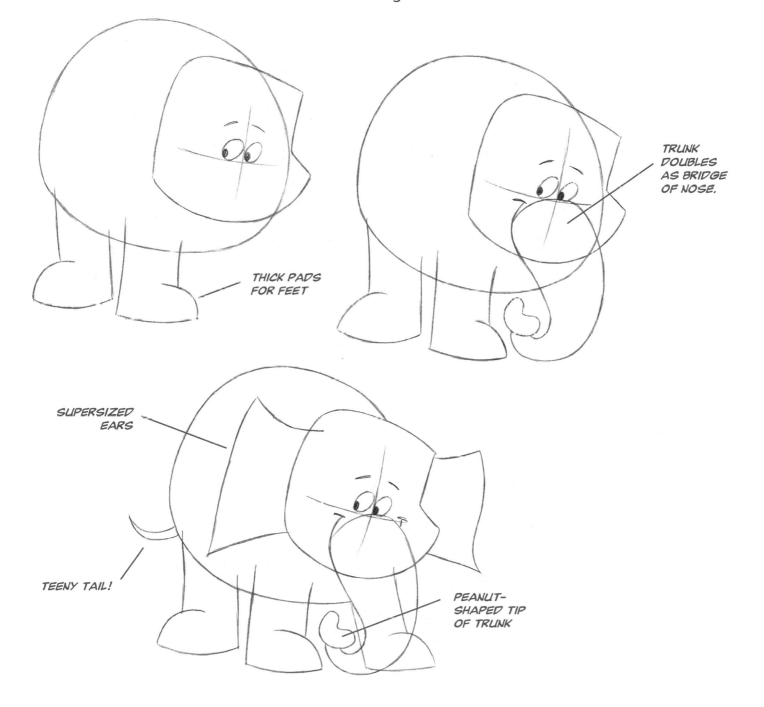

THICK PADS FOR FEET

TRUNK DOUBLES AS BRIDGE OF NOSE.

SUPERSIZED EARS

TEENY TAIL!

PEANUT-SHAPED TIP OF TRUNK

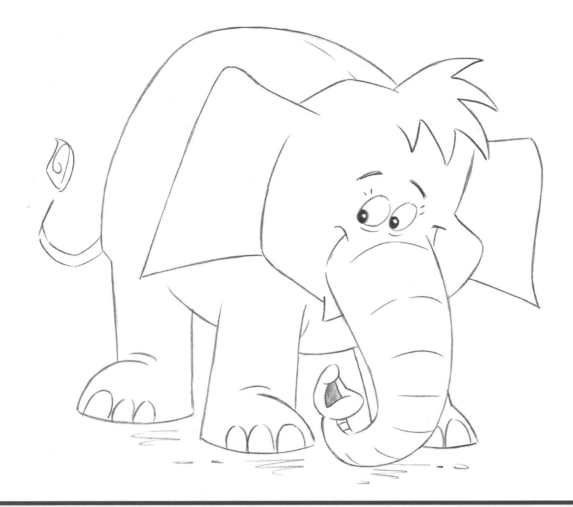

COMPARING THE ELEPHANT'S HEAD TO A PRETEEN'S

When we create an animal to look like a preteen, we can actually go so far as to use the outline of a human preteen's head as the model for the elephant's head, too. Of course, the elephant's head will be bigger, but the shapes are nearly identical. Compare the two shapes and you'll see why it works.

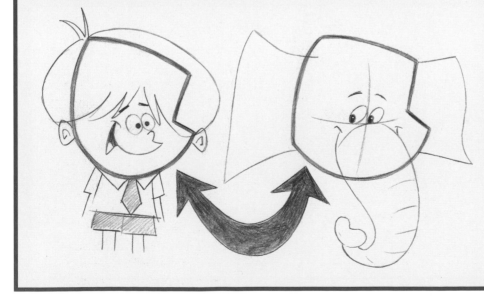

Similarities

Forehead is bigger than lower half of head.

Protruding cheek is pointy and exaggerated.

Small mouth.

Tiny eyes in middle of face.

Differences

Boy has small ears.

Elephant has big ears.

Top of boy's head is rounded (hair creates the rounded look).

Top of elephant's head is flat.

The elephant has a trunk!

DRAWING THE TRUNK

The trunk starts out wide and gets narrower as it lengthens, but never comes to a point. It's always thick and rubbery.

Front View

In the front view, the trunk obscures the mouth, so that you can't see it. If you feel that you need to show the mouth in the front view, you can tug the mouth to one side. Another alternative is to swing the trunk to the side, revealing the mouth. But if you draw expressive eyes, the mouth usually isn't missed. And as you can see, this cute little guy isn't lacking in personality.

BIG ROUND FOREHEADS ARE CUTE.

BIG EARS ARE ENDEARING ON YOUNGSTERS.

ELEPHANTS DON'T HAVE NECKS!

MAKE YOUNG ELEPHANTS SLIGHTLY KNOCK-KNEED.

NO! YES!

*DON'T draw straight lines across the trunk. They will make it look stiff and lifeless. DO draw **curved** lines, which make the trunk look **round**.*

Side View

The trunk begins at the level of the eyes, as the bridge of the nose, then *protrudes outward from the face, before drooping down.* It doesn't fall down right away. You can see this more clearly in the side view than in the front view.

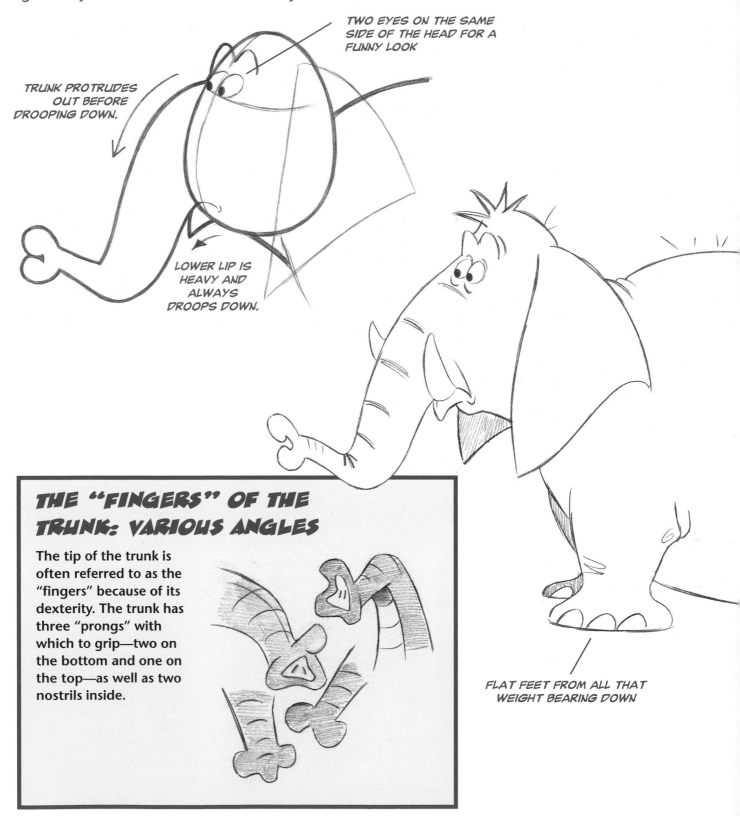

TWO EYES ON THE SAME SIDE OF THE HEAD FOR A FUNNY LOOK

TRUNK PROTRUDES OUT BEFORE DROOPING DOWN.

LOWER LIP IS HEAVY AND ALWAYS DROOPS DOWN.

FLAT FEET FROM ALL THAT WEIGHT BEARING DOWN

THE "FINGERS" OF THE TRUNK: VARIOUS ANGLES

The tip of the trunk is often referred to as the "fingers" because of its dexterity. The trunk has three "prongs" with which to grip—two on the bottom and one on the top—as well as two nostrils inside.

DRAWING ELEPHANT EARS

Elephant ears can be drawn in many silly styles. But when you draw *large* elephant ears, it's important to follow a few basic principles. Try to draw the bottom line of the ears as if it were one single line that goes through the head and connects both ears. This will create a pleasing arch. You can do the same thing with the tops of the ears; however, the tops of the ears often go off in different directions. This method will help you align the ears so that they stay level with one another.

I often shade the interior of the ears to set them off, visually, from the other parts.

ELEPHANT ODDS & ENDS

Adding a flourish here and a touch there adds up to a cool style. By giving a "retro" look to the elephant's hands and feet, for example, you bring a fresh perspective to the character. The cartoon elephant is one animal that suffers from an abundance of ordinary types in the media. Here are a few methods to create an edgier look.

Elephant "Hands"

Notice the funny "nails," which are squeezed together, with no space in between.

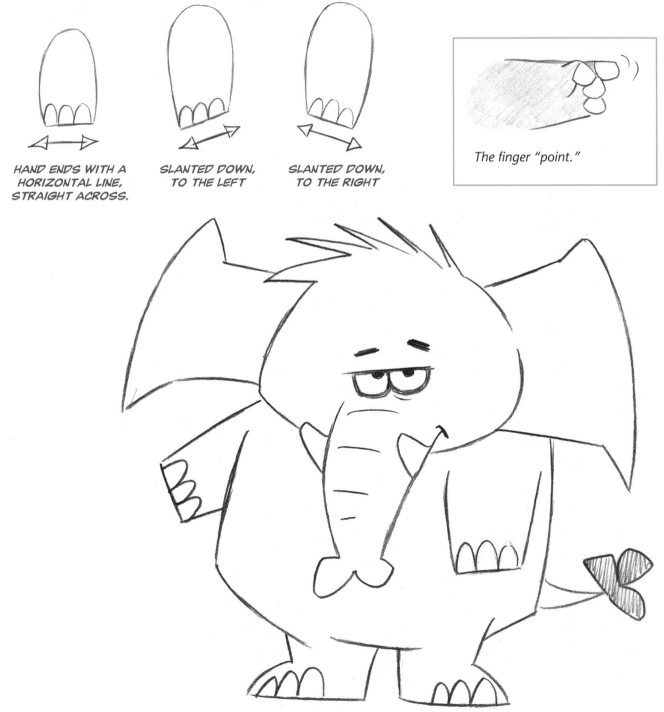

HAND ENDS WITH A
HORIZONTAL LINE,
STRAIGHT ACROSS.

SLANTED DOWN,
TO THE LEFT

SLANTED DOWN,
TO THE RIGHT

The finger "point."

Elephant Legs & Feet

The pads extend past the "nails"
on either side of the foot.

Knee wrinkle variations.

*Lines of the leg are **parallel**.*

*Left line of leg slants in;
right line is vertical.*

*Left line of leg is vertical;
right line slants out.*

Types of Tails

Elephants are funniest when you stylize the details.
Even the tail can be "cartooned" to give it a silly look.

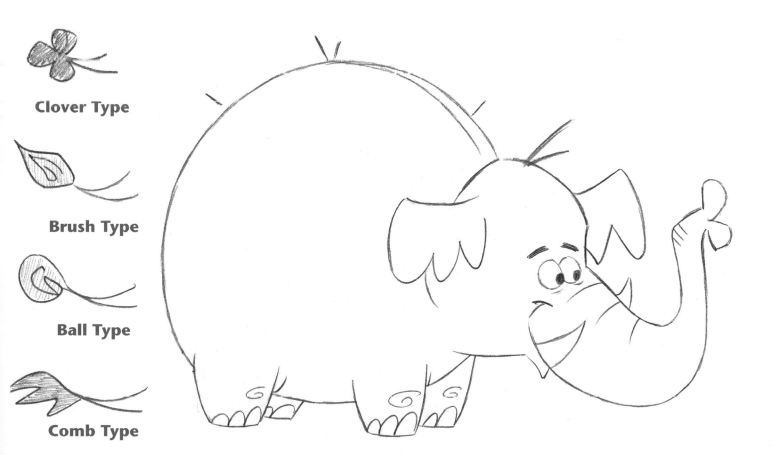

Clover Type

Brush Type

Ball Type

Comb Type

STANDING ELEPHANT: ANGLES OF THE BODY

Here's an elephant that is all trunk. Look at him! There's hardly any face on his face. That honker is taking up all the room. There are subtle angles built into the outline of the head and body that give the character its unique look. This is a somewhat challenging character design. That's why I've added the visual hints to the second step. That's the "refining stage," where you have to be sure to emphasize those angles.

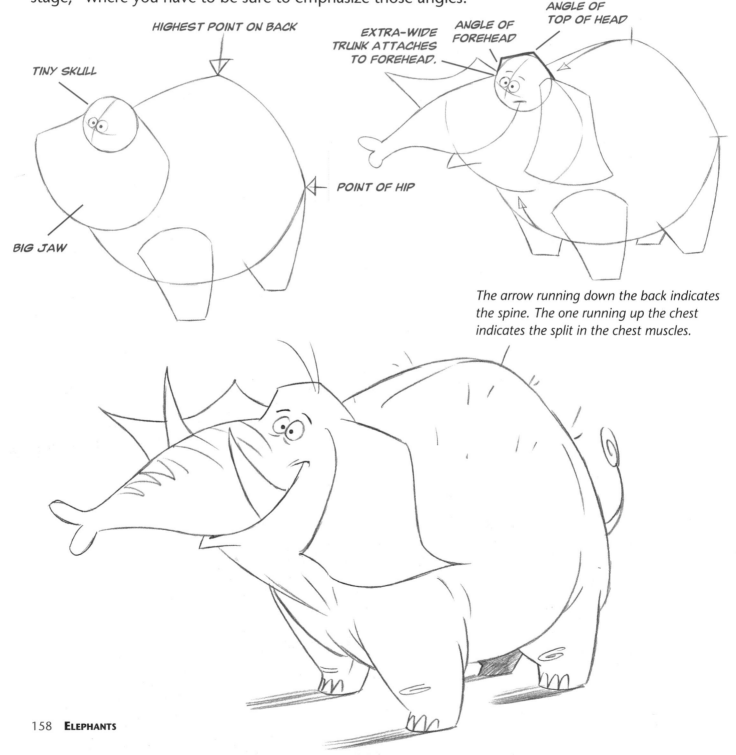

HIGHEST POINT ON BACK

TINY SKULL

BIG JAW

POINT OF HIP

EXTRA-WIDE TRUNK ATTACHES TO FOREHEAD.

ANGLE OF FOREHEAD

ANGLE OF TOP OF HEAD

The arrow running down the back indicates the spine. The one running up the chest indicates the split in the chest muscles.

BABY ELEPHANT

I usually don't draw the head of a character as a perfect circle. But in this case, the head is *sooo* round, it almost makes fun of itself! This baby elephant is totally helpless. The only thing that works is his trunk, which is still strong and powerful. The slightly crossed eyes give him the look of a toddler who has crawled into a few too many walls.

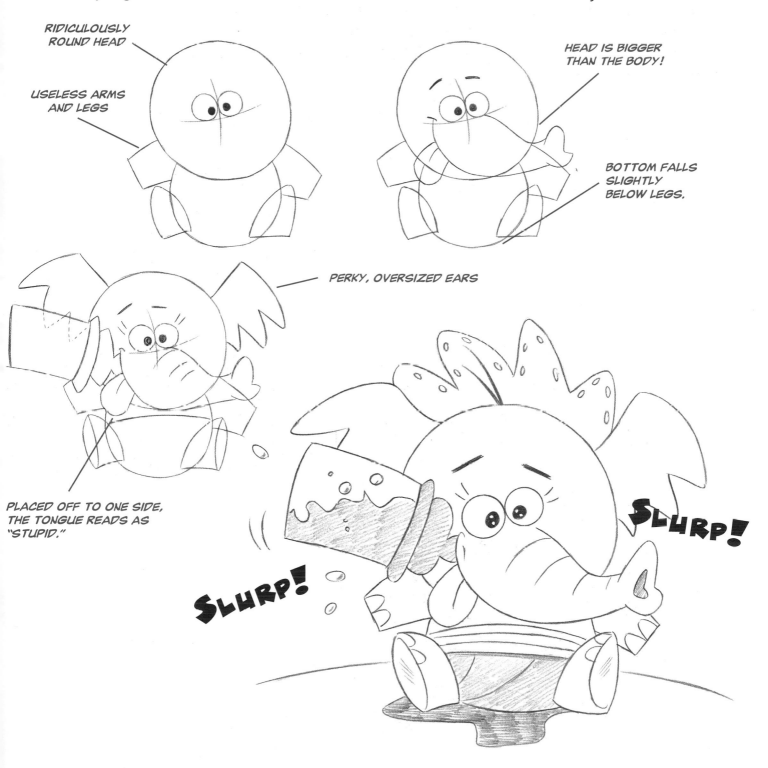

RIDICULOUSLY
ROUND HEAD

USELESS ARMS
AND LEGS

HEAD IS BIGGER
THAN THE BODY!

BOTTOM FALLS
SLIGHTLY
BELOW LEGS.

PERKY, OVERSIZED EARS

PLACED OFF TO ONE SIDE,
THE TONGUE READS AS
"STUPID."

SLURP!

SLURP!

DON'T STEAL *HIS* PEANUTS!

Angry elephants are *funny.* But it takes more than just a frown to turn anger into a humorous expression. Angry isn't funny per se, or we all would have laughed when our dads yelled at us. But *apoplectic*—that's funny! I like to draw super-angry elephants "huffing and puffing." Look at that huge chest filled with hot air and how it causes the waistline to narrow. As he clenches his fists, his muscles tremble with tension: See the motion lines around him in the final drawing, on the facing page? His shoulders flex and tighten, and his head is placed low on his frame. Even his knees are locked, creating a rigid look throughout his body.

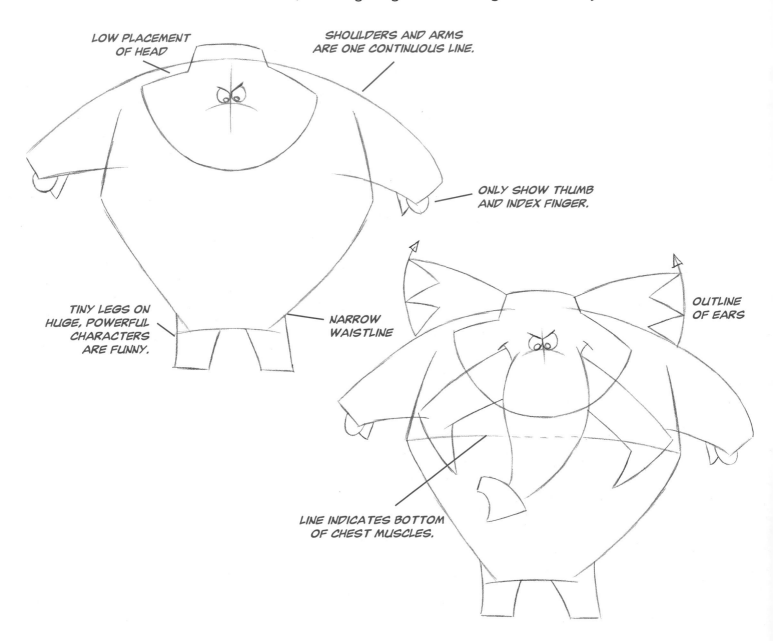

LOW PLACEMENT OF HEAD

SHOULDERS AND ARMS ARE ONE CONTINUOUS LINE.

ONLY SHOW THUMB AND INDEX FINGER.

TINY LEGS ON HUGE, POWERFUL CHARACTERS ARE FUNNY.

NARROW WAISTLINE

OUTLINE OF EARS

LINE INDICATES BOTTOM OF CHEST MUSCLES.

A few light touches of shading bring him to life. Shading isn't an all-or-nothing technique, where you use a lot of it or none at all. Sometimes, just a suggestion of it, such as on the tips of the tusks, is all you need.

ULTRA-STYLIZED ELEPHANT

You can get away with extreme character designs, like this one, for elephants, that you might not be able to pull off on some other animals. The oval body and trunk are such simple, strong forms that they can be manipulated to the point of absurdity and still read as an elephant.

Look at how deeply the smile cuts into the shape of the elephant. Any deeper and it would cut his head in two! And that's what makes the character so funny. Even the ears are ridiculous! We learn lots of "rules" when we draw. It's fun to learn how to break them!

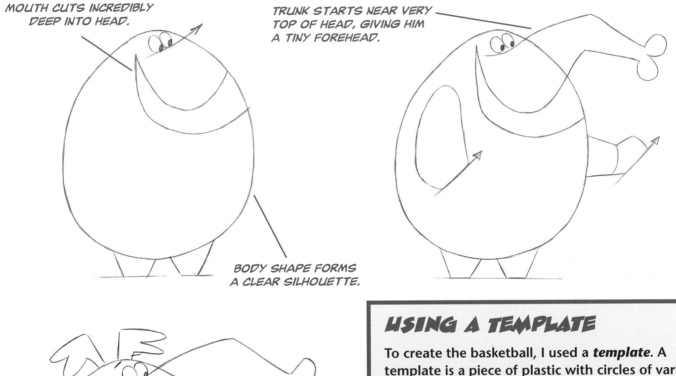

MOUTH CUTS INCREDIBLY DEEP INTO HEAD.

TRUNK STARTS NEAR VERY TOP OF HEAD, GIVING HIM A TINY FOREHEAD.

BODY SHAPE FORMS A CLEAR SILHOUETTE.

USING A TEMPLATE

To create the basketball, I used a *template*. A template is a piece of plastic with circles of various sizes cut out of it, so you can run your pencil along the interior, and—voilà—a perfect circle every time. You can buy one at any art store for just a few bucks.

I almost never use a template on characters, because a perfect circle looks lifeless on an animal or a person. The exception to this rule is when you're drawing an utterly stupid, young character, like the baby elephant a few pages back. That head shape was outlined with a template, because I was making fun of its roundness, satirizing it.

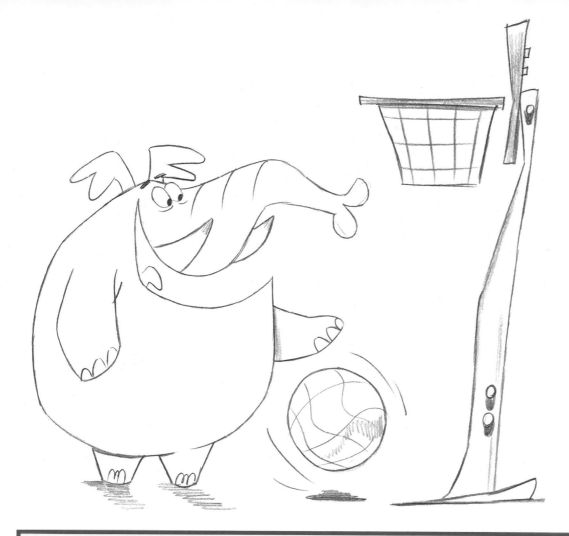

MAKING AN ELEPHANT LOOK EXTRA-PLUMP

Here are a few hints you can use to add a couple of humorous pounds to your portly pal, and add a bit more style, to boot.

TINY OVERHANG

MORE OVERHANG

ARMS AND LEGS TAPER.

Standard Elephant
The arms and legs don't taper. Oh, he's fat all right. But there's not that much style, or flair, to the outline of this figure.

Extra-Plump Elephant
With hardly any alteration to the body, we've changed the look. All we have done is *tapered* the arms and legs. Plus, we built out the bottom so that it appears to overhang the back of the legs. Now he looks even plumper—and funnier.

SURPRISED ELEPHANT

This is a look you might see on an elephant who just found a mouse in his bag of peanuts! Look at those stunned eyes. Notice anything in particular about them? The pupils are very small. That's right, the pupils actually *change size* according to the type of expression a character evinces.

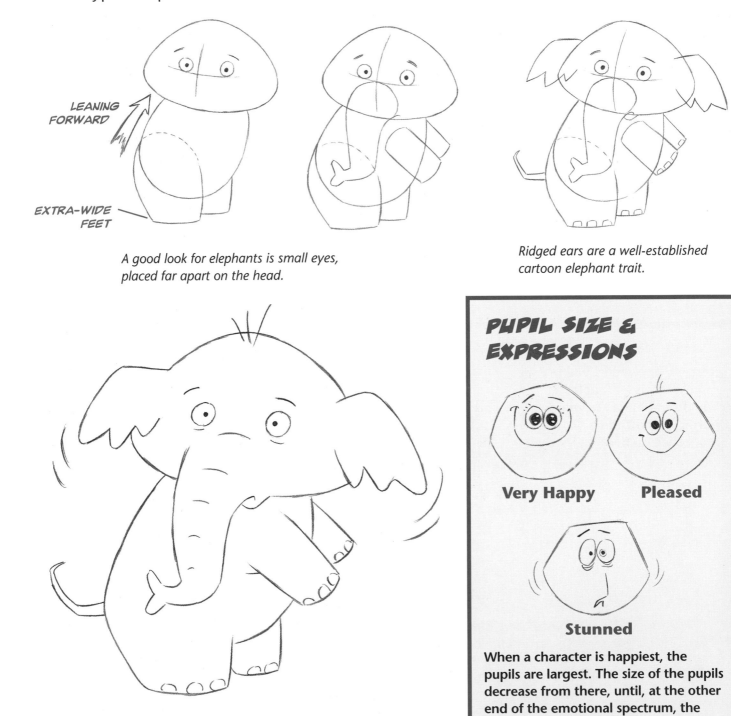

LEANING FORWARD

EXTRA-WIDE FEET

A good look for elephants is small eyes, placed far apart on the head.

Ridged ears are a well-established cartoon elephant trait.

PUPIL SIZE & EXPRESSIONS

Very Happy

Pleased

Stunned

When a character is happiest, the pupils are largest. The size of the pupils decrease from there, until, at the other end of the emotional spectrum, the pupils are just tiny dots.

Notice the motion lines that make it appear as if this elephant just did a "double take."

TEEN ELEPHANT

I wish this elephant would stop worrying about her weight. I mean, she's only 5,000 pounds, but she still thinks she looks fat! This is a fanciful character, almost along the lines of something you would find in a children's picture book. Instead of being boldly humorous, this drawing is more whimsical. The proportions have been exaggerated, but without the broad, bombastic tone of most current cartoons.

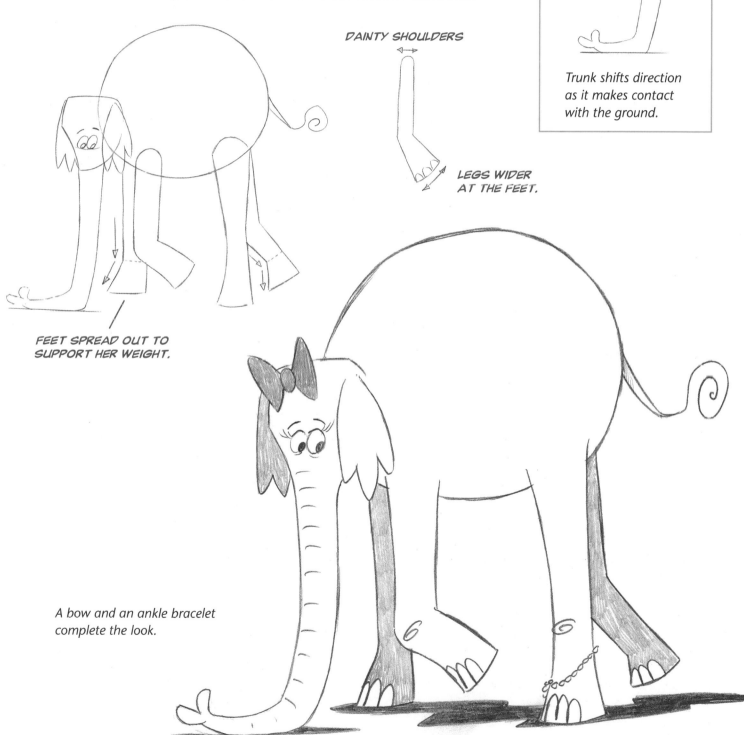

BASIC HEAD SHAPE

Trunk shifts direction as it makes contact with the ground.

DAINTY SHOULDERS

LEGS WIDER AT THE FEET.

FEET SPREAD OUT TO SUPPORT HER WEIGHT.

A bow and an ankle bracelet complete the look.

DECISIONS, DECISIONS

Perplexed expressions can be very appealing. They give characters an earnest quality. And here's an inventive pose to go along with the expression. Instead of showing the character simply standing with a baffled look on his face, we've brought him down to the ground, sort of ducking out of the way, as he figures out what to do. In this way, we combine body language with facial expressions.

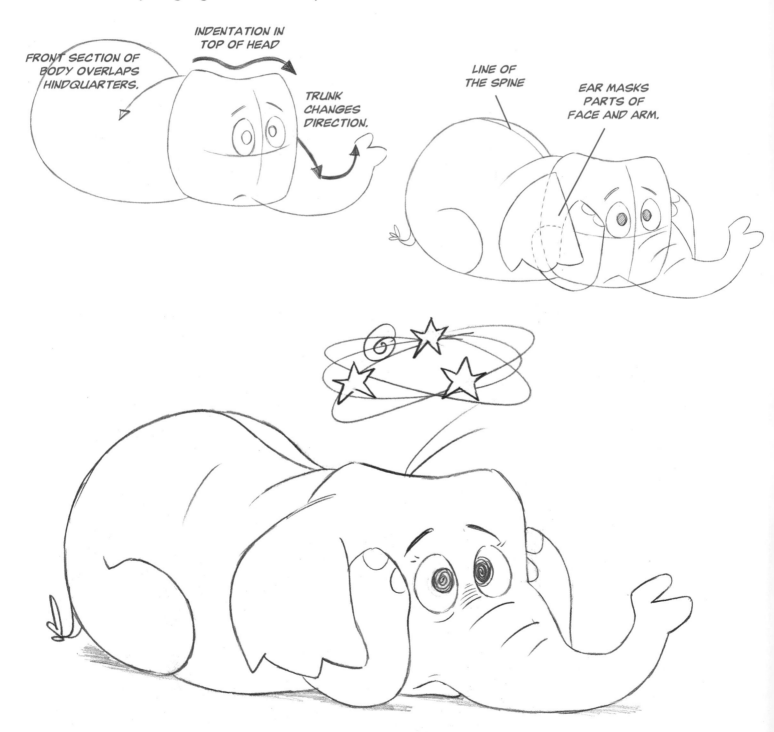

FRONT SECTION OF BODY OVERLAPS HINDQUARTERS.

INDENTATION IN TOP OF HEAD

TRUNK CHANGES DIRECTION.

LINE OF THE SPINE

EAR MASKS PARTS OF FACE AND ARM.

KOOKY ELEPHANT

This guy is built like a refrigerator. He's very easy to draw, because the body outline is so simple. We've moved his legs close together, which is a silly look, as it causes his hips to hang over the sides. (That's everyone's "problem area"!) All he's doing is standing, and yet he's still funny. How come? It's because we've found ways to add small accents of humor here and there. Let's take a look.

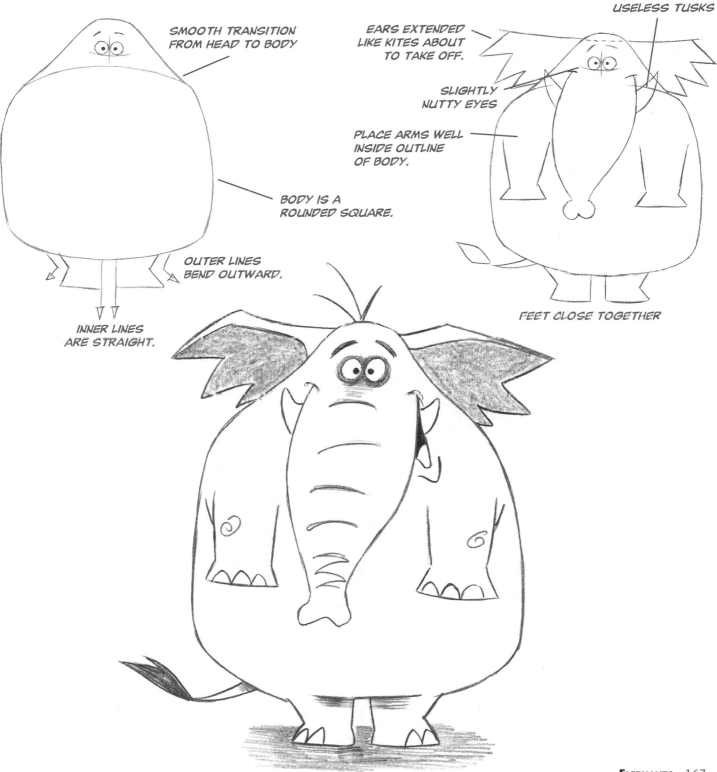

SMOOTH TRANSITION FROM HEAD TO BODY

BODY IS A ROUNDED SQUARE.

OUTER LINES BEND OUTWARD.

INNER LINES ARE STRAIGHT.

EARS EXTENDED LIKE KITES ABOUT TO TAKE OFF.

TEENY, HOPELESSLY USELESS TUSKS

SLIGHTLY NUTTY EYES

PLACE ARMS WELL INSIDE OUTLINE OF BODY.

FEET CLOSE TOGETHER

SUPER-EASY ELEPHANT

A character doesn't have to be complicated to be effective and charming. Here's one that can be drawn in only a few minutes—and probably with the fewest amounts of erasures of any other character we've done so far. It starts off basic—and stays that way.

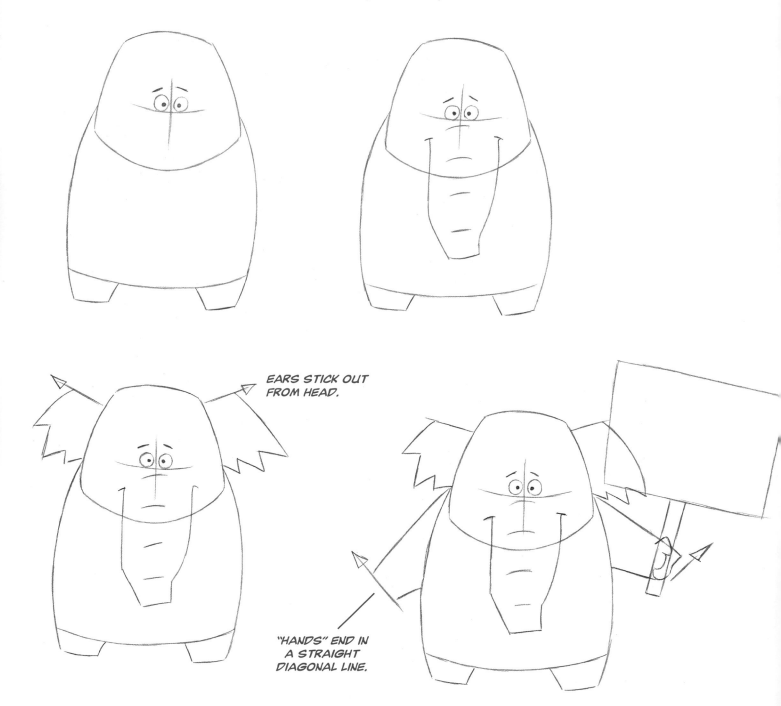

EARS STICK OUT FROM HEAD.

"HANDS" END IN A STRAIGHT DIAGONAL LINE.

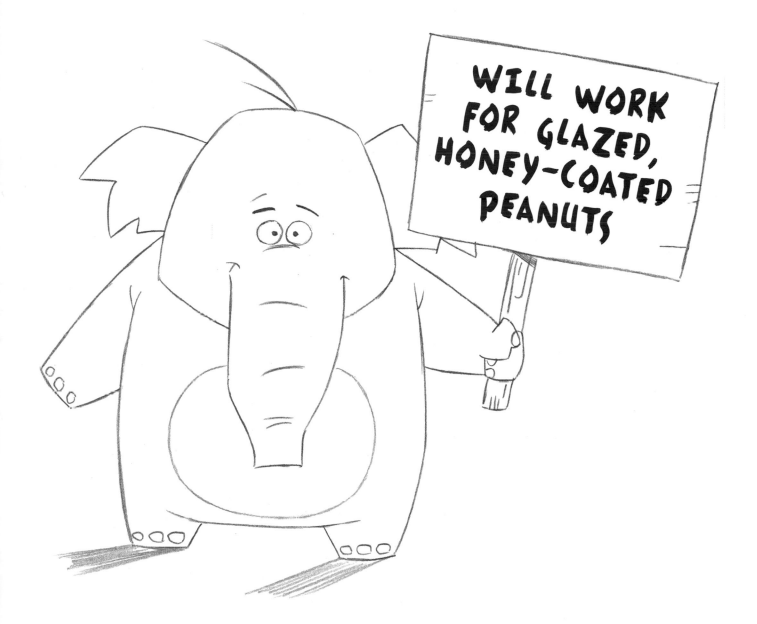

SURF'S UP!

When zoologists tell us that elephants can actually swim, I'm not sure this is what they mean. The total body *s-t-r-e-t-c-h* shown here is a great demonstration of exuberance. The arms and legs are at their maximum length—which, since they're tiny to begin with, isn't much! Be sure he's way off the ground. The fun is in the degree to which he is airborne.

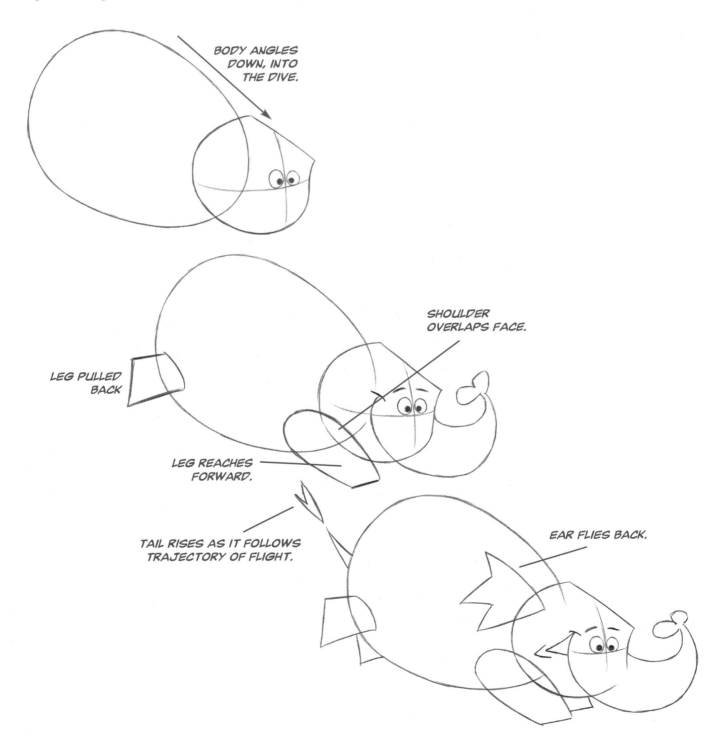

BODY ANGLES DOWN, INTO THE DIVE.

SHOULDER OVERLAPS FACE.

LEG PULLED BACK

LEG REACHES FORWARD.

TAIL RISES AS IT FOLLOWS TRAJECTORY OF FLIGHT.

EAR FLIES BACK.

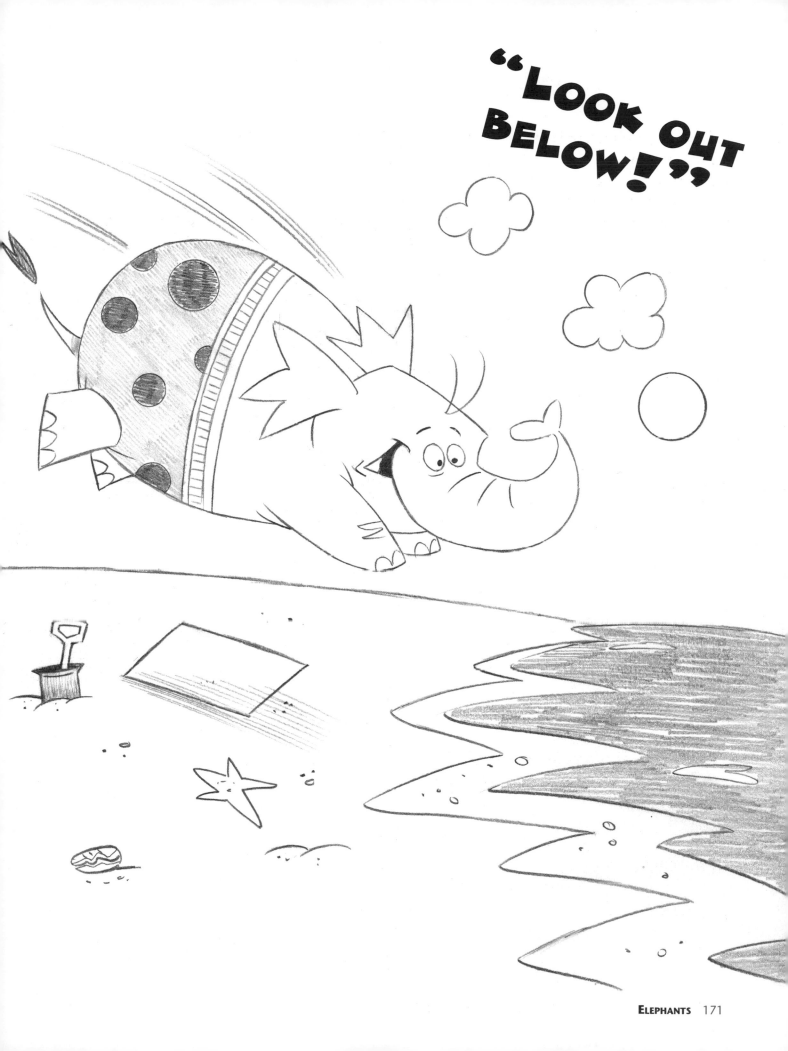

ELEPHANTS CAN'T RUN!

It is physically impossible for an elephant to run. They simply cannot do it. Watch a stampede of elephants on a nature channel. What they do is they *walk fast.* But they never break into a running stride, unless . . . they have a cartoonist drawing them! That's what makes a cartoon elephant run so funny: No one's ever seen one, and we're making it up!

Insane Elephant Run

All four legs are gathered under the body, with knees deeply bent. And the elephant is off the ground, leaning way forward.

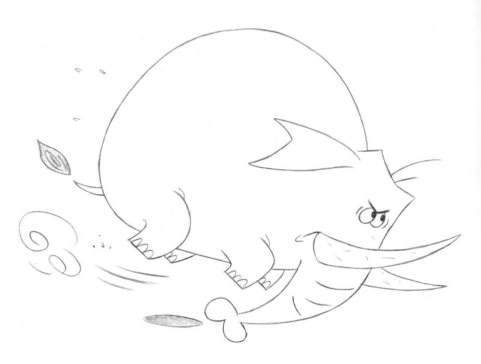

Stampede "Run"

In reality, this is an elephant's fast walk. The elephant is off the ground, but just a little. The knees are straight—just like those race-walkers you see on the side of the road. Also, like walkers, the stampeder doesn't lean forward as much as the runner.

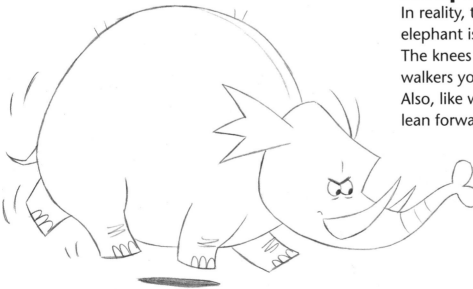

Happy-Go-Lucky Trot

Here's another improbable elephant gait. This bouncy trot directly reflects the mood of the character. You can't walk like this if you're pouting. Try to marry the type of gait to the character's personality. Have you ever seen an angry person skipping?

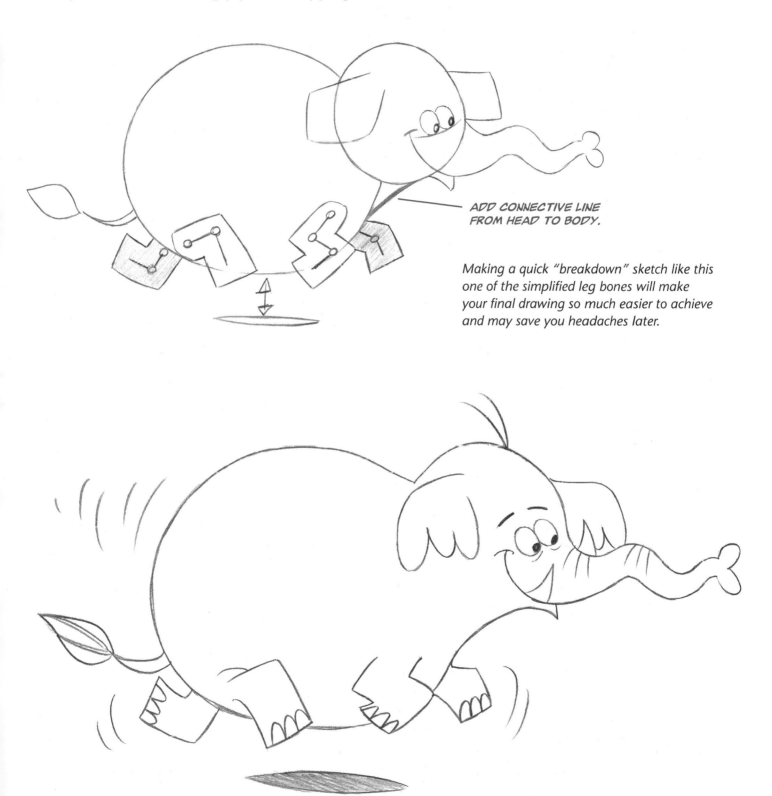

ADD CONNECTIVE LINE FROM HEAD TO BODY.

Making a quick "breakdown" sketch like this one of the simplified leg bones will make your final drawing so much easier to achieve and may save you headaches later.

WOOLLY MAMMOTH

This relative of the elephant became extinct thousands of years ago, but lucky for us, mammoths are still pushing humans around in cartoons about prehistoric times. The woolly mammoth makes a great cartoon character, because it's so bold and eye-catching. The key to drawing one is to think of the woolly mammoth as an elephant with a carpet on its back, a shaggy haircut, and *really* long tusks. It also needs to have big, bushy eyebrows. It's the Neanderthal of elephants.

Let's go through the steps and identify what makes a mammoth so . . . mammoth!

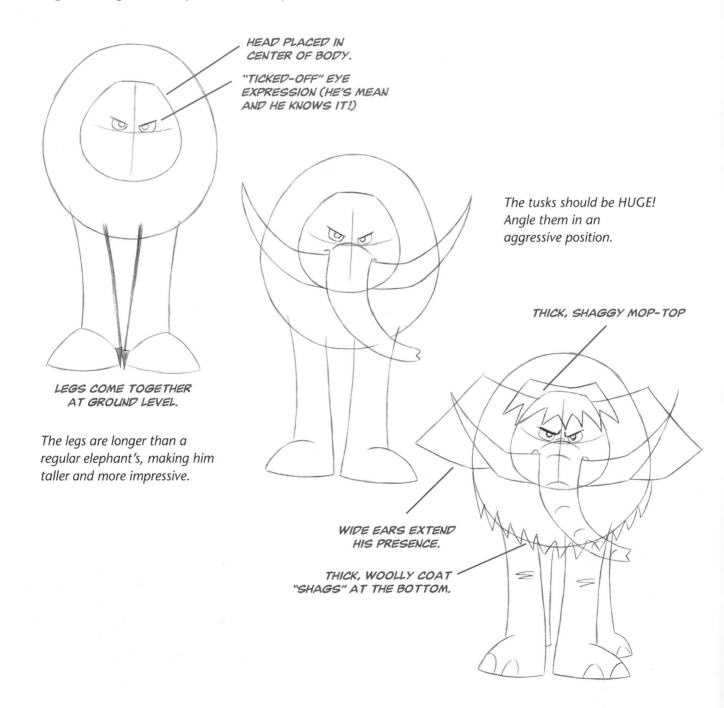

HEAD PLACED IN CENTER OF BODY.

"TICKED-OFF" EYE EXPRESSION (HE'S MEAN AND HE KNOWS IT!)

The tusks should be HUGE! Angle them in an aggressive position.

LEGS COME TOGETHER AT GROUND LEVEL.

The legs are longer than a regular elephant's, making him taller and more impressive.

THICK, SHAGGY MOP-TOP

WIDE EARS EXTEND HIS PRESENCE.

THICK, WOOLLY COAT "SHAGS" AT THE BOTTOM.

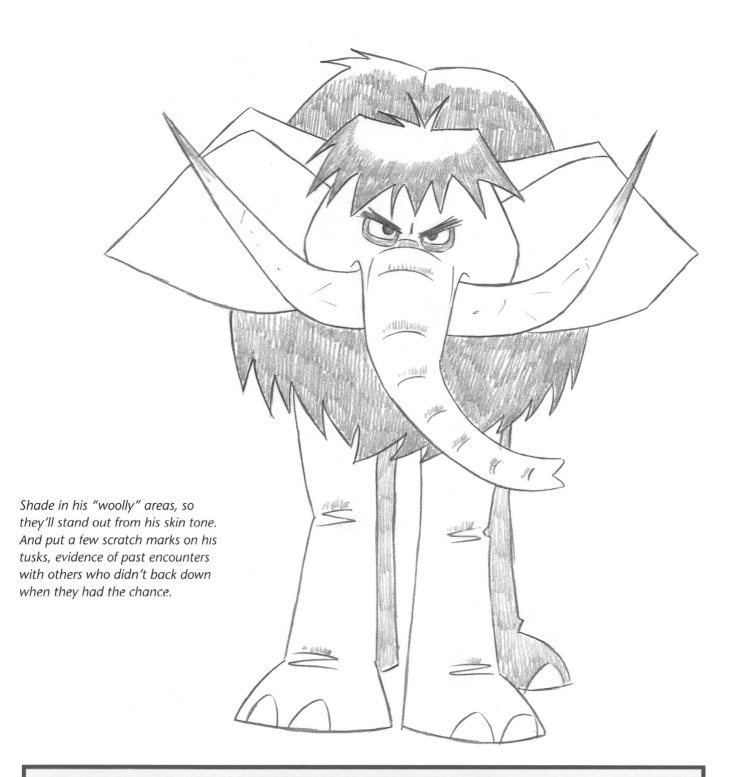

Shade in his "woolly" areas, so they'll stand out from his skin tone. And put a few scratch marks on his tusks, evidence of past encounters with others who didn't back down when they had the chance.

ANGRY EYES VS. WOOLLY MAMMOTH EYES

Angry Eyes

Woolly Mammoth Eyes

Regular angry eyes have simple eyebrows that push down toward the bridge of the nose. But the woolly mammoth has thick, bushy eyebrows and dark circles under the eyes that make him seem to glower.

THE EVER-POPULAR BEAVER

What everyone likes about beavers is their high-energy, positive, can-do attitudes. And their compact, squeezable bodies are just so cute. And look at that face. If those cheeks were any rounder, I'd just about explode. Sure, beavers build dams, which flood streams, causing damage to houses, wrecking neighborhoods . . . but when you're this cuddly, you can get away with anything! The beaver is a simple character, with charm to spare. If you're going to assemble a cast of woodland creatures for a comic strip or an animated show, he's a sure winner.

THE BEAVER'S HEAD

The nose and muzzle are the most important elements of the beaver. Just as the cartoon tiger's stripes are its "recognizers"—the elements you use to tell the reader what the animal is—well, the nose and muzzle are the recognizers of the beaver. Beavers—real beavers, as well as cartoon beavers—have small eyes.

Front View

The beaver's head is wide. How wide? The outline of the head is the same shape as a football, tilted on its side. Now *that's* wide! On top of the football shape, we add a tiny forehead and scruffy hair, to complete the look.

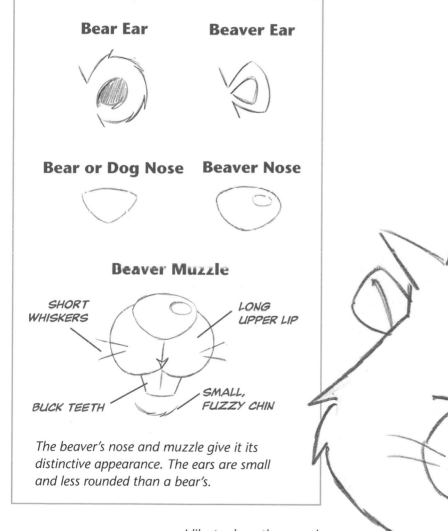

Bear Ear **Beaver Ear**

Bear or Dog Nose **Beaver Nose**

Beaver Muzzle

SHORT WHISKERS

LONG UPPER LIP

BUCK TEETH

SMALL, FUZZY CHIN

The beaver's nose and muzzle give it its distinctive appearance. The ears are small and less rounded than a bear's.

I like to draw the eyes close together because it gives the beaver a perky quality.

3/4 View

The 3/4 view is pretty easy to draw on a simple character, like the beaver. The trick is to keep the muzzle big and round. The snout is going to poke out a bit in this view—but not too much. It's not a long snout, like a dog's or a lion's.

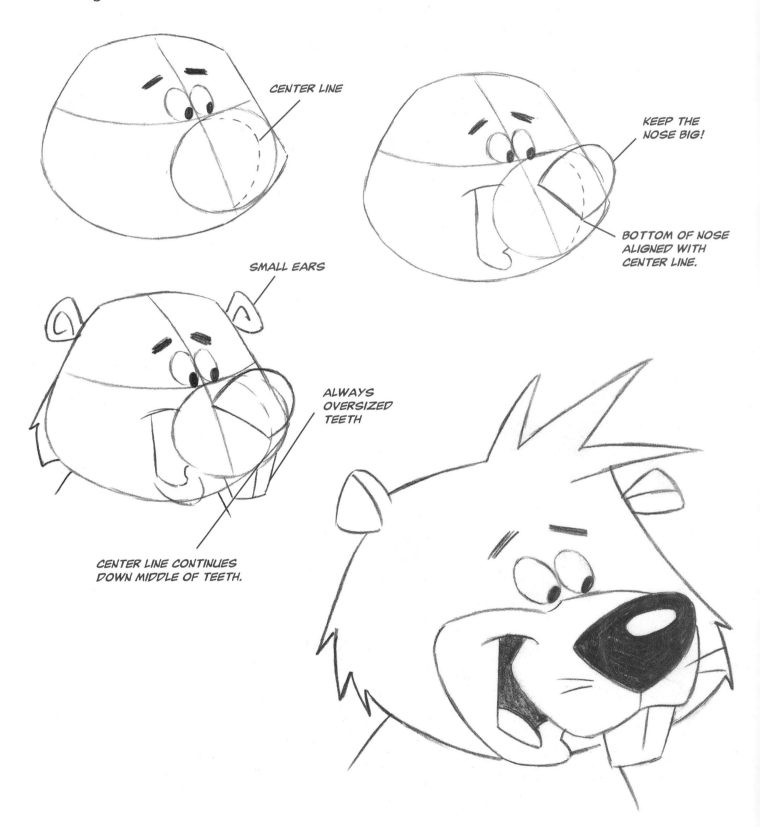

CENTER LINE

KEEP THE NOSE BIG!

BOTTOM OF NOSE ALIGNED WITH CENTER LINE.

SMALL EARS

ALWAYS OVERSIZED TEETH

CENTER LINE CONTINUES DOWN MIDDLE OF TEETH.

BEAVER: FULL LENGTH

Here he is, the beaver, in all his glory. Okay, so he's not so impressive, but he *is* funny. He's short of stature, with tiny hands and feet, which are black—a hallmark of the beaver. He's bottom-heavy, but it doesn't seem to bother him any. You'll never find a beaver on a low-carb diet. His fur is ruffled, never smooth. And then there's that famous paddle tail.

In this and every pose, remember to maintain the basic beaver traits:

- Pudgy, compact body
- Small legs, which make him low to the ground
- No neck
- Large, wide head
- Rounded back
- Thin wrists and ankles

Front View

In the front view, the beaver is widest at the hips, which is a funny look.

WIDEST AT THE HIPS

TINY FEET

CHUBBY ARMS

SMALL HANDS

TINY WRISTS

RUFFLE THE FUR— HE'S SCRUFFY!

I like to indicate the thickness of the tail.

3/4 View

One reason I love drawing beavers is that their entire bodies are so expressive. Can you see how his posture reflects his expression? That "uh-oh" look is mirrored in that tense posture, which, no matter how you draw it, still remains cute!

Football shape works for the body, too!

LOW CENTER OF GRAVITY

THE BEAVER'S TAIL

The beaver's tail should not be drawn straight in the 3/4 view. It should have a little bend at the end to give it character.

NO!

YES!

Add an extra tip to the tail.

BABY BEAVER

Let's turbocharge the cuteness. We'll increase the size of the head and decrease the size of the body. The arms and legs will become even fatter, but smaller, and completely useless. The muzzle has to go, too. I know we said that the muzzle is the signature feature of the beaver, and *all* babies have small mouths.

Make the eyes huge. Yes, I know, beavers have small eyes, but again, we're drawing a *baby.* When you're drawing babies and toddlers, you've got to adjust your character to the standard proportions of the age, and babies have huge eyes.

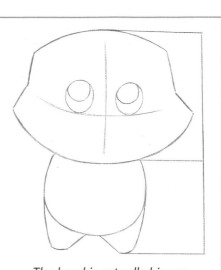

The head is actually bigger than the body!

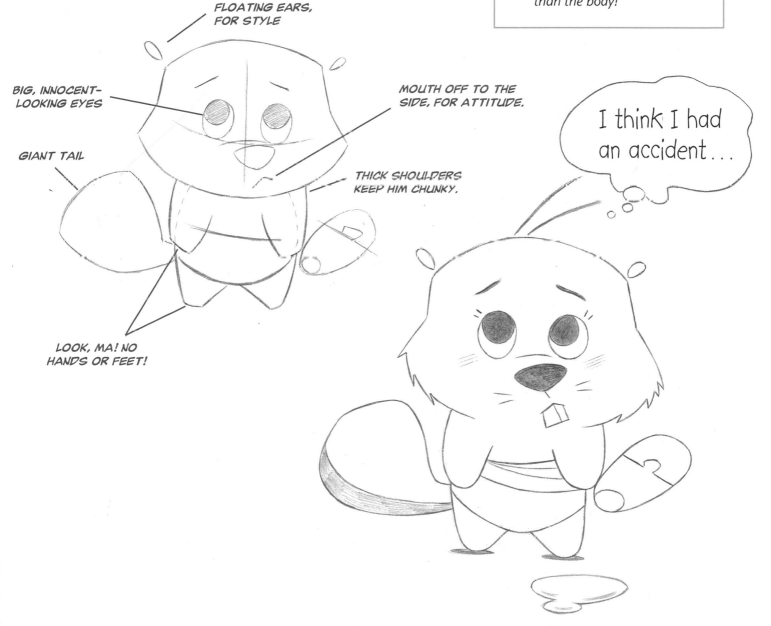

FLOATING EARS, FOR STYLE

BIG, INNOCENT-LOOKING EYES

GIANT TAIL

MOUTH OFF TO THE SIDE, FOR ATTITUDE.

THICK SHOULDERS KEEP HIM CHUNKY.

LOOK, MA! NO HANDS OR FEET!

I think I had an accident...

BEWILDERED BEAVER

Beavers are usually determined and on the go. They build things, even if things don't need to be built. That's why it's funny when you have a beaver who suddenly forgets what it is he's supposed to be doing. I've mixed things up a bit with this character and varied some of his traits from those of the traditional cartoon beaver. But he's still an easy, and fun, character to draw, so give him a try!

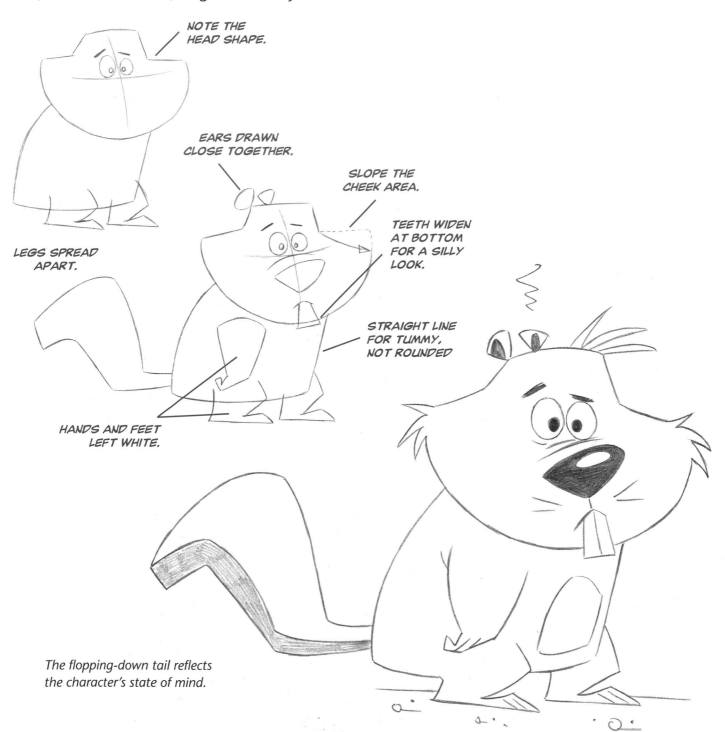

NOTE THE HEAD SHAPE.

EARS DRAWN CLOSE TOGETHER.

SLOPE THE CHEEK AREA.

TEETH WIDEN AT BOTTOM FOR A SILLY LOOK.

LEGS SPREAD APART.

STRAIGHT LINE FOR TUMMY, NOT ROUNDED

HANDS AND FEET LEFT WHITE.

The flopping-down tail reflects the character's state of mind.

HOW A BEAVER REALLY STANDS

This is, roughly, the way a real beaver actually stands when it's walking on all fours. It's kind of a funny posture, because its bottom is so big that it sticks up in the air. And since the legs are so small, the tummy is very close to the ground. I prefer to tilt the eyes diagonally. I think it gives the character more personality than if I drew them vertically (up and down).

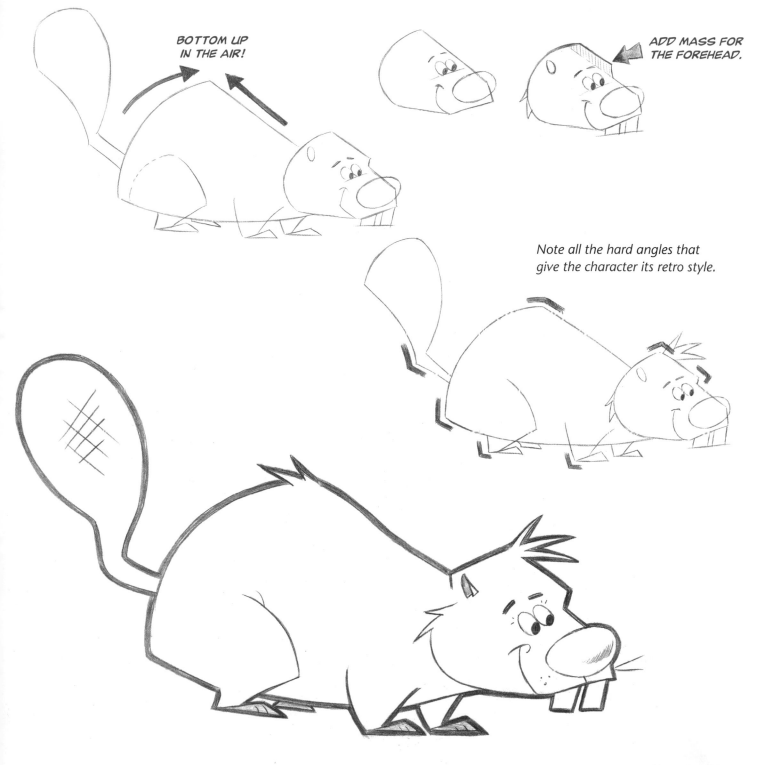

BOTTOM UP IN THE AIR!

ADD MASS FOR THE FOREHEAD.

Note all the hard angles that give the character its retro style.

THE MASTER BUILDER

Here he is, hard at work, measuring, taking notes, planning. It's worth asking: Why this extreme pose, with the beaver off the ground? Why not just have him standing in front of the tree? The answer should give you an insight into an important aspect of the cartoonist's job.

As cartoonists, we do more than just draw funny pictures. We also look to maximize the humor in any given situation. Just as we're not satisfied with an ordinary character design, likewise, we're not satisfied with ordinary staging. This levitated pose is more inventive. It shows the beaver at his most energetic. Plus, it catches the audience off guard, surprising them.

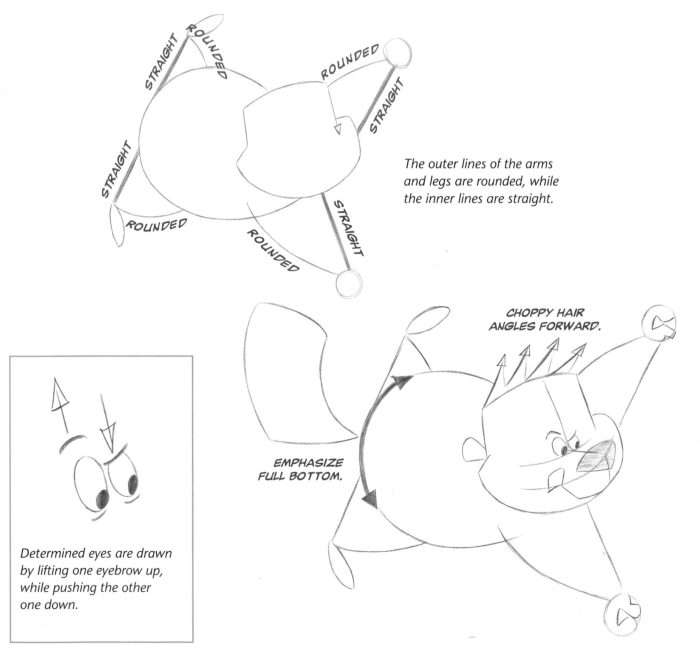

The outer lines of the arms and legs are rounded, while the inner lines are straight.

CHOPPY HAIR
ANGLES FORWARD.

EMPHASIZE
FULL BOTTOM.

Determined eyes are drawn by lifting one eyebrow up, while pushing the other one down.

Notice that I've left a space
between the beaver's teeth.
That's yet another good way
to draw them.

RACCOONS: BANDITS OF THE ANIMAL KINGDOM

If you've ever left your garage door open at night and found the garbage cans pilfered, you'll know why they call this little critter the "bandit." The raccoon is smart and resourceful—a real rascal. You could really grow to dislike it, except for one thing: It's so darn cute. Raccoons have that signature "mask" across the eyes and stripes across their bodies. That should be enough to identify them, making them easy to draw, right? Not so fast. Raccoons are, surprisingly, a bit challenging. They have a unique head shape, and if you don't get it right, the mask and stripes won't save the drawing. But you're not going to have trouble with this mischievous little creature, because I'll give you the keys you need to get it on the first try. No guessing necessary.

THE BASIC RACCOON

The raccoon has a wide face, but a narrow, pointy snout, with a small nose. The eyes are set low on the face. Be sure to keep that in mind. The ears are also small. The body is totally "medium." That's right—not fat, not skinny, just in the middle.

Front View
The front view plops a simple half-moon head shape onto a square body. The markings are incredibly important as they clue us into the type of animal this is.

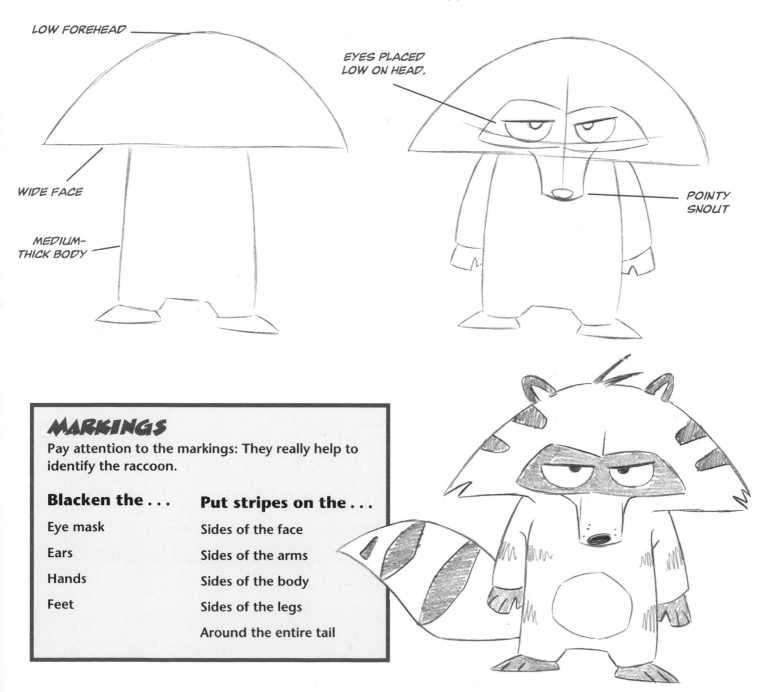

LOW FOREHEAD

WIDE FACE

MEDIUM-THICK BODY

EYES PLACED LOW ON HEAD.

POINTY SNOUT

MARKINGS
Pay attention to the markings: They really help to identify the raccoon.

Blacken the . . .	Put stripes on the . . .
Eye mask	Sides of the face
Ears	Sides of the arms
Hands	Sides of the body
Feet	Sides of the legs
	Around the entire tail

Side View

In this variation, I've shortened the snout, but, as you can see, it's still somewhat pointed. The tip swoops up, like a ski jump. Note, too, that the eye mask does not bleed all the way to the end of the head but trails off in the middle.

In a *strict* side view, you wouldn't see this much of the raccoon's body. So we cheat a bit. We place the head in a profile (side view) and the body in a 3/4 view. It's an appealing pose. The profile of the head cuts a strong silhouette, while we show more of the body for a softer feel.

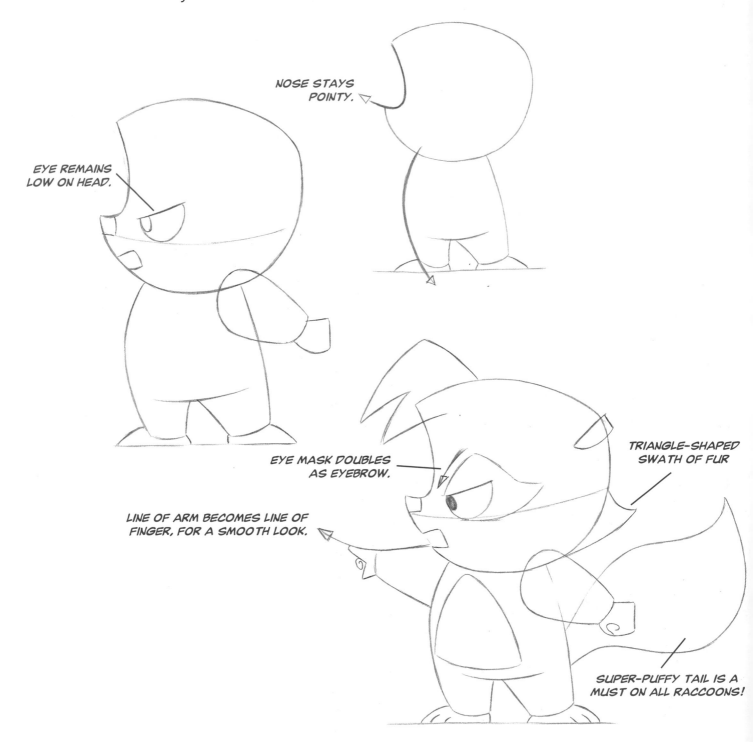

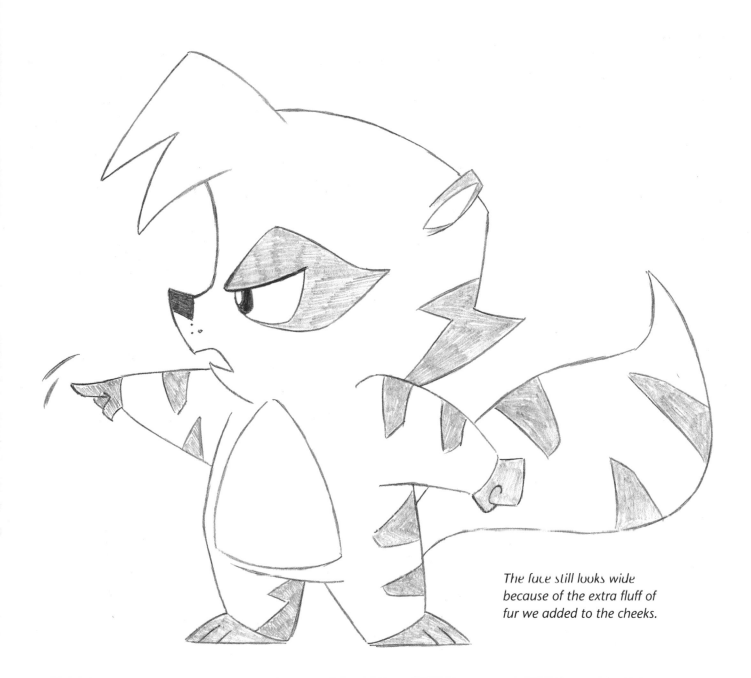

The face still looks wide because of the extra fluff of fur we added to the cheeks.

DRAWING THE EYES IN THE SIDE VIEW

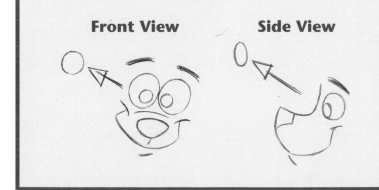

Front View **Side View**

See how, in the side view, the eyes flatten out a bit? They become oval shaped, whereas in the front view, they are circles. However, one thing you may not have noticed, which is equally important, is that the *pupil* itself also becomes oval in the side view.

NO MORE LEFTOVERS?

The raccoon has a versatile body. It can bend and twist, which makes it a great character for lots of action poses. I like to draw these little guys getting into trouble. Does he look like he's in trouble? Not yet, but stick around. In the next moment, I'd draw the homeowner coming after him with a trap. And no, he wouldn't get caught. He'd probably scamper into the house on a wild chase and finally make it out the back way, safe. With a cheese sandwich he swiped on his way out!

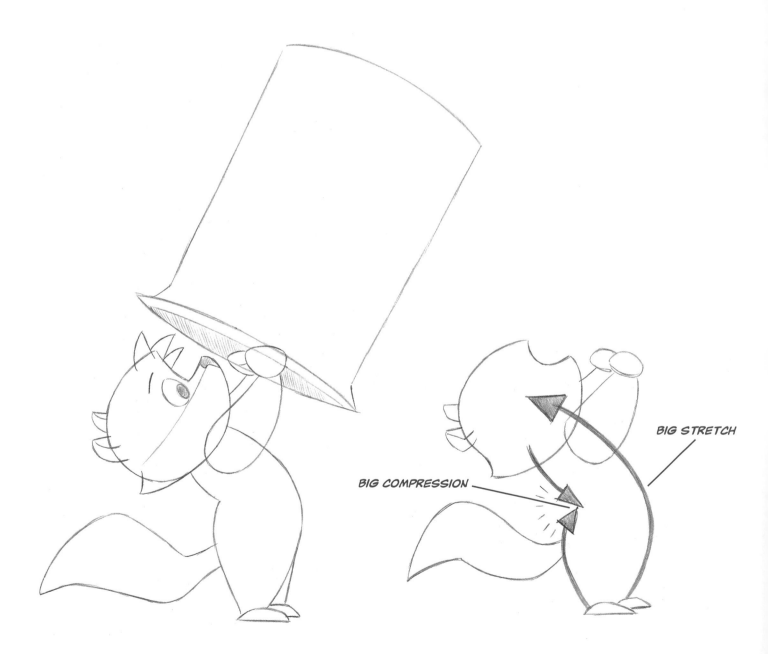

BIG STRETCH

BIG COMPRESSION

COME BACK HERE WITH THAT ACORN!

This type of run is called a "mad dash." It's an all-out sprint that is a classic in the cartoon world. Typically, the arms are held straight out, ahead of the character, while the legs pump like mad. You probably think I'm going to tell you that the body has to lean forward. Well, I certainly have made this character lean forward. But there have been many funny "dashes" where the character is standing straight up, or even leaning backward! The farther back he leans, the sillier the run. The more forward-leaning he is, the more determined he looks.

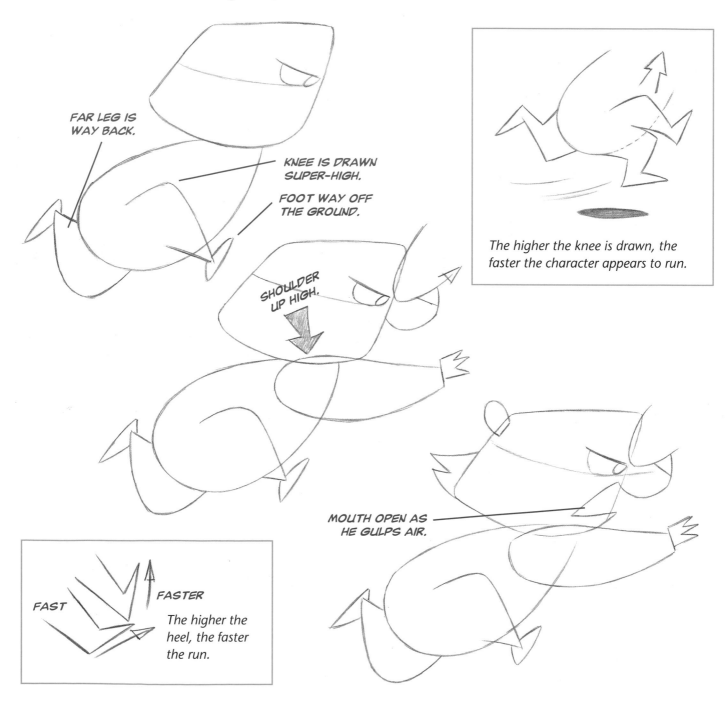

FAR LEG IS WAY BACK.

KNEE IS DRAWN SUPER-HIGH.

FOOT WAY OFF THE GROUND.

SHOULDER UP HIGH.

The higher the knee is drawn, the faster the character appears to run.

MOUTH OPEN AS HE GULPS AIR.

FAST FASTER

The higher the heel, the faster the run.

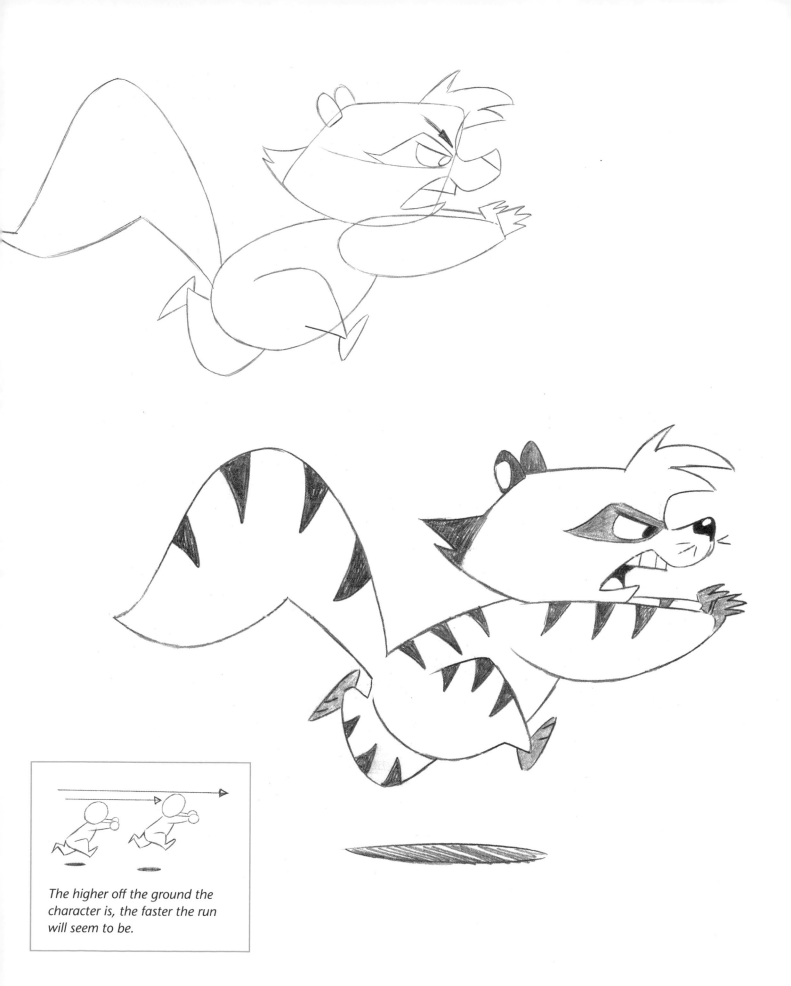

The higher off the ground the character is, the faster the run will seem to be.

BUNNIES & RABBITS: BUSHY-TAILED CUTIES

What's the difference between a bunny and a rabbit? Cartoonists tend to think of bunnies as warm and fuzzy and rabbits as wise guys and mischief-makers. The warm and fuzzy types are often drawn to look ridiculously adorable—on purpose. It's a funny look. And the mischievous ones are hyperactive and zany, like a boy in a third-grade classroom listening to his teacher talk about Mozart. You all know the features stereotypically associated with rabbits and bunnies: big ears, bushy cheeks, buck teeth, a cotton tail. Instead of drawing a completely straightforward rabbit out of those elements, which would be rather ordinary, let's try to find some fresh ways to reinvent the character type.

RETRO BUNNY

Here's a cute but highly stylized bunny. Yes, I know you want to squeeze him, but unfortunately, you can't: He's only 2-D!

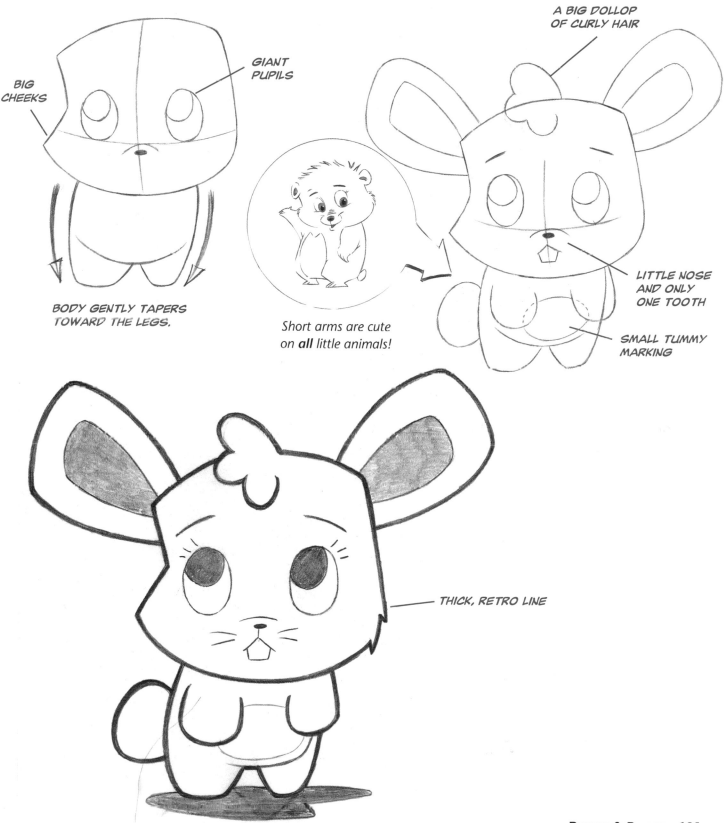

BIG CHEEKS

GIANT PUPILS

BODY GENTLY TAPERS TOWARD THE LEGS.

Short arms are cute on **all** little animals!

A BIG DOLLOP OF CURLY HAIR

LITTLE NOSE AND ONLY ONE TOOTH

SMALL TUMMY MARKING

THICK, RETRO LINE

FLAPPING EARS

We think of cartoon bunnies with their ears perched up at a 45° angle. But real rabbits more often have their ears back. Hares' ears stick up, but hares are usually gangly, and people don't cotton to them. So we don't use them in cartoons.

Just because you've seen something done the same way, over and over again, doesn't mean you have to repeat it. Maybe it's become a tired convention, and it's time for a change. Here I've placed the ears parallel to the ground and flapped them like wings. This bunny seems to be enjoying it! And it's a fresher look.

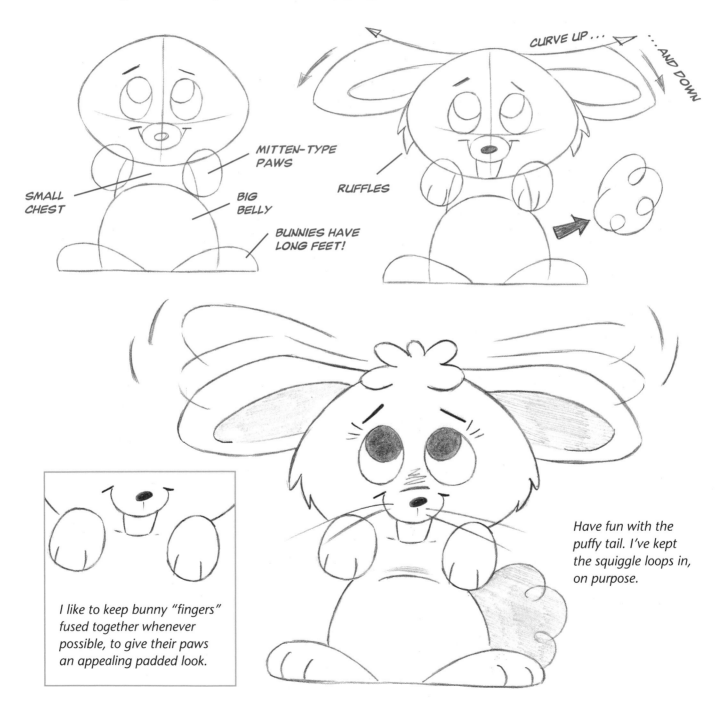

SMALL CHEST

MITTEN-TYPE PAWS

BIG BELLY

BUNNIES HAVE LONG FEET!

CURVE UP . . .

. . . AND DOWN

RUFFLES

I like to keep bunny "fingers" fused together whenever possible, to give their paws an appealing padded look.

Have fun with the puffy tail. I've kept the squiggle loops in, on purpose.

FLOP-EARED BUNNY

I also like to draw bunnies with ears that surround the head, almost like a hood. Be sure to define the interior and exterior of the ears and to shade the interior.

It may not appear so from the final drawing, but this guy is actually *easy to draw,* because the shape of the head is simple. See the first step? It doesn't get much more difficult than that. Everything else is just a bunch of small details. Let's try it. I bet you'll be surprised.

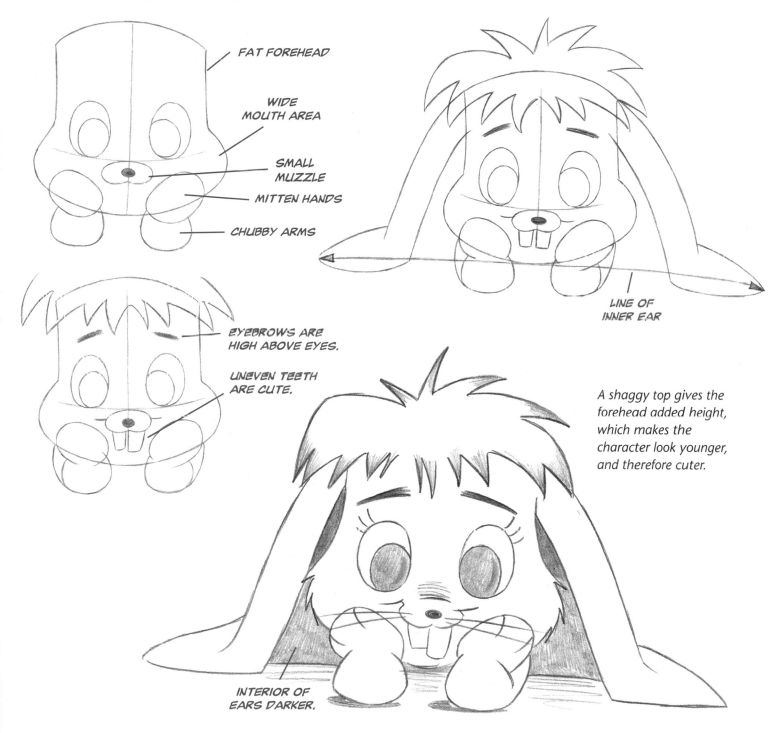

FAT FOREHEAD

WIDE MOUTH AREA

SMALL MUZZLE

MITTEN HANDS

CHUBBY ARMS

LINE OF INNER EAR

EYEBROWS ARE HIGH ABOVE EYES.

UNEVEN TEETH ARE CUTE.

A shaggy top gives the forehead added height, which makes the character look younger, and therefore cuter.

INTERIOR OF EARS DARKER.

EARS DRAGGING BEHIND THE HEAD

Here's another popular variation on the cartoon bunny, with the ears falling behind the back of the head. Another thing that gives this guy his own look is his totally oval head. *He's all cheeks and ears!* The body is small, and the legs are so little, they're almost nonexistent! But still, they sit on top of long feet, which makes him endearingly awkward. The big eyes make him a bright character—probably an "idea guy" in his patch of the woods.

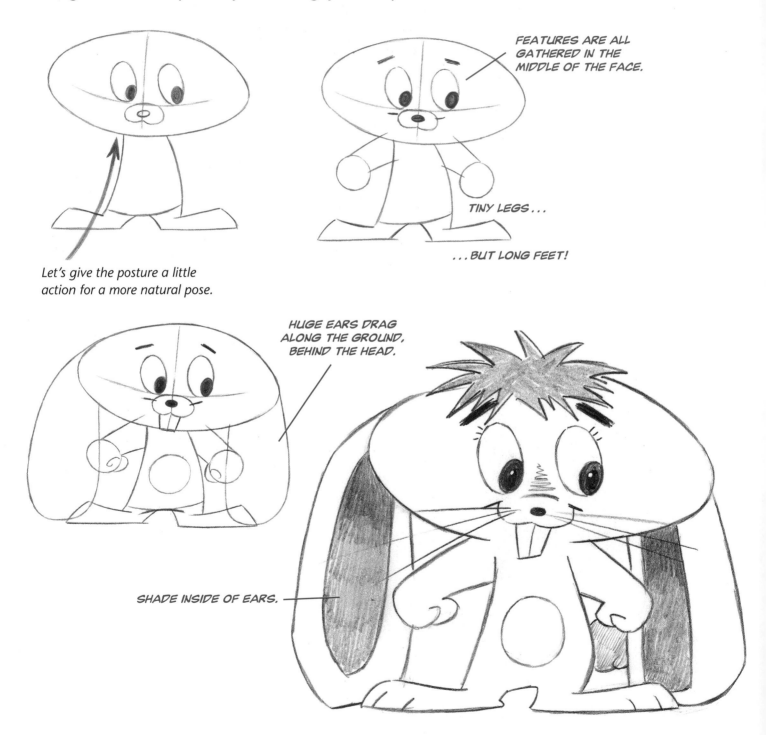

Let's give the posture a little action for a more natural pose.

FEATURES ARE ALL GATHERED IN THE MIDDLE OF THE FACE.

TINY LEGS...

...BUT LONG FEET!

HUGE EARS DRAG ALONG THE GROUND, BEHIND THE HEAD.

SHADE INSIDE OF EARS.

IF ONLY HE'D STUCK TO CARROTS & LETTUCE

But the french fries at the campgrounds were *sooo* yummy. And now look at him! You have any idea how much hopping he's going to have to do to lose all those extra inches?

Every cast of cartoon animal friends can use one character who's a little less athletic than the others. He's a bit nervous and apprehensive and needs lots of encouragement to follow the rest of the bunnies on their daily bunny chores. He can't hop very high. He can't jump very fast. He doesn't fit into the rabbit holes in the ground. Plus, he can always be lured away by any predator offering a chocolate bar.

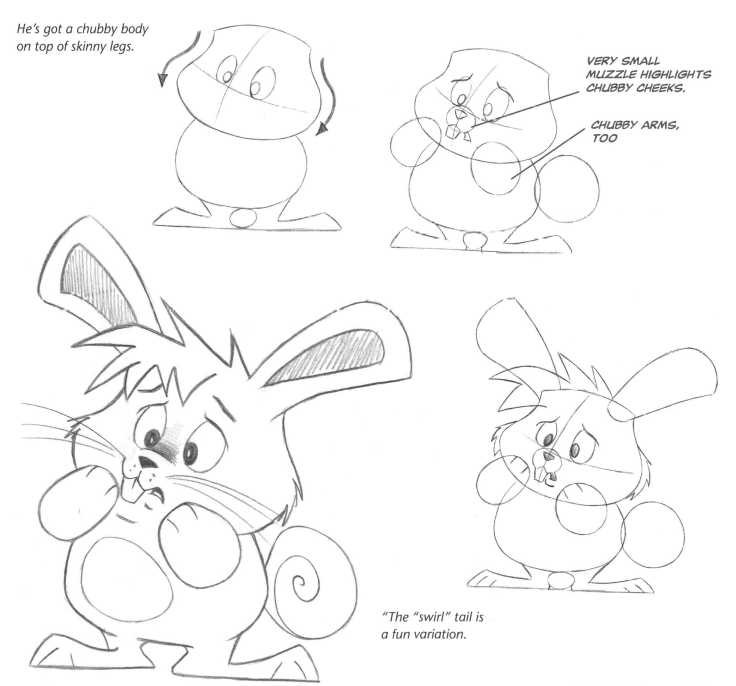

He's got a chubby body on top of skinny legs.

VERY SMALL MUZZLE HIGHLIGHTS CHUBBY CHEEKS.

CHUBBY ARMS, TOO

"The "swirl" tail is a fun variation.

WISE-GUY RABBIT

This is the rabbit who wants to be your friend, whether or not *you* want another friend! Here are a few wise-guy characteristics to keep in mind:

- Rubbery frame
- Long arms with big hands
- Huge feet
- Springy legs
- Medium-to-small eyes
- Small chest and a bit of a tummy
- Big buck teeth

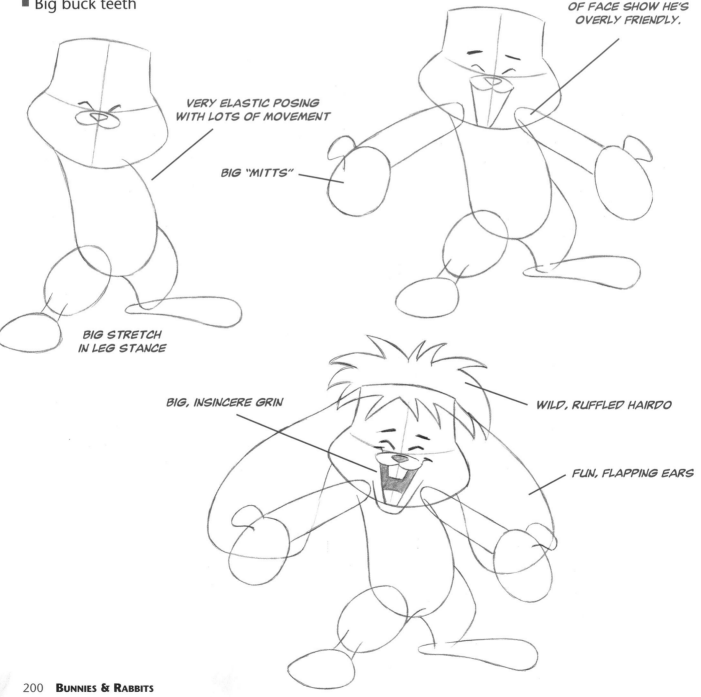

VERY ELASTIC POSING WITH LOTS OF MOVEMENT

BIG "MITTS"

BIG STRETCH IN LEG STANCE

SHOULDERS IN FRONT OF FACE SHOW HE'S OVERLY FRIENDLY.

BIG, INSINCERE GRIN

WILD, RUFFLED HAIRDO

FUN, FLAPPING EARS

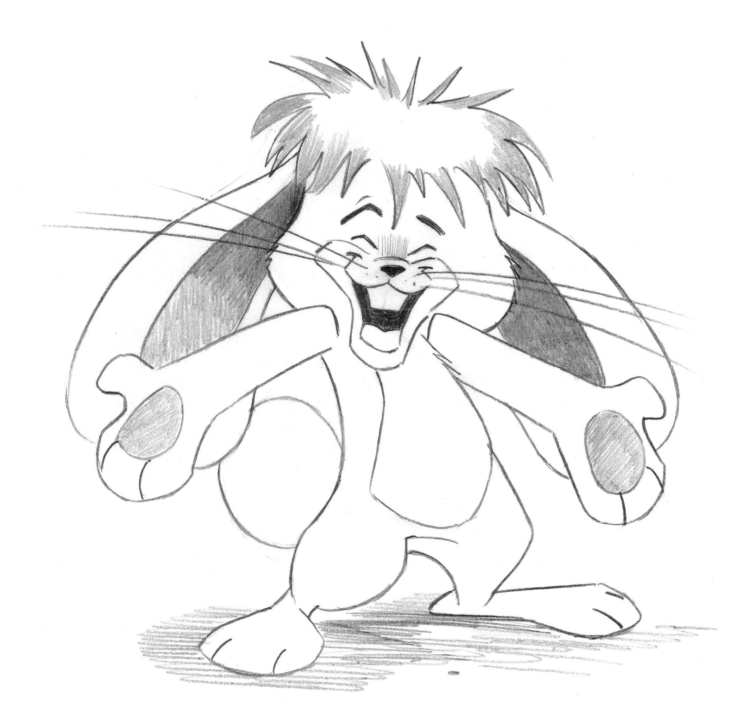

DEER: NIMBLE WOODLAND CREATURES

Deer are elegant, dainty, and refined, except, of course, when they are porky, rotund, and goofy—in other words, drawn by cartoonists! Yeah, you can make fun of anything with a pencil if you're evil enough. However, these animals really are beautiful creatures, so I like to draw at least some of them as streamlined, along with their bumptious buddies, of course. But in all cases, deer have compact bodies and long, thin legs that taper down to tiny hooves, as well as bushy, upright tails. You can give them big antlers, if you like. But they can also have little "knobs," like they do in the spring when the antlers haven't fully grown in yet. And female deer never have antlers.

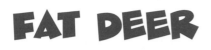

FAT DEER

Deer are usually thought of as elegant, beautiful, graceful creatures. I think they're simply lovely, don't you? So let's draw a *fat* deer! This funny guy has a body the shape of an overblown watermelon with toothpicks for legs. The teeny hooves are a humorous contrast to the porky body.

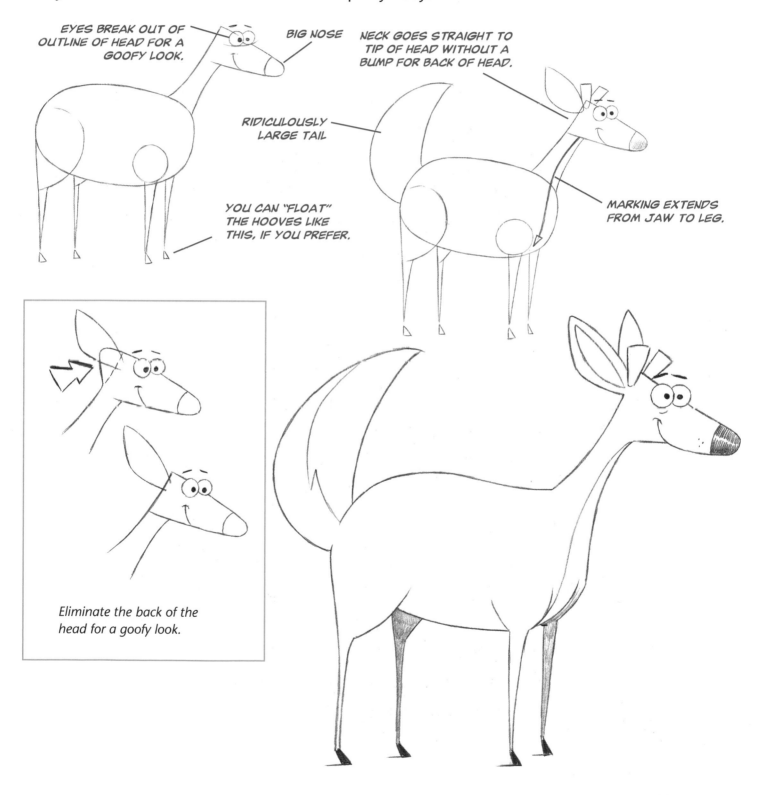

EYES BREAK OUT OF OUTLINE OF HEAD FOR A GOOFY LOOK.

BIG NOSE

NECK GOES STRAIGHT TO TIP OF HEAD WITHOUT A BUMP FOR BACK OF HEAD.

RIDICULOUSLY LARGE TAIL

YOU CAN "FLOAT" THE HOOVES LIKE THIS, IF YOU PREFER.

MARKING EXTENDS FROM JAW TO LEG.

Eliminate the back of the head for a goofy look.

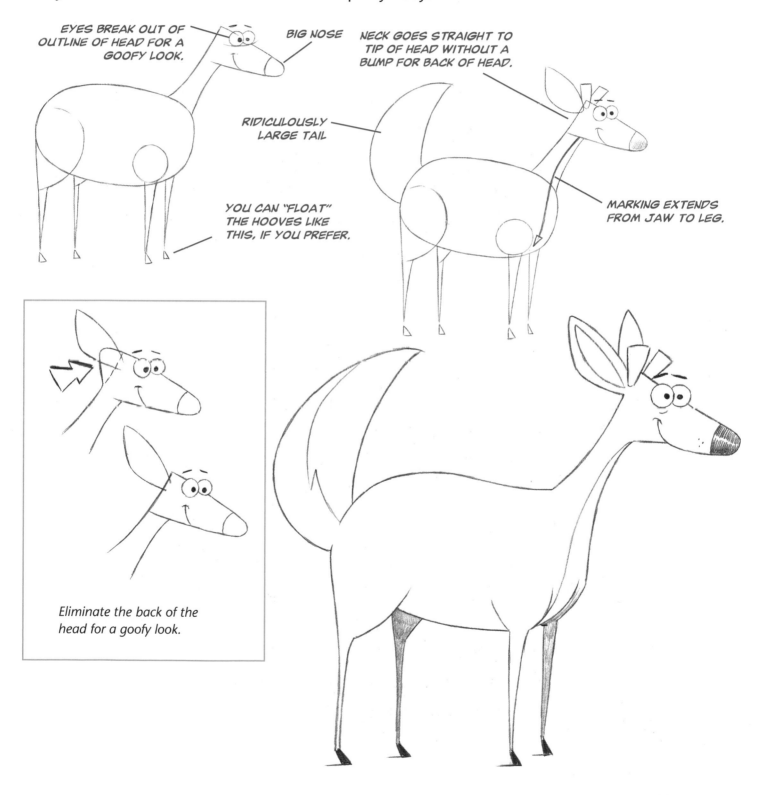

CUTE LITTLE FAWN

Fawns—very young deer—look a little wobbly on their legs. Keep the legs skinny and long. The head is round and so is the snout, unlike the adult's. Big eyes with long eyelashes are also important. I always feminize fawns, because we tend to think of young deer as female. That's probably because young deer never have antlers, and we associate males with antlers.

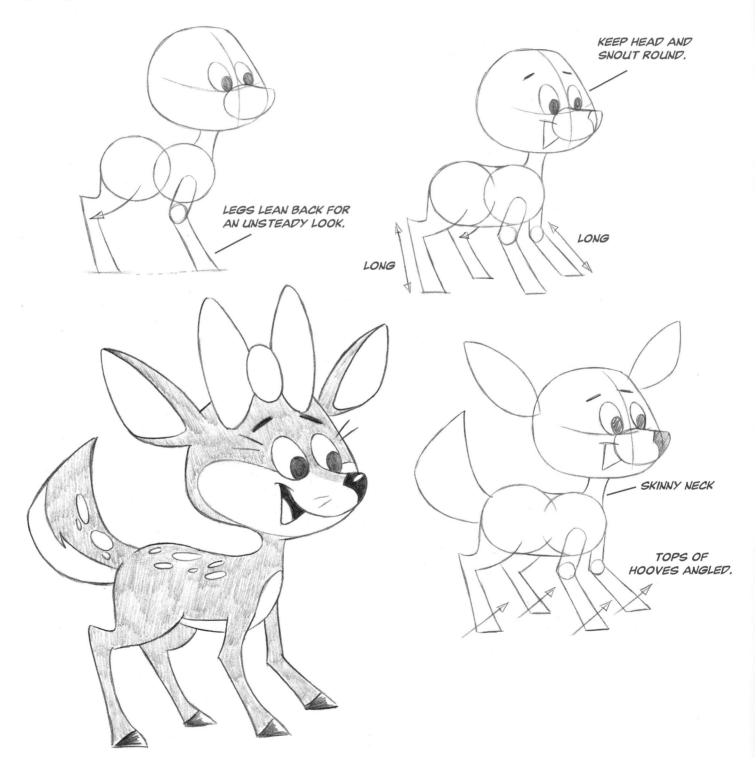

KEEP HEAD AND SNOUT ROUND.

LEGS LEAN BACK FOR AN UNSTEADY LOOK.

LONG

LONG

SKINNY NECK

TOPS OF HOOVES ANGLED.

DELICATE DEER

Deer can be very light on their feet, and we can have fun designing them so that their forelegs and hind legs taper down to practically nothing. To design a more *graphic* look, we'll use an oval as the basic shape of the body but draw a straight line for the underbelly. We'll also go for a straighter, more angular look to the head as well.

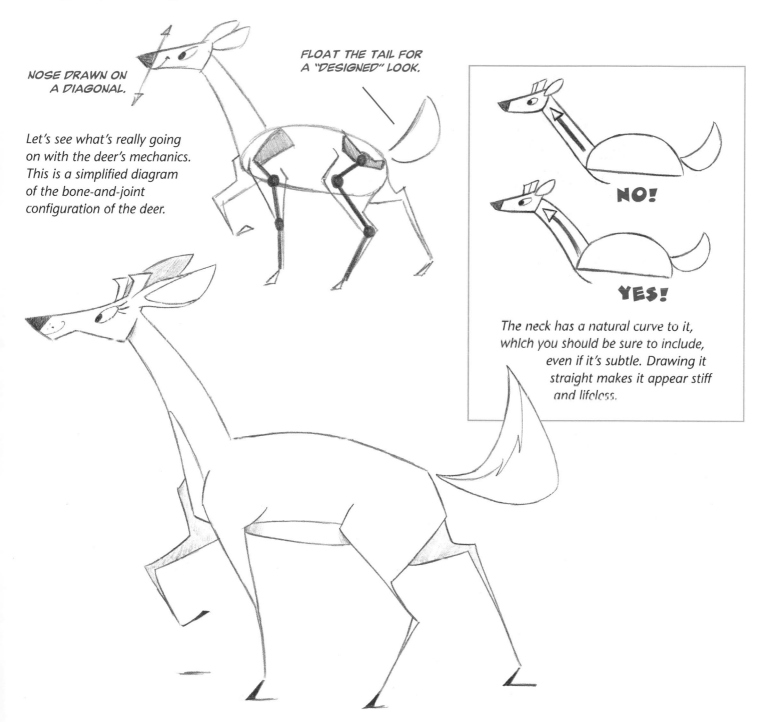

NOSE DRAWN ON A DIAGONAL.

FLOAT THE TAIL FOR A "DESIGNED" LOOK.

Let's see what's really going on with the deer's mechanics. This is a simplified diagram of the bone-and-joint configuration of the deer.

NO!

YES!

The neck has a natural curve to it, which you should be sure to include, even if it's subtle. Drawing it straight makes it appear stiff and lifeless.

REINDEER

So many elves to shop for! Hey, if Santa can wear a holiday costume, why not Rudolph? Dressed incognito, maybe he can duck into Saks, get his presents, and make it back to the North Pole without being noticed. What do you think the odds are?

The long legs of the deer and his long neck give him his height when you stand him up on two legs. His powerful legs give him full thighs, but skinny "calves"—a funny look. Don't overcomplicate the antlers; just two or three ridges are all you need. All cartoon deer—and realistic ones, too—have big ears.

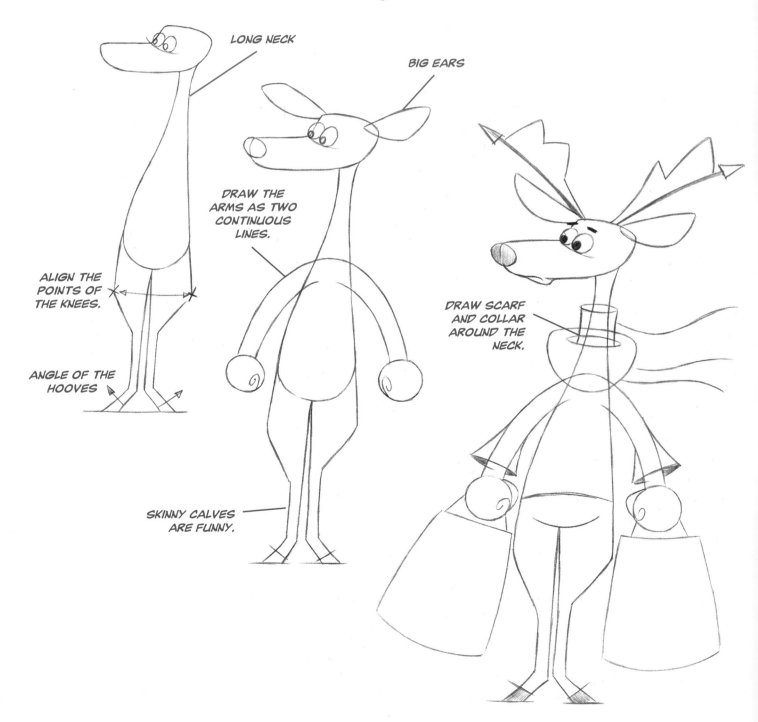

LONG NECK

BIG EARS

DRAW THE ARMS AS TWO CONTINUOUS LINES.

ALIGN THE POINTS OF THE KNEES.

ANGLE OF THE HOOVES

DRAW SCARF AND COLLAR AROUND THE NECK.

SKINNY CALVES ARE FUNNY.

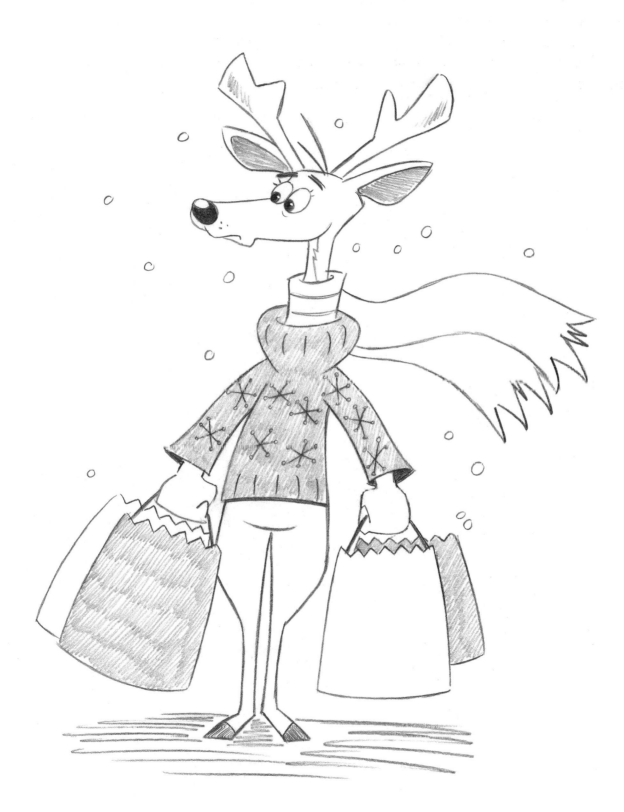

ASSORTED ANIMAL SIDEKICKS

Now we move on to the sidekicks of the animal world. Sometimes these types of animals star in cartoons, animated movies, and comic strips, but more often, they're the buddies, pals, and mischief-makers. They're big on personality, but unfortunately, not so big on brains. They always have a scheme for getting out of trouble. Too bad they never bothered to wonder why, if they're so clever, they get into so much trouble to begin with!

ONE LITTLE PIGGY

Where did pigs get this rep for being fat? Real pigs are actually pretty athletic. When drawing barnyard piggies, I like to draw the boyish, energetic type with the long ears. They have hard, firm bodies—very compact and short. I take liberties with the face by giving them extra-cute cheeks. (Real pigs have narrow faces, although you wouldn't know that from watching cartoons!) Here are a few more tips to help you "pig out"!

Young Piggy
This young pig is like a puppy dog—a real cutie.

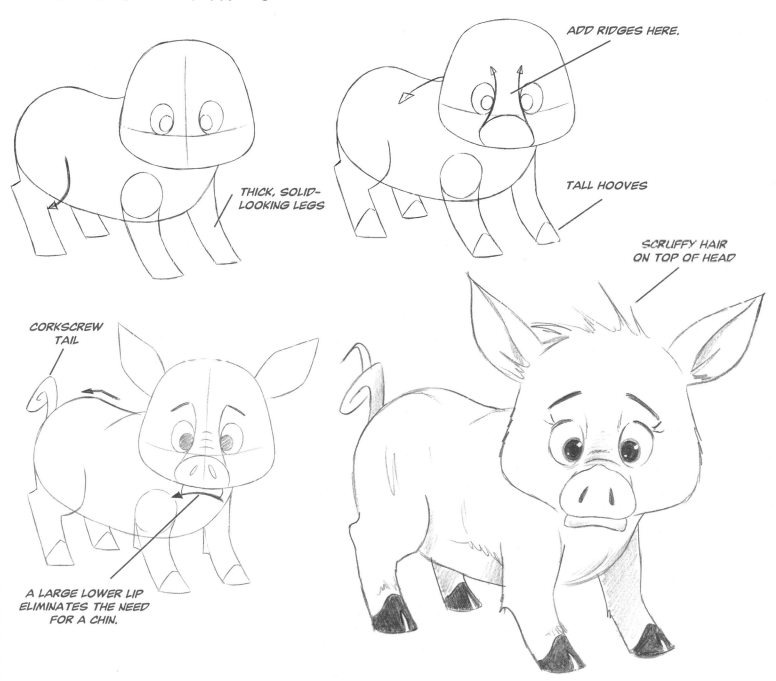

ADD RIDGES HERE.

THICK, SOLID-LOOKING LEGS

TALL HOOVES

SCRUFFY HAIR ON TOP OF HEAD

CORKSCREW TAIL

A LARGE LOWER LIP ELIMINATES THE NEED FOR A CHIN.

Retro Pig

Calm down there, big fella. This retro-style pig is hot to trot. What a match. This must have been set up by some pig e-dating service.

He's been drawn with a fat retro outline and a thinner line to detail the features inside of the head. More hard angles are used than in drawing the girl pig, which has a softer look.

Dainty Porker

Isn't she a regular knockout? The boy pigs can hardly take their eyes off her. And look how she's kept her girlish figure!

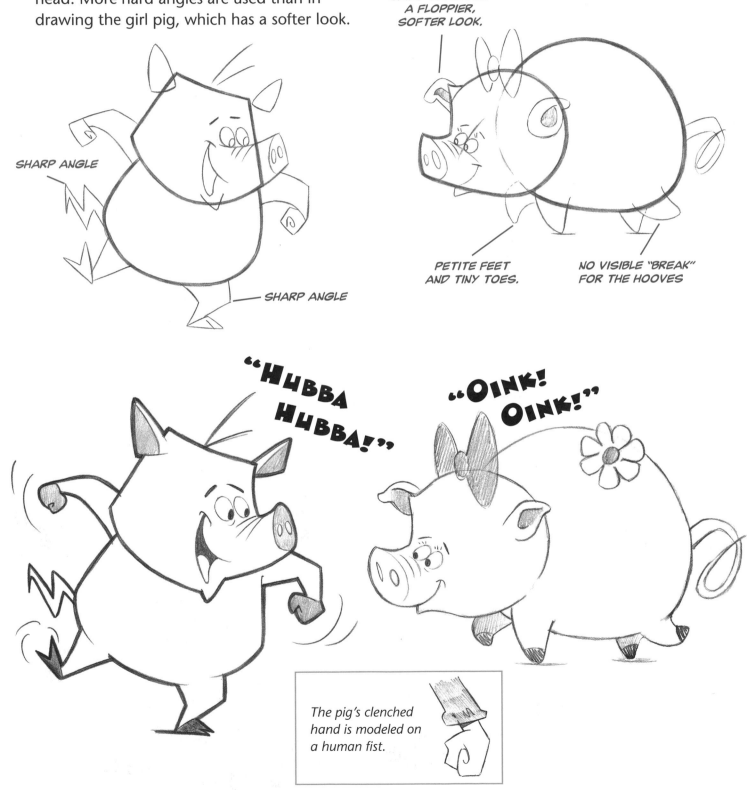

SHARP ANGLE

SHARP ANGLE

CRIMP EARS FOR A FLOPPIER, SOFTER LOOK.

PETITE FEET AND TINY TOES.

NO VISIBLE "BREAK" FOR THE HOOVES

"HUBBA HUBBA!"

"OINK! OINK!"

The pig's clenched hand is modeled on a human fist.

Jumbo-Size Pig

Some prize-winners at farm fairs actually get up to 400 pounds. And their legs are tiny, buckling under all that flab. When a real pig gets that big, it looks like a cartoon anyway! When you super-size your pig, small-size its legs, and you'll have just the right combo for a humorous character.

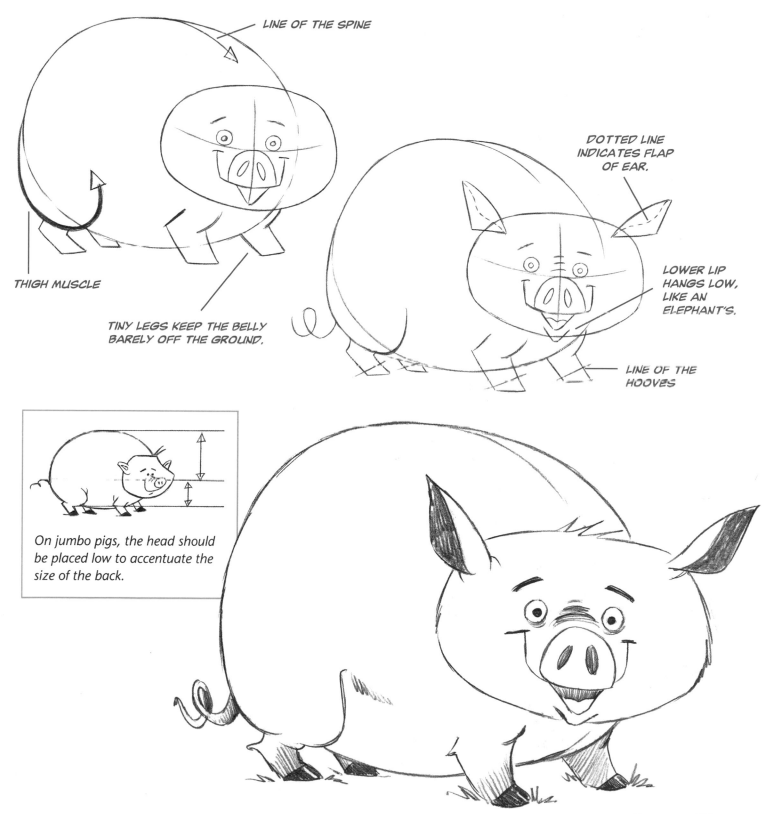

LINE OF THE SPINE

THIGH MUSCLE

TINY LEGS KEEP THE BELLY BARELY OFF THE GROUND.

DOTTED LINE INDICATES FLAP OF EAR.

LOWER LIP HANGS LOW, LIKE AN ELEPHANT'S.

LINE OF THE HOOVES

On jumbo pigs, the head should be placed low to accentuate the size of the back.

HOLY COW!

In modern cartooning, cows are no longer content, quiet farm animals. Instead, they are silly, reactive personalities—often standing on two legs, with rude udders bobbing uncontrollably off their tummies.

The snout of the cartoon cow is big and bulbous, with two oversized circles for the nostrils. Small horns on the forehead are optional. Little flappy ears hang off the sides. And remember that the cow is a maternal, female character. So you're never going to draw one that looks overly powerful, with broad shoulders and muscular arms. And they're *always* going to have extra pounds around the hips!

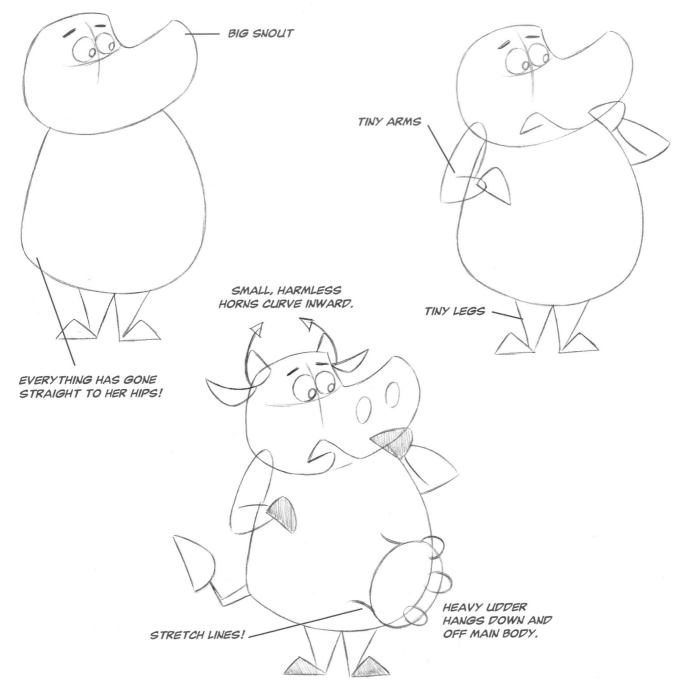

BIG SNOUT

TINY ARMS

SMALL, HARMLESS
HORNS CURVE INWARD.

TINY LEGS

EVERYTHING HAS GONE
STRAIGHT TO HER HIPS!

STRETCH LINES!

HEAVY UDDER
HANGS DOWN AND
OFF MAIN BODY.

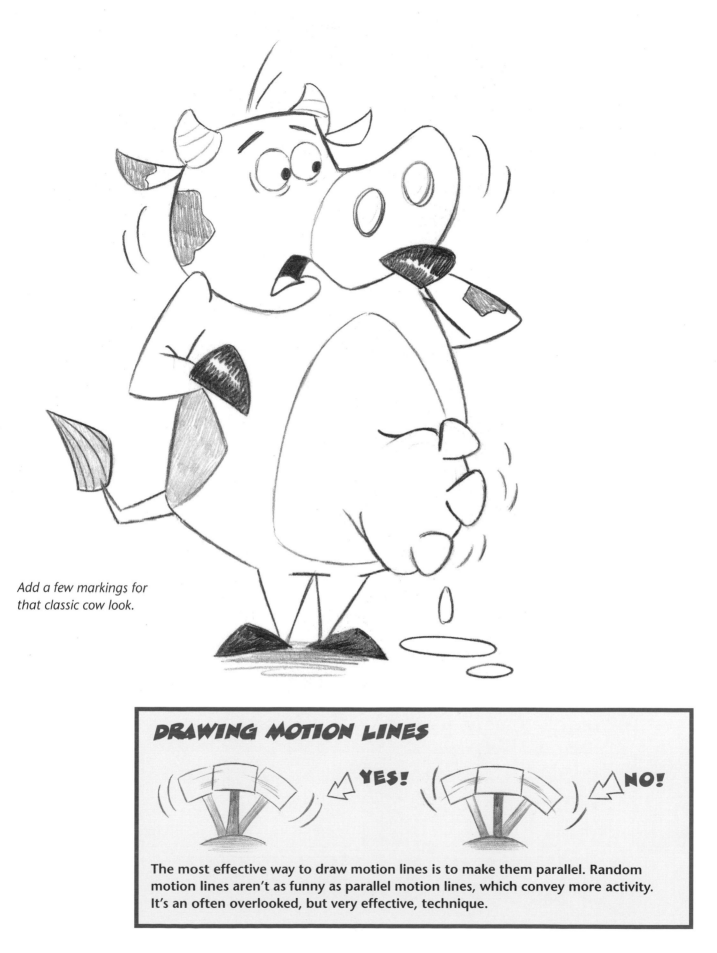

Add a few markings for that classic cow look.

DRAWING MOTION LINES

YES! NO!

The most effective way to draw motion lines is to make them parallel. Random motion lines aren't as funny as parallel motion lines, which convey more activity. It's an often overlooked, but very effective, technique.

More Cows

In many of the animals we have drawn, we've added a circle to the tummy to break up an area that otherwise might be too plain. We did this with, most notably, bears, but also dogs, cats, and others. By enlarging the cow's udder and making it circular, it serves the same purpose. Not surprisingly, not all clothes are designed to be worn with udders. And this is the result. This type of awkward "udder play" is hugely popular with kids. Parents cannot, for the life of them, understand why. Which is just one more reason why kids love it!

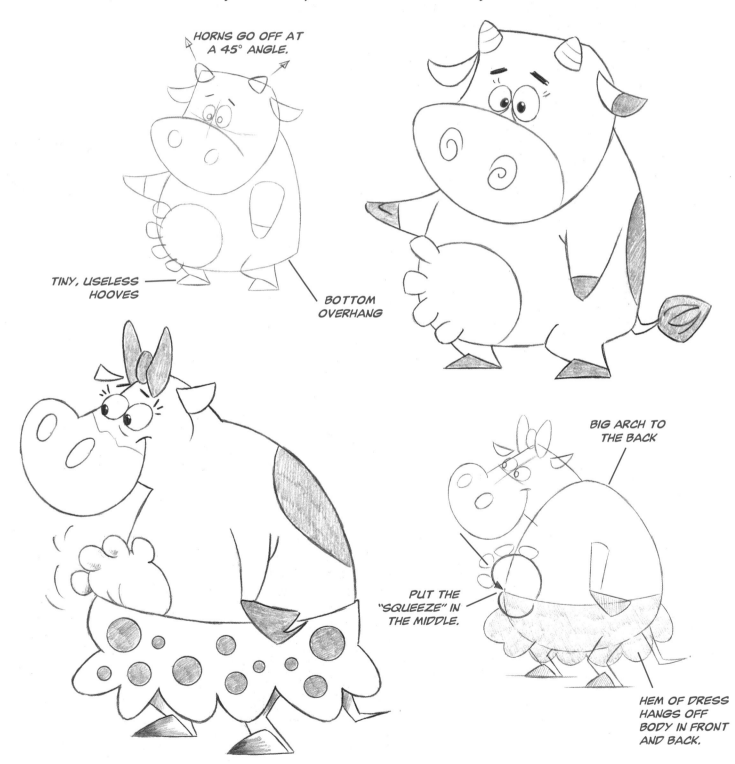

HORNS GO OFF AT A 45° ANGLE.

TINY, USELESS HOOVES

BOTTOM OVERHANG

BIG ARCH TO THE BACK

PUT THE "SQUEEZE" IN THE MIDDLE.

HEM OF DRESS HANGS OFF BODY IN FRONT AND BACK.

TURTLES: THE SHELL GAME

Cartoon turtles are never drawn as caricatures of sea turtles, or even regular pet-store turtles. They're almost always land turtles, which are actually tortoises. To give these slow but appealing critters ample personality, stand them upright. If you place them horizontally on four legs, the shell will dominate the figure and pull all the attention away from the head. By standing them upright on two legs, however, the head will take center stage and lead the way. Plus, the tummy, which is the inside of the shell, offers a nice visual design.

THE RUBBERY SHELL

In cartoons, the shell compresses and stretches to accommodate the expression of the character. For example, when this turtle places his arms akimbo and sets down for a "sulk," the shell **compresses**. Conversely, when he snaps up in a surprised pose, the shell **stretches**.

JUMPING AHEAD TO KANGAROOS

When drawing the kangaroo, I use bits and pieces from other animals and put them all together: the head of a deer, feet like a giant rabbit, and skinny, human arms.

Kangaroo and Joey

A joey is a baby kangaroo that is still being carried around in its mom's pouch. Which makes me wonder if kangaroos are experiencing the same problem that older human parents do: Their twenty-year-old kids are starting to move back home. Ouch! That could hurt!

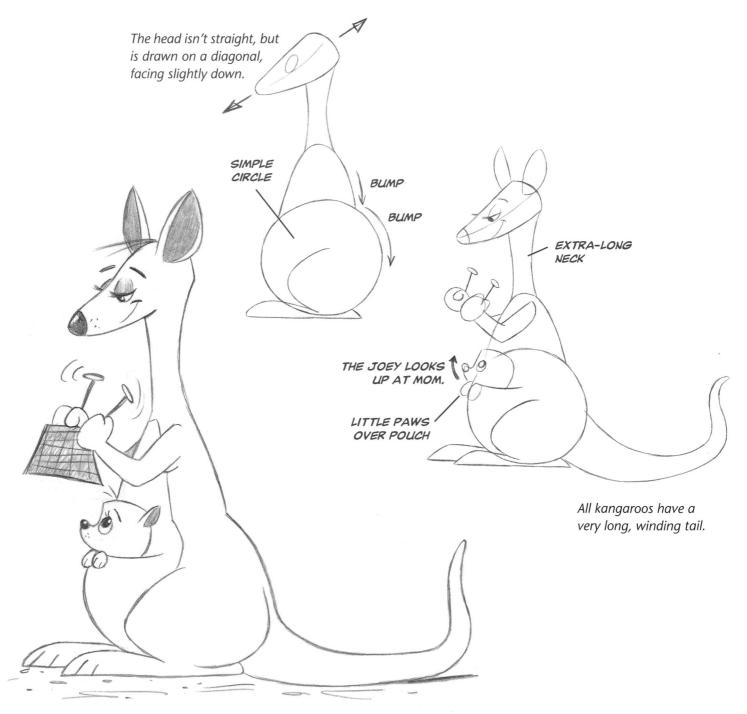

The head isn't straight, but is drawn on a diagonal, facing slightly down.

SIMPLE CIRCLE

BUMP

BUMP

EXTRA-LONG NECK

THE JOEY LOOKS UP AT MOM.

LITTLE PAWS OVER POUCH

All kangaroos have a very long, winding tail.

Stupid Kangaroo

With their elongated necks and lack of a chin, kangaroos make the ideal "stupid character." And this one, in particular, looks dumb because of his straight legs: He's forgotten how to jump! The tongue hanging naturally out of the mouth is a cartoonist's trick to show a less than stellar IQ. (Note that this is different than showing a character sticking his tongue out *at* someone.)

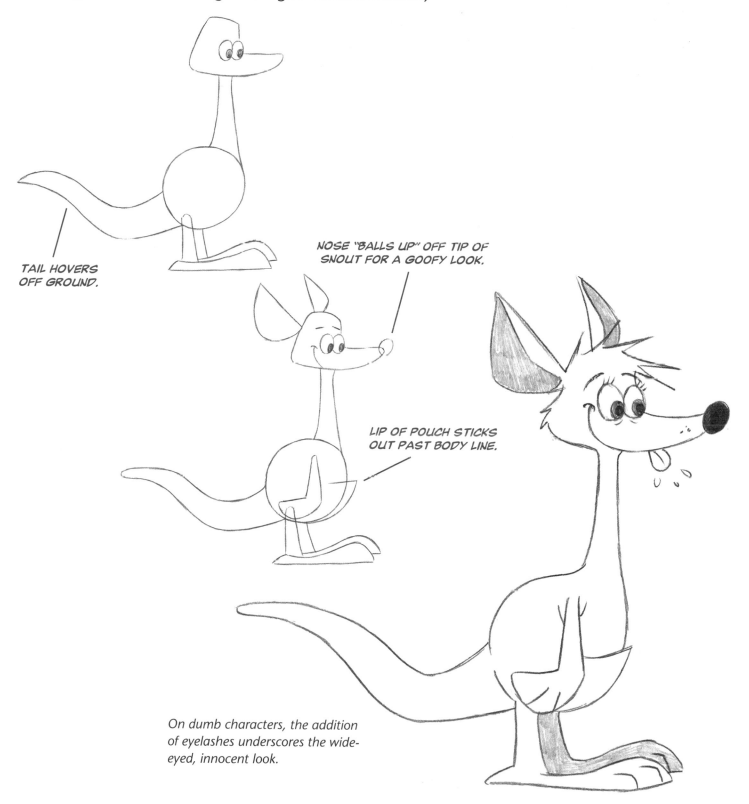

TAIL HOVERS OFF GROUND.

NOSE "BALLS UP" OFF TIP OF SNOUT FOR A GOOFY LOOK.

LIP OF POUCH STICKS OUT PAST BODY LINE.

On dumb characters, the addition of eyelashes underscores the wide-eyed, innocent look.

Kangaroo in Action

When drawing an action like a hop, *never* draw the point of contact where the feet touch the ground. Strange though it may seem, that would make the pose seem frozen. Instead, show the character off the ground, having *already* made contact with it, and let the "speed lines" show that the action has already taken place.

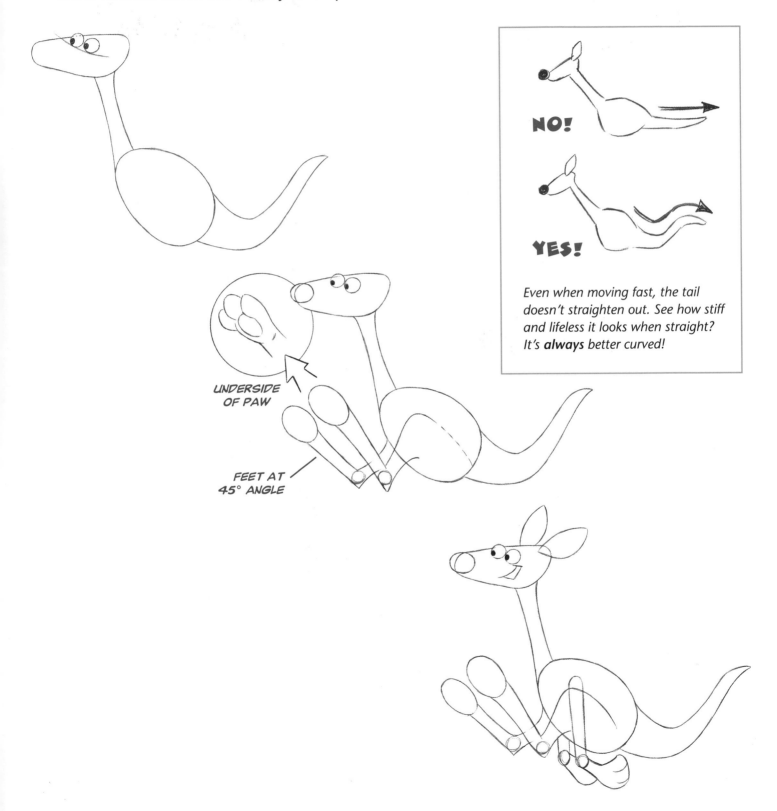

NO!

YES!

*Even when moving fast, the tail doesn't straighten out. See how stiff and lifeless it looks when straight? It's **always** better curved!*

UNDERSIDE OF PAW

FEET AT 45° ANGLE

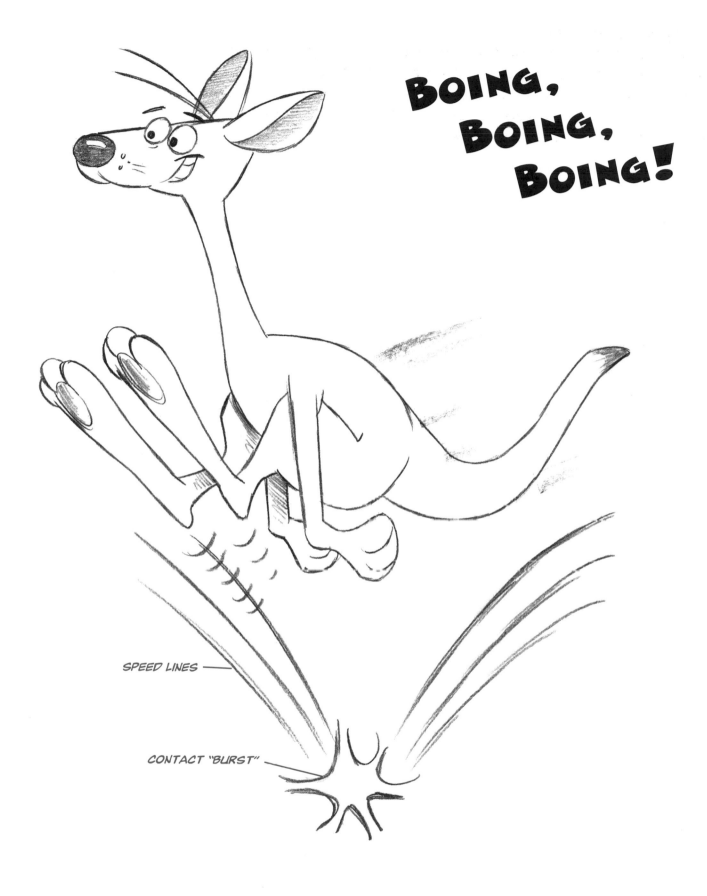

BOING,
BOING,
BOING!

SPEED LINES

CONTACT "BURST"

STRETCH YOUR DRAWING SKILLS WITH GIRAFFES

Never invite a giraffe to a party. They hate balloons and goody bags. The giraffe is perhaps the longest-legged animal in the cartoonist's portfolio. The elephant may, in fact, have longer legs when measured in actual feet and inches, but no animal's legs look longer than the giraffe's, proportionally speaking. Part of the reason is that its body is so small and compact. And its neck is so long.

From the torso down, the giraffe is all legs. From the torso up, it's all neck. That's perfect counterbalance. And if you've worked through a lot of this book with me, you'll almost be able to guess what I'm going to say next: Don't draw the neck as stiff and straight! Yeah, yeah, I know: You already knew that!

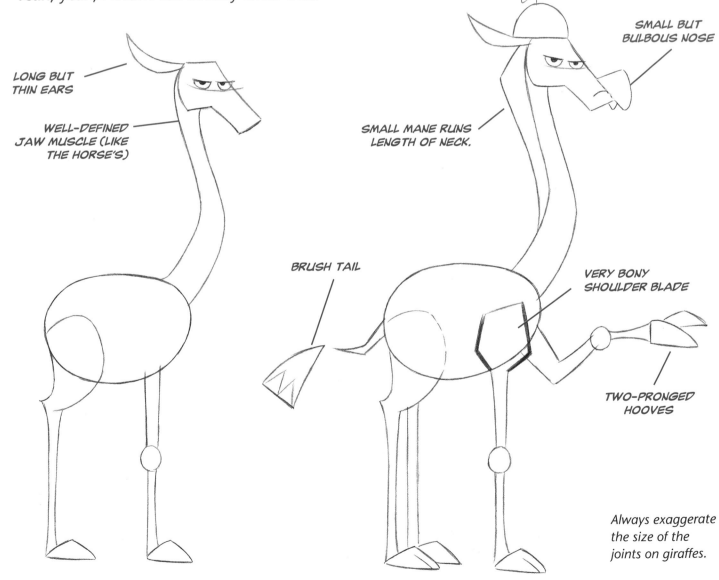

LONG BUT THIN EARS

WELL-DEFINED JAW MUSCLE (LIKE THE HORSE'S)

SMALL BUT BULBOUS NOSE

SMALL MANE RUNS LENGTH OF NECK.

BRUSH TAIL

VERY BONY SHOULDER BLADE

TWO-PRONGED HOOVES

Always exaggerate the size of the joints on giraffes.

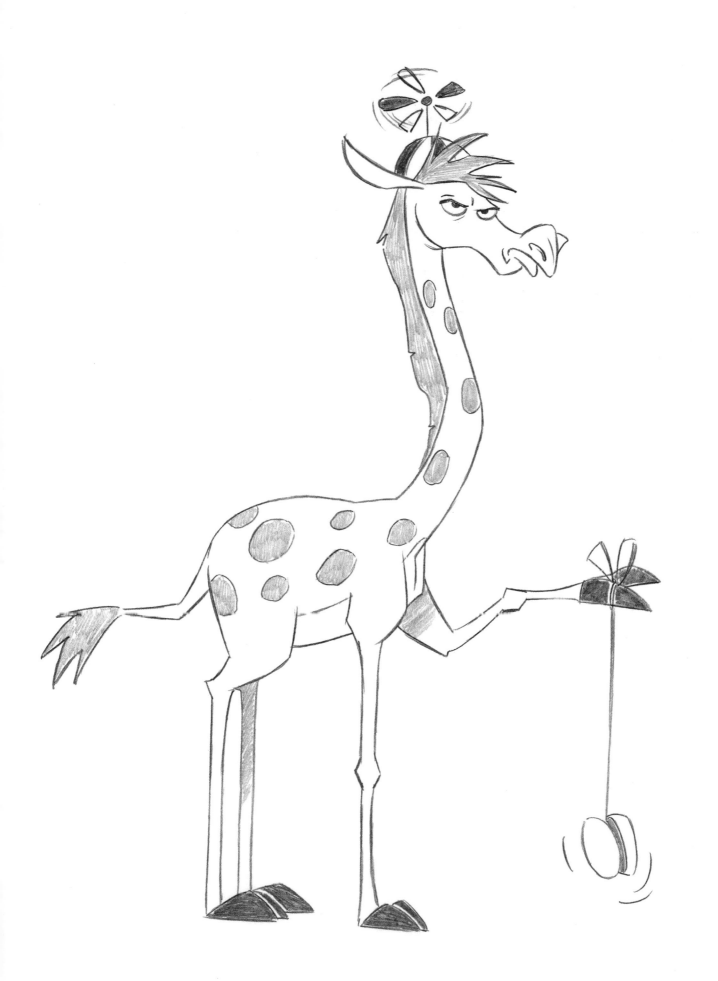

HOORAY FOR HIPPOS!

The hippo can be hard to draw if you don't know a few, simple keys. The first key is in the humongous snout. It's big and curves and takes up so much of the face that it leaves no room for a chin— just a lengthy lower lip.

To complete the head, draw the skull with a subtle split down the middle and add tiny—I mean tiny—ears on either side and small eyes. The body is a huge, simple oval, punctuated with stubby, elephant-like feet.

BIG, CURVED SNOUT

SMALL EYES

SIMPLE OVAL BODY OUTLINE

SHORT, FLAT, ELEPHANT-LIKE FEET

RIDGE OVER EYES

FAT ROLL

PIG-LIKE TAIL

LIP FLAP AT END

LONG LOWER LIP, BUT NO CHIN

MONKEY BUSINESS

Welcome to my village! I love these little guys. They're full of curiosity and frenetic energy. A chimp has a small forehead and inquisitive eyes, so I like to make them very round and open. A perfect example of the "bright-eyed" character we've talked about.

The hallmark of the chimp is its way, way oversized arms. And its forearms are particularly thick, more so than its upper arms! Be sure to treat the feet like hands by giving them a thumb at the bottom of the foot, near the inner ankle.

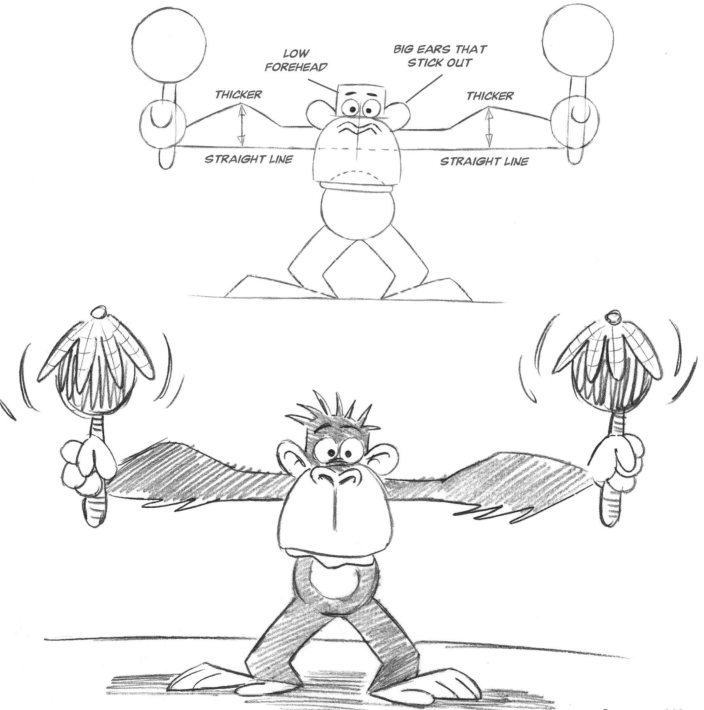

INDEX